# Leading with Passion

# Leading with Passion

## Change Management in the 21st-Century Museum

SHERENE SUCHY

ALTAMIRA
PRESS

A Division of
ROWMAN & LITTLEFIELD PUBLISHERS, INC.
*Walnut Creek • Lanham • New York • Toronto • Oxford*

ALTAMIRA PRESS
An Imprint of Rowman & Littlefield Publishers, Inc.
1630 North Main Street, #367
Walnut Creek, CA 94596
www.altamirapress.com

Rowman & Littlefield Publishers, Inc.
A wholly owned subsidiary of The Rowman & Littlefield Publishing Group, Inc.
4501 Forbes Boulevard, Suite 200
Lanham, MD 20706

PO Box 317
Oxford
OX2 9RU, UK

British Library Cataloguing in Publication Information Available

**Library of Congress Cataloging-in-Publication Data**

Suchy, Sherene, 1952–
   Leading with passion : change management in the 21st-
century museum / Sherene Suchy.
       p. cm.
   Includes bibliographical references and index.
   ISBN 0-7591-0365-8 (hardcover : alk. paper) — ISBN 0-7591-0366-6 (pbk. : alk. paper)
   1. Art museums—Management. 2. Art museums—Administration. 3. Art
museums—Educational aspects. 4. Museums—Management. I. Title.

N470.S83 2003
708'.0068—dc22

                                                                        2003018967

Printed in the United States of America

♾™ The paper used in this publication meets the minimum requirements of American
National Standard for Information Sciences—Permanence of Paper for Printed Library
Materials, ANSI/NISO Z39.48-1992.

Dedicated to the two people who introduced museums into my life and who supported this project in all ways.

Herschel and Lorene Johnson

and

In Memory of Dr. Phillip Kent

# Contents

*Foreword*                                                          xi

*Preface*                                                           xvii

*Introduction*                                                      1

**1  Catalysts for Change**                                         15
  Clues and Cues for Change                               16
  Evolution of the Entrepreneurial Museum                 18
  Changes in Selection Criteria for Directors             20
  Succession Planning Tension                             22
  Integrating Clues                                       25

**2  Passion: Representing the Organization**                       29
  Passion Makes the Difference                            30
  Flow and Pleasure in Work                               32
  Emotional Intelligence, or EQ                           34
  Passion, Flow, and the Representational Role            38
    A Passion for the Primary Product           39
    A Passion for Social Principles and Romanticism   42
    A Passion for People and Education           44
    A Passion for Entrepreneurship and Innovation   48
    A Passion for Constructive Discontent        50
  Integrating Change and the Representational Role        53

**3  Context: Creating a Place**                                            59
A Model to Map Change                                                        60
Levels of Organizational Complexity                                          62
Increasing Complexity and Changes in Context                                 65
Decision Making, Complexity, and Intuition                                   66
Intuition, Creativity, and New Contexts                                      69
Creating Collaborative Teams                                                 72
Participative Leadership and Change Management                               77
Gender Differences and the Influence on Context                             82
Integrating Change and the Creating Context Role                            86

**4  Entrepreneurism: Selling Integrity**                                    93
Maintaining Flow during Economic Shifts                                      94
Making Money by Making a Difference                                          96
Making a Difference with Social Capital                                     100
Attracting Stakeholders in Social Capital                                   104
Ethical Entrepreneurs and Change Management                                 109
Coaching Staff to Be Entrepreneurs                                          112
Stories about Selling Integrity                                             115
Integrating Change and the Entrepreneurial Role                            118

**5  Trust: The Director–Trustee Interface**                                125
Nurturing Relationships of Trust                                            126
Change and Role Confusion                                                   130
Clarifying Governance and Stewardship                                       132
Policy Development and Financial and Legal Responsibility                   136
Succession Planning Issues                                                  140
Integrating Change and the Nurturing Trust Role                            146

**6  Realigning: Past and Present Leadership Requirements**                 153
Realigning Position Descriptions                                            154
Tracking Change through Position Descriptions                               156
Realigning Remuneration with Job Complexity                                 159
Tracking Change with Professional Development                               161
On-the-Job Development Is the Favorite Option                               169
Alternative Career Paths for Development                                    172
The Importance of Mentors                                                   176
Integrating Change and Leadership Requirements                             179

**7  Action: Principles into Practice**                                  185
 Testing Principles in Practice                                          186
 Personality Type, Self-Selection, and Succession Planning              188
 Type and Organizations in Society                                      194
 Preparing for Leadership Transitions                                   196
 Initiatives for Cost-Effective Succession Planning                     202
 Integrating Principles and Practice for Action                         207

*Appendix 1: Research Methodology*                                      215

*Appendix 2: Survey Questionnaire*                                      223

*Appendix 3: Research Interviews*                                       241

*References*                                                            249

*About the Author*                                                      267

# Foreword

*Leading with Passion: Change Management in the 21st-Century Museum* is based on international research designed to build bridges between different domains of expertise in the cultural and humanities sector. With this intention at heart, we gratefully acknowledge the cross-cultural perspectives offered by Richard E. Boyatzis from the United States and Patrick J. Boylan from the United Kingdom in the foreword.

\* \* \*

Watch people as they enter the Galleria dell'Accademia Museum in Florence. They are puzzled as they walk down the main gallery past Michelangelo's blocks with parts of statues, as they put it, "struggling to be free of the stone." Further down the hall, they gaze upon David. Almost universally, people stop moving when they first see him. Their mouths drop a little. They stand in awe. They approach David with the tenuousness of getting close to a growling dog barring its teeth at you—but they keep moving slowly, wanting to get closer. Circling David, eyes move to the muscles in his back, his legs, his hands, his face. Imagine if our world did not have such places.

Without museums, our lives would lack perspective, history, and beauty. Generous patrons donate millions of dollars every year. Meanwhile, government and the public invest their hard-earned tax dollars into creating and sustaining these important aspects of our social fabric. And, yet, we devote so little time to understanding how to effectively and efficiently build and operate museums.

Scholars have devoted their lives to museums, but they typically address the content or offering of the museum. Visitor studies came into vogue in the United States in the 1920s. The objective was to understand how someone visiting a museum would explore it. Using this information, it was believed, would help to enhance the experience by providing better displays, signage, and layout. The field advanced in small steps through the 1980s, where professional associations sponsored continuation of such studies.

Up to this point, the enlightened museum director read literature and attended courses on leadership or management on his or her own initiative. Most specialized in their field (e.g., textiles, preclassical Greek urns, Baroque painting, etc.) while the organizations plodded along surviving on a steady flow of donations. The U.S. federal tax code helped by making such contributions tax-deductible. Museum directors began to create development offices and enter into sophisticated strategies to raise money, using tax and estate planning as a major impetus to get the attention of people for larger and larger donations and inclusion in their wills.

The 1980s gave rise to academic programs to develop museum directors in the United States. There were a growing number of management schools developed to do research and deliver courses for not-for-profit organizations, and specifically focused on arts management. But, here again, the efforts were sporadic.

An example of such an effort occurred at Case Western Reserve University in Cleveland, Ohio. Mort Mandel and his family inspired and sponsored a Center for Nonprofit Management. It was a joint effort of the management, law, and social work schools. It started research in numerous types of nonprofit organizations, began a master's degree in nonprofit management, and started a major journal in the field. But specific work addressing arts organizations awaited Fidelity Investments. They sponsored an arts management program at the Weatherhead School of Management in the late 1980s. As part of this effort, fields such as organizational behavior, marketing, and finance were brought into projects to help the Cleveland Museum of Art, the Contemporary Art Center, and several performing arts organizations. Museum curators and faculty began studies on optimizing collection rotation, scheduling algorithms, strategic planning, board development and governance, and such.

Quite possibly the most important contribution of these grants and programs was to call the attention of faculty and scholars to arts organizations.

Collaborations began that produced scholarly articles, case studies, and enhancements in courses, including the MBA program.

Dr. Suchy's work offers to the museum world a window into this perspective and work. She helps people find their way around the "business-speak" and away from trivial notions of making museums more like businesses. But the concepts and methods developed from research in business schools have merit when applied sensitively to this context. Her work, since the 1980s, can help most museums, anywhere in the world, manage themselves for a vibrant future. Whether it is facing the entrepreneurial dilemmas of starting a museum in Botswana or the complex issues of storage, divestment, and acquisition for museums with collections far too large to exhibit in Chicago, these ideas can help. Enjoy the coming pages; they will help you work toward your mission.

Richard E. Boyatzis, Professor and Chair
Department of Organizational Behavior
Weatherhead School of Management
Case Western Reserve University
Cleveland, Ohio, USA

\* \* \*

Management and leadership training have been part of specialized (particularly graduate) museum professional education and training for many decades. The first modern-style museum studies course was probably that established in Buenos Aires, Argentina, in the mid-1920s, with the University of Rio de Janeiro, Brazil, following in 1933, and the master's program in the M. S. University of Baroda, India, in 1947.

In 1964 compulsory courses and examinations in organization and management were added to the already long-established (UK) Museums Association Diploma and associateship program (thirty-five years before the equivalent was made compulsory for applicants to the associateship of the British Institute of Management!). The objective was to ensure that all successfully completing the program would be fit to take up the directorship of any medium-sized museum. (One of the original authors of the 1964 revised Diploma used to describe it as "a license to drive a museum.") Requirements taken more or less directly from the UK Diploma program were incorporated into the UNESCO International Council of Museums (ICOM) "Program Type" (Model Curriculum) for Museum Professional Training adopted in 1971 (regularly updated since then and now called the Curricula Guidelines for Museum Professional Development, last revised in 2000).

Among the world's hundred thousand or more museums major, or even medium-scale, specialist art museums are numbered in hundreds, or at most a few thousand, depending on the definition or the perspective adopted. However, over the past few decades this tiny percentage of museums has arguably attracted a very disproportionate level of attention from government in those countries where these are wholly or partly supported by the state, and from the national and international media just about everywhere.

However, art museums have tended to regard themselves as very different from the great majority of museums, in terms of their policy, organization and—not least—staff training and career development. Also, despite the high public and media profile of major art museums, there has been very little serious research on the internal organization and management of these increasingly prominent features of the cultural sector.

This is in marked contrast with the large volume of both doctoral research and academic journal papers on most other types of important arts organizations such as orchestras, opera, theatre, major festivals, and govern-

ment cultural policy. The research program in my own department at the City University London, probably the largest multidisciplinary postgraduate center for cultural sector advanced management education and research is typical: out of sixteen recently completed policy and management PhDs, there have been four on orchestras, three each on opera, theatre and on national cultural policies, and one each on education and training, the contemporary art market, and the cultural economics of information technology developments.

Therefore, the publication of this extensive research on major museums, mainly art museums of Australia, and England, and North America, is an important landmark, and particularly welcome. Sherene Suchy has explored recent change and future possibilities, particularly in relation to the nature and role of the directors of major art museums, against the background of marked changes in the composition and role of boards of trustees. Boards nowadays look far more like the boards of major business corporations, rather than the traditional board of scholars and connoisseurs expert in the museum's field of study and collections. These new boards—and funding bodies such as governments—in turn now expect the museum director to take on the role of a CEO of international corporations. I am sure that this will remain for many years a key text for consideration and discussion of management and leadership in museums more generally, not just of the role of the director and board.

Patrick J. Boylan
Professor of Heritage Policy and Management
City University London

# Preface

My aim in *Leading with Passion* is to create a bridge between organizational psychology, management theory, and cultural institutions like museums. As an organization development specialist and part-time academic, I have a unique vantage point: a window into many different kinds of organizations. After twenty years in the field, I've looked into many different kinds of organizational windows and I especially like looking into those of museums. I like the opportunity window museums offer to look into the past, present, and future. Museums play a role for me in my community as centers for protecting cultural heritage, celebrating cultural diversity, enjoying pleasurable learning, and engaging in serious play. With a deep love of travel, I use museums to orient myself in new locations (regional, national, and international). As a change management consultant, I advocate the use of museums as sites for cultural orientation and social connection when I coach international managers and their families on change management strategies.

This book emerged as a labor of love in response to encouragement from conference audiences in the museum sector, publishers and readers of some of my journal articles, and the wish to share more of the magic behind my PhD research on change and museum leadership. The PhD was completed with a scholarship at the University of Western Sydney in the late 1990s. The framework for *Leading with Passion*, essentially about change management, is based on the original research with the addition of new insights and suggestions based on my experience after 1998. The heart of the book offers a rich insight into a decade of change in the 1990s, through personal interviews with and survey feedback from

seventy-two museum directors or associate directors and other professionals in Australia, Canada, England, and the United States. We agreed on the importance of participating in and sharing research outcomes in what I now call a benchmark study on 21st-century leadership and change management using the museum as a case study organization. All of the professionals who contributed to this book were very busy people, and I am most grateful for their willingness to share. I hope they can use the results as a journey map to track changes over time.

I used those professionals' insights to design a unique program called *Leading with Passion: EQ Leadership Development*, launched in Australia in 1998 with participants from different industry sectors: banking, public utilities, and the government. This intensive program uses case studies from the museum sector and incorporates what is now called emotional intelligence competencies to encourage individuals to develop the fourfold leadership role explored in this book:

- First, represent the organization internally and externally, guided by your passion. Leaders with passion care about their organizations. They know what they stand for and find it easy to tell their organizations' stories in a way that engages the hearts of others including staff, the public, trustees, key stakeholders or investors, and volunteers.
- Second, create a context for others to give their best. Leaders with passion understand that an important part of the job is acting as a coach. They build teams and encourage others to express their unique talent on behalf of the organization.
- Third, act as an ethical entrepreneur to ensure the organization's financial future. Leaders with passion can see new ways to create profitable opportunities for the organization. Although much has changed since the 1990s, entrepreneurship and ethics is still a serious concern. (In April 2002, the Bowater School of Management and Marketing at Deakin University in Melbourne, Australia, invited participation in an international symposium on entrepreneurship and the arts. I was reassured to hear that issues described in this book are still relevant.)
- Fourth, nurture relationships of trust with key stakeholders throughout the organization. Leaders with passion manage the delicate interface between directors and the board of trustees knowing that this shared leadership role can make or break the integrity of an organization.

A number of people and organizations were influential in the birth of this book. The ideas started with my research at the University of Western Sydney in Australia, so I would like to thank my previous supervisors Dr. Campbell Gray (current director of the Brigham Young University Art Museum in Utah) and Dr. Phillip Kent (University of Western Sydney) for their guidance and encouragement. Dr. Graeme Sullivan, previously with the College of Fine Arts, University of New South Wales, and now at Columbia University in New York, provided feedback and verification on the research methodology.

Special thanks go to Dr. Des Griffin, past director of the Australian Museum in Sydney and of Museums Australia, for mediating the tension between museums and the art and science of management. Thanks also go to the director and staff at the Art Gallery of New South Wales in Sydney for continuing to create a special place for serious play. I have enjoyed the exchange and support of particular colleagues associated with UNESCO and those who work so passionately through the International Council of Museums (ICOM): Margaret Birtley (Museum Studies Unit, Deakin University in Melbourne); John McAvity (president, Canadian Museums Association); Professor Patrick Boylan (City University, London); Carol Serventy and David Tunney (World Federation of Friends of Museums); and Stephen Weil and Nancy Fuller (Smithsonian Institution, Washington, D.C.). A referral from the Smithsonian Institution led to AltaMira Press and Susan Walters, who saw the value in *Leading with Passion.*

Love and encouragement came from many sources: my parents Lorene and Herschel Johnson, family, friends, clients, guides, and colleagues in the School of Management at the University of Technology, Sydney. I give my heartfelt thanks to all of them.

I want to encourage leaders and potential leaders to explore the bottom line described in *Leading with Passion:* Go to work for the heart of it. Do what you love to do. Figure out what you care about most and find an organization that stands for it. Rediscover a passion for some part of your work. Passion acts as a personal anchor to weather the waves of change. Passion also provides contagious enthusiasm for our leadership story. When we love what we do, it appeals to the hearts of others to get involved with what we love. In this case, museums. It doesn't matter how big or small the organization is or even whether it's a museum. When leaders believe they have a role to play, go to work for the heart of it, and care for the organization, magic happens.

# Introduction

*Leading with Passion* is about change management in the museum sector based on the insights of people who know about it firsthand—the directors. It starts with an outline of cues and clues that pointed to a leadership crisis in the 1990s. It ends with suggestions for ways to expand and nurture a pool of new-breed leaders for our museums over the next two decades. *Leading with Passion* describes the 1990s as a decade of change with the evolution of what I call the entrepreneurial museum. This change has had serious implications for selection, career paths, leadership development initiatives, and succession planning strategies.

The book has been written as a benchmark study for students in museum studies programs; new and mid-level professionals in museums (small to medium sized, as well as large); seasoned museum professionals; and cultural leaders, trustees, and board members. I would also like to think it would make an interesting read for people working in other industry sectors. We can all learn from each other by building bridges between different domains of expertise. My role is a mix of facilitator, investigator, narrator, advisor, and change management coach. The role is based on experience as a part-time academic in the School of Management at the University of Technology, Sydney in Australia, as a full-time change management consultant, as a leadership development program facilitator, and as a passionate advocate for museums as sites for cultural celebration.

## WHY TARGET MUSEUMS AS A CASE STUDY ORGANIZATION?

I wrote this book about change management and leadership for the 21st century using the art museum as a case study organization for a specific reason. While leaders in the museum field may like to think museums and museum leadership roles are not interchangeable, there are similarities between the problems facing all museum directors and leaders of other types of organizations. The journey behind this book began in 1989 when I was a manager in the Organization Development Unit for the Corporate and International Division at Westpac Bank's headquarters in Sydney, Australia. My job was threefold: manage an executive development program for high-potential senior managers; establish a best practice model for selection and management of international or expatriate staff; and develop communication strategies for corporate change management. When my partner and I moved to Singapore in 1991, I continued to use the techniques I was trained in with a new client group for Singapore's National Arts Council and the British Council. My new client group was the cultural industry sector. Teaching management, marketing, and communication strategies to arts businesses in Singapore led to my masters of art administration degree in 1993 and an internship at the Art Gallery of New South Wales in Sydney. My master's degree research project focused on sponsorship management in a public art gallery, which led to a strategic planning project with the same museum.

That strategic planning project raised vexing questions about change, challenge, and museum leadership in an era of economic rationalism. Government policy was forcing public sector organizations like museums to become self-funded and to redefine themselves as businesses in the culture industry sector. This signaled a change in role for museum directors and senior staff with an expectation that directors would be entrepreneurs and curators would be sponsorship managers. That change triggered my research on change, challenge, and museum leadership.

### WHY FOCUS ON ART MUSEUMS?

I used art museums for reasons that will be revealed shortly and because I believe the visual arts have something special to offer. I enjoy all kinds of museums: art, natural history, history, science, marine, children's, and aviation. As a child, I grew up in museums in the United States. My father was a pilot in the U.S. Air Force. We were posted to new locations on a regular

basis and traveled frequently. Museums were our sites for serious play and cultural orientation as we settled into new home bases. Our family home looked like a museum. My parents were collectors and my mother was an artist. One of her teachers painted the original dioramas for the Natural History Museum in Denver, Colorado. Our family dug up dinosaur bones and crystallized fish from the Badlands National Park in South Dakota and donated them to the local science museum. As a ten year old, my first visit to the J. Paul Getty Museum in Los Angeles with my father and sister was a big adventure because we had a private consultation with a curator.

Why use the art museum? The visual arts are a link to an important part of our human psychology. We make pictures in our minds to see the destinations we imagine for our organizations and ourselves. We see or create images of what we want to bring into reality. The intuitive or right side of our brain communicates in visual symbols. Leadership texts, change management theory, organizational psychology, and the directors who contributed to this book all made reference to that *leadership vision thing*. We have to visualize our destination. We must see ourselves on the way and how we want to be when we arrive. We need to make ourselves a journey map that we can study so we know the way and the destination by heart.[1] Learning how to see the outer world through art is similar to learning how to see the inner world through psychology.

### WHY FOCUS ON MUSEUM LEADERSHIP?

Although leadership has been studied in the commercial, military, and public sectors, it has not been studied extensively in cultural organizations. According to one management theorist, "museum leadership has received little serious scrutiny."[2] Leadership can be a contentious area of study because opinions and definitions may vary widely. There are at least 350 definitions of *leadership*, including the opinion that leadership is a mentor role.[3] Leadership has traditionally involved the ability to influence people toward goal achievement during major change, to excite others to extend themselves, and to enjoy sharing that *leadership vision thing*. Management, on the other hand, has been described as a task orientation involving activities such as planning, budgeting, organizing, staffing, controlling, and problem solving. Experience teaching *Effective People Management* and *Organization Change and Adaptation* at the University of Technology, Sydney, for nearly a decade has taught

me an important lesson. Distinctions between leadership and management may have been important prior to the 1990s, but the 21st century requires a new approach that heals splits and resolves dichotomies. Managers cannot be successful without being good leaders, and leaders cannot be successful without being good managers.[4]

That all organizations need some form of leadership provides a starting point. From that point, I discovered that theorists diverge into trait theory, style or situational theory, and what is currently termed post-heroic leadership. Trait theory argues that leaders are born, not made. Style theory argues that leaders rise to and are shaped by situations that call for specific behaviors and decision-making styles. The post-heroic model describes *leadership* as a form of change management, coordination, and team building.[5] Museum directors have traditionally been described through the trait theory approach, born as curators and selected as directors based on scholarly qualifications.[6] During the 1970s trait theory shifted to management theory to describe directors in management roles. The 1980s shifted toward style theory with styles often ill-matched to museum needs. The 1990s introduced what appeared to be a leadership crisis in museums. In 1994, the director for the National Gallery of Australia (NGA) in Canberra believed that the "requirements for the museum director's role are impossible to meet."[7] This view reflected an international situation and that is why my research explored an international perspective. In 1994, there were at least thirteen major art museums in the United States alone having difficulty recruiting new directors, including the Museum of Modern Art in New York, the Los Angles County Museum of Art, and the Museum of Fine Arts in Boston.[8]

When the director for the National Gallery of Australia retired in the late 1990s, it took nearly three years to locate a new director.[9] There were several reasons for the delay. Executive recruitment for senior positions in large organizations is a complex process. An important factor in any search process is the size of the candidate pool. The executive search for the new director at the National Gallery of Australia was conducted on an international basis. It highlighted the reasons for researching and writing *Leading with Passion*. The pool of people willing and able to take on directorship roles in museums was actually shrinking in the 1990s, while the number of museums expanded.[10] It seemed that potential candidates were aware of increasing job complexity around the director's role and were comparing this to what they had been

trained in and actually liked doing. People were self-selecting out of leadership career paths just at the time the leadership candidate pool needed to be expanding.

I wondered what would happen if that trend continued. How big would the candidate pool be in 2005 or in 2010? I asked the question with some concern based on research into leadership development and my own experience with executive development programs—it takes at least ten years to develop leadership potential.[11] That ten-year period is usually devoted to developing expertise as a leader in a specific domain of excellence. Then a choice must be made about whether to move from leading in an indirect way as an expert in a specific domain to direct leadership of the organization as a whole.

In museums, domains of expertise are exceedingly diverse. Museums as organizations are also very diverse in terms of subject matter, mission, and size. My research on change and museum leadership took account of the differences by focusing on leadership characteristics that are applicable across a broad range of organizations and domains of expertise.[12] Many professionals in the museum world may not accept the proposition that museum leadership may be interchangeable among art, children's, science, natural history, and history museums.[13] The resistance around cross-museum leadership roles becomes even more contentious if the search for potential leaders is extended *outside* the traditional domain of expertise. Leadership, though, is based on two fundamental questions that must be asked: *Why are we here? Who do we serve?*[14] These two questions were the entry point for researching museum leadership.

## RESEARCH STRATEGIES

*Leading with Passion* is written based on cross-disciplinary PhD research completed in 1998 at the University of Western Sydney. The original research has been used as a benchmark study to help the museum sector explore, adapt to, and plan for ongoing changes as we continue to move into the 21st century. To understand and describe changes in the museum sector, I have used my own experience as an organization development practitioner as well as a range of theories and models to understand and describe changes in the museum sector: behavioral science, cognitive psychology, communications theory, social work, systems theory, action research, survey

methodology, human resource management, and leadership theory. The research strategy appears in appendix 1.

As a brief overview, I used four different research strategies to explore the director's leadership role as a change manager—a literature search, sample survey questionnaires, one-on-one personal interviews with museum directors and other professionals in the field, and visits to a range of cultural institutions. The literature search was designed to provide an update on what seemed to be the most pressing leadership issues for museums in the 1990s. The search covered the museum sector as well as contemporary management material. I chose particular theories and models to guide the research and to provide an acceptable framework in which to discuss patterns and predictions. I was careful to broaden the literature search, looking for patterns that might illustrate similar issues across different industry sectors. Career academics who may measure the worth of research based on extensive literature searches need to be warned in advance. Although an extensive search was done, a line was drawn. The worth of this book is found in the directors' lived experience as leaders. Readers are encouraged to use my work as a benchmark for their own literature search to fill in any obvious gaps in a process of ongoing learning.

The second research strategy involved a sample survey questionnaire based on stratified systems theory and the levels of complexity model.[15] Stratified systems theory was used as a framework to explore individual capability and organizational complexity with museum directors and deputy directors. Stratified systems theory describes different levels of complexity in organizations and ways to understand leadership roles within each level of complexity. The survey questionnaires explored organizational culture, change management, decision making, relationships with key stakeholders, legal responsibilities, and financial management. One hundred and forty-four survey questionnaires were distributed to: alumni of the international Getty Museum Management Institute in the United States; alumni of the international Senior Museum Management Program in Australia; art museum directors in regional cities in Australia and Singapore; and directors of five art museums in London. There was a 21 percent response rate ($N = 30$). The majority of respondents were directors or deputy directors of art museums or art/history museums followed by history, park/zoo, and children's museums. Most of the responses came from the alumni of the Getty Museum Management Institute

Program who were located around the world, with a significant number based in the United States. The second largest survey response came from the Australian sector. A copy of the survey results and tables appears in appendix 2.

The third research strategy combined stratified systems theory with action research to put theory into practice. I wanted first hand experience and a way to provide museum directors with an opportunity to describe leadership in the 21st-century museum. Action research, which is based on a model of collaborative diagnosis, engages people directly involved in the issue by inviting their participation in the research process. There is an implicit understanding that the target group concerned will take action on any issues, outcomes, and needs identified in the research. Using a guided interview process called Career Path Appreciation, I worked with forty-two art museum leaders in one-on-one interviews using a guided interview process I was trained in called Career Path Appreciation to explore current and future change challenges. In my opinion, the personal interviews are the heart of *Leading with Passion*. I was entrusted with the directors' stories and have done my best to capture and share their lived experience. I accepted their descriptions of directing museums at face value and linked many of their observations with appropriate theory to draw conclusions. I understand and accept issues about the validity of research based on subjective experience and descriptions based on self-perception. The value of data generated through this "first-person method" has been validated and described by others as breaking the taboo of subjectivity.[16] However, it is a valid research technique. It is impossible to study change and leadership challenges without asking people what they experience and to value their subjective experience.

Based on the value of the lived experience, extended quotes are used in this book for two reasons. First, lived experience is the best form of authority. Extended quotes give the directors' an opportunity to describe and illustrate their experience of leading change for the 21st-century museum. Secondly, the extended quotes provide evidence for my interpretations about shifts in organizational complexity as well as patterns associated with personality type preferences. The guided interviews were designed to support a process of reflection without undue formality. The quotes reflect an informal exploration, and I take full responsibility for any ungrammatical expression or repetition as the narrator.

The directors who agreed to participate in the action research were leading museums that fit a particular criterion: their museums were located in a major tourism or cultural destination within the English-speaking world and had community presence. The main destinations included Sydney, Brisbane, Melbourne, Canberra, Los Angeles, San Francisco, Chicago, New York, Washington, D.C., Ottawa, Toronto, and London. Some museums were included that were off the beaten track because they had unique community presence. A museum with community presence was defined as an institution with something special to offer in terms of site, collection, programs, or perceived stature in the museum field.[17] The complete list of interview participants appears in appendix 3.

The fourth research strategy involved ongoing research, interviews, and exchanges with other professionals in the field. This strategy started with visits to ten different institutions in the mid-1990s to discuss current and future changes in museum management: Singapore, Los Angeles, San Francisco, Portland (Oregon), Seattle, Boulder (Colorado), New York, Washington, D.C., Baltimore, and Chicago. I arranged additional interviews to discuss succession planning and development with professionals specializing in museum leadership development programs, executive selection and recruitment, and board development. This included seeking opinions from government representatives and specialists in nonprofit board development such as those at the National Center for Nonprofit Boards in Washington, D.C. I have continued to track change and leadership requirements for the 21st century via my membership and participation in professional associations, such as Museums Australia, the International Council of Museums, and the Institute of Management Consultants, and through contact with participants in the EQ leadership development program called *Leading with Passion*. My participation in the museum sector includes various consulting projects as well as contributions to regional, national, and international conferences held in Australia and Canada.[18]

## SETTING THE STAGE

Chapter 1 outlines the cues and clues from the 1990s that fueled my concern over what appeared to be a diminishing pool of leadership candidates in the museum sector. I worked from the premise that by exploring changes, we may find ways to encourage people to prepare for and take on leadership roles over

the next two decades. The reasons why the art museum was chosen as the case study organization are presented with evidence from museum professionals and the literature. The evidence describes how art museums were having a particularly difficult time in what appeared to be a broad-based museum leadership crisis during the 1990s. Changes in government funding policy were pressuring nonprofit institutions into adopting for-profit corporate strategies in order to survive. The new entrepreneurial model called for business management competencies that challenged directors and their museums to change and adapt. The way one museum director adapted produced the description for the fourfold leadership role that provides the structure for the chapters that follow.

Chapter 2 introduces the first part of the fourfold leadership role—representing the organization internally and externally, guided by personal passion. In this chapter, museum directors describe how passion is an anchor that helps keep them from being swept away by change. For example, the director of the Cleveland Museum of Fine Art said, "First of all, it is a difficult job and without passion, you just cannot do the director's work. You come to work for the heart of it."[19] A new director for the National Gallery of Australia in Canberra described the outgoing director with reference to heart: "Betty is incredibly honest and straightforward. It comes from the heart as well as the head, and I think that's crucially important for anybody working in such an institution."[20] Representing the organization based on passion and heart relies on a combination of emotional intelligence competencies and discovering ways to stay in flow.

Flow theory was developed by Mihaly Csikszentmihalyi and is described in his book *Flow: The Psychology of Optimal Experience*.[21] He describes flow as a process of successfully rethinking skills to adapt to change. He also describes cultural institutions as places of undiscovered psychological significance, which are used by some people to create meaningful order out of life's confusing changes. Staying in flow and the successful expression of leadership passion also involves emotional intelligence, or EQ. EQ received increasingly serious attention in the 1990s as a major factor in individual and organizational well-being.[22] Popular writers on EQ such as Daniel Goleman proposed that 80 percent of success in life can be ascribed to EQ and 20 percent to IQ.[23]

A generic definition for emotional intelligence includes empathy, mood management, motivation, self-awareness, and social skills. Specific EQ leadership

competencies described by directors in my research include purpose or inten-
tionality, trust, creativity, intuition, interpersonal connection, and resilience or
energy.[24] The link between EQ and leadership behavior becomes evident in an
individual's ability to organize groups, negotiate solutions, make personal con-
nections, and show concern for others' feelings and motivations. Generally
speaking, the management domain and cognitive researchers create unnecessary
tension by placing the heart and emotions in opposition to the head or mind
with an explicit value on the rational over the emotional. Since the emergence
and understanding of emotional intelligence in the 1990s, we can create greater
acceptance of heartfelt wisdom as a trustworthy guide for decisions.[25]

Chapter 3 focuses on the second part of the fourfold leadership role—
creating a context for others to give their best. In this role, the leader becomes
the "cheerleader, team builder, and hit person."[26] Creating a context for others
requires something more than just the director's passion. As the director of
the Yale Center for British Art said, "Passion does not equal the rational."[27]

Creating a context for others to give their best is explored using stratified
systems theory. The theory is used to describe levels of complexity in an or-
ganization using my museum research to illustrate key points about change in
the 1990s.[28] Creating a context for others is woven together with reference to
two very different theorists: Howard Gardner with *Leading Minds* and Joseph
Jaworski with *Synchronicity: The Inner Path of Leadership*. Jaworski describes
leadership as an ability to create a stage or domain that encourages flow and
ongoing learning for others: "A true leader sets the stage on which predictable
miracles, synchronistic in nature, can and do happen."[29] Gardner describes the
leader as an individual who creates a story or mental representation that sig-
nificantly affects the thoughts, behaviors, and feelings of a significant number
of people.[30]

Chapter 4 explores the third part of the four-fold leadership role—acting as
an ethical entrepreneur to ensure the organization's future. The 21st-century
museum has forced directors to review and invent new stories describing
themselves as entrepreneurial enterprises in the intelligent leisure industry.[31] It
takes a deep understanding of the museum's role in cultural meaning-making
to sell the museum's story successfully without losing integrity. Chapter 4 rein-
forces a view that art is about the social expression of the heart. Given this, an
ethical entrepreneur sells the museum as a site for the creation of social capital
in a market economy. Social capital is based on the trust we create, using our

emotional intelligence competencies to build networks in and around organizations. The leader needs these networks to achieve professional and personal aims. Francis Fukuyama (George Mason University) described social capital or trust between others as a necessary prerequisite before any serious economic exchange can take place.[32]

Chapter 5 explores the fourth part of the fourfold leadership role—nurturing relationships of trust with key stakeholders. In this chapter, the board of trustees is described as a key stakeholder because the director shares leadership through an interface with trustees. The term *interface* describes a common boundary between two bodies of knowledge. It is a boundary where two systems or disciplines interact, communicate, and exchange ideas. In an organizational context, the interface involves strategic planning, policy development, and governance. The trustees are also responsible for selecting leaders for the 21st-century museum. It is their responsibility to design and manage succession planning with a clear vision, appreciating current needs, and predicting leadership requirements at least ten years ahead.

Chapter 6 describes the evolution of the entrepreneurial leader—an individual capable of fulfilling the four-fold leadership role. Museums are complex organizations. Astute museum boards are looking for so-called new-breed or entrepreneurial directors. In chapter 6, existing directors describe what influenced their shift from indirect scholarly leaders to more direct leaders in the intelligent leisure industry. Some directors negotiated the transition with grace because they were more willing and able to go with the flow: adapting, shaping, and selecting new responses in a constantly changing environment. For example, the director of the National Gallery of Canada in Ottawa consciously adjusts the museum's story to suit different audiences:

> Yes, I use the word *business*. I have to sell a lot with a lot of issues. We have a product that defies measurement at the art museum here in Ottawa. I am comfortable using the word *product* to describe art and art museums if the audience I am selling to uses that term. I can then use art terms with a different sort of audience.[33]

Chapter 7 presents strategies designed to coach new approaches to leadership development for 21st-century museums. This includes insights into the way personality preferences may influence career paths and, ultimately, individual

and organizational development. Factors to consider for new position descriptions for directors of our major national museums are offered, and suggestions for succession planning are discussed based on an analysis of international trends. Finally, leaders are encouraged to take heart as they continue to manage change and shape museums as sites to celebrate cultural diversity, creativity, and imagination.

## TERMS, NAMES, AND JARGON

Some people think there are far too many leadership books on the market already, and I agree with that view. *Leading with Passion* is about change management using the art museum as a case study organization. Museum leaders in the 1990s who told me their stories were navigating complex change, guided and sustained by a passionate commitment to their organizations. I have made a point of using the name of the museum, institution, or organization rather than individual names for a reason. I wanted to make sure the focus stayed on ideas, issues, and solutions rather than on personalities because every leader eventually moves on. I have also used some common abbreviations for the large well-known museums. For example, the Met for the Metropolitan Museum of Art in New York; MoMA for the Museum of Modern Art in New York; AIC for the Art Institute of Chicago; MFAH for the Museum of Fine Arts in Houston; the V and A for the Victoria and Albert Museum in London; and AGNSW for the Art Gallery of New South Wales in Sydney.

Endnotes contain the names for published references, conference paper presentations, and interviews. A *C* after a name in the endnotes indicates a conference paper presentation, and the author's name is included in the references. Professional groups such as the American Association of Museums and Museums Australia collect papers presented at their conferences and usually make them available electronically or as published proceedings. An *I* after a name in the endnotes indicates a personal interview, and the complete list of respondents appears in appendix 3. Some of the terms and words used may sound like management jargon to readers who have not had the pleasure of study and reading in the fields of management and psychology. I have tried my best to use language to build bridges between differences and would like to encourage readers to explore as cross-cultural detectives.

## NOTES

1. Courtenay 1997; Moore 1992.

2. Moore 1994: 11; Alexander 1979; Duncan 1995.

3. Bennis 1984: 4; Caldwell & Carter 1993.

4. Carlopio, Andrewartha, & Armstrong 2001: xix–xx.

5. Caldwell & Carter 1993: 118; Garfield 1995: 32–56.

6. Washburn 1996: 60–63.

7. Churcher 1994 (I).

8. Jones 1994: 10.

9. Morgan 1997b: 11; McDonald 1997c: 15; Bennie 1997: 3.

10. Parker 1995 (I).

11. Gardner 1995a; Suchy 1998a.

12. Gardner 1983: xxiv; Gardner 1995a; Jaworski 1996.

13. Boyd 1995: 180–83.

14. Anderson 1996 (I).

15. Jaques & Clement 1991; Stamp 1989.

16. Varela in Goleman 2003: 312.

17. Waterlow 1993 (I); Gibson 1995 (I); Capon 1995 (I); Kent & Gray 1995–1998 (I).

18. Suchy 1995, 1999a, 2000a, 2000b, 2001a, 2002a.

19. Bergman 1996 (I).

20. Morgan 1997b: 11.

21. Csikszentmihalyi 1990: 235, 1993.

22. Pearce 1992; Gardner 1995a; Cooper & Sawaf 1997; Fineman 1997; Suchy 1998a.

23. Goleman 1996, 1998.

24. Orioli Essi Systems 1996, 1997.

25. Goleman 1996: 8.

26. Kolb 1996 (I).

27. McCaughy 1996 (I).

28. Jaques 1956, 1989; Jaques & Cason 1994; Stamp 1986, 1993.

29. Jaworski 1996: 182.

30. Gardner, in collaboration with Emma Laskin 1995a: 27.

31. Capon 1995 (I); Rentschler 2002.

32. Fukuyama 1995.

33. Thomson 1996 (I).

# 1

# Catalysts for Change

Museum directors in Australia, Canada, England, and the United States have all affirmed that the 1990s was indeed a decade of change. The Ninth World Congress of Friends of Museums held in October 1996 in Mexico, highlighted a major theme and concern affecting museums internationally in the 1990s: the increasing need to focus on funding as more museums moved toward greater self-sufficiency as business enterprises. A board member for the World Federation of Friends of Museums identified two critical issues: pressure on museums to attract new audiences in a competitive leisure industry and questions about the future of the physical museum in a time of rapid social change.[1] The move toward a business enterprise reflected a dramatic shift from the museum's traditional role as a nonprofit organization of service to society open to the general public. As the museum reinvented itself as an entrepreneurial business enterprise, there were corresponding pressures on directors to reinvent themselves as business leaders.

In this chapter, we will explore how any kind of change in and around an organization necessitates a reevaluation of the way change is anticipated, managed, and led.[2] As a specialist in change management and executive development, I am interested in how individuals adapt to change and shape organizational culture. When I initially started tracking clues for changes in museum leadership, I noticed interesting patterns. In the past, for example, curatorial skills were the fundamental basis for museum leadership. Skills in marketing, sales, human resource management, audience research, customer service, sponsorship management, and education were not as highly valued as

curatorial skills. Now, these skills and functions are critical to the success of the 21st-century museum. Changes in museum functions have shaped expectations about leadership roles. There has been a move toward leading in a broad way, in a team environment, with a willingness to adopt what one museum director called *worldliness*.[3] Worldliness means reading *Museum News* and the *Financial Review* on the same day. For the new entrepreneurial museum, worldliness has blurred the boundaries between for-profit and nonprofit organizations. For-profit organizations design their mission and strategy to make money. Nonprofit organizations raise funds to make their mission possible. The focus for the museum in the 21st century blends both to ensure the museum survives and thrives in a tough, competitive, global marketplace.

## CLUES AND CUES FOR CHANGE

Prior to the 1990s, the museum director's role was described as one of scholarly excellence, a dash of the dilettante, a focus on collecting and exhibiting, with guaranteed financial support from government, corporate, and benefactor sources. For example, the director of the Metropolitan Museum of Art (the Met) in New York said, "All a director needs is administrative ability, knowledge of art, communication skills, international connections, languages, a blue suit, and dinner with the trustees."[4] Changes in the 1990s challenged directors to expand, adapt, and shift skills to manage the microworld of the museum in the macroworld of global markets. The increasing international push for self-sufficiency forced directors to become more commercial, more entrepreneurial, and more capable of handling million-dollar budgets. The director of the Philadelphia Museum of Art (PMA) described how the changes radically redefined the director's role:

> Over recent years, the challenges have changed a lot. Funding issues became critical with reduced federal and public support so by 1990 we were in trouble. Corporate support for cultural institutions rose strongly until 1990, then all corporate budgets were cut. The director is split as a fund-raiser, managing increased membership, developing the operations, and expanding the museum in different ways. The museum director's job is to be all things to all people as a very, very public person with a mix of donor, public, and scholarly functions.[5]

In addition to complex splits in the director's role, the physical future of the museum was being questioned as rapid social and technological change

challenged the relevance of cultural sites.[6] The director of the Art Gallery of Western Australia in Perth described a delicate balance, sustaining an appreciation of the true essence of the museum with changes in government policy:

> The government expects revenue generation out of the museum whether it is with a focus on the object or the experience! Changes have actually been occurring over a long period but the last five years have seen an acceleration where we now need skills to know the market place so we can develop and produce merchandise that is popular with an audience. In the old museum, if something was worth seeing, it was put on public view. Now the criterion is that if something is put on view, it must be palatable, attractive, popular, and seen as an opportunity to generate income for the museum. Generating income is the yardstick. It calls the tune. As a society, though, why do we have these institutions in the first place? The world dismisses them too quickly with an economic model as the bottom line. Where and how do we draw the line? Society needs certain things to survive mentally, emotionally, and physically. . . . I am a convert, hear me spout the *production line* but it is dangerous.[7]

A respected professional body with an interest in change, challenge, and the impact on museum management is the Museum Management Institute (MMI). Funded by the J. Paul Getty Trust in Los Angeles, the MMI is designed as an international management skills development program for middle- and senior-level museum staff. For nearly thirty years, the annual residential program has been held at the University of California in Berkeley. One of the program's coordinators described a major curriculum review in 1996 that led to significant changes. Based on the review, the program shifted focus to prepare museum professionals for new business roles by sponsoring sessions on marketing, finances, and change management. The MMI program coordinator explained that while all museums were experiencing change in the 1990s, some institutions like art and history museums were experiencing more difficulties than others because of particular conventions:

> Science centers are more proactive with alliances to corporations, schools, and technology. Art museums are lagging behind because they *track history* rather than *projecting* it. The art museum's history was one of a club atmosphere with private money. The change has been in seeing museums as a business with public accountability as it uses public money on several levels.[8]

Another research team described similar issues while comparing career paths in art museums with universities against four areas: career development, diversity, social role, and the board's management role.[9] In the area of career development, the researchers found the transition from scholar to leader was easier for university staff than for museum professionals because there were more career paths and more training available in universities. Universities were also more receptive to diversity than museums. For example, more women occupy leadership roles and act on boards of trustees in universities than in museums. In terms of social role, the researchers found art museums struggling to define a meaningful role for themselves in society because of the lack of clarity on how art functions best in a pluralistic society. And, finally, in terms of the board's management role, the researchers found that boards of trustees in art museums involve themselves more often and more deeply in daily management issues than do their counterparts in universities. In addition, museum trustees appeared to be unclear about the criteria for a museum CEO, thus overlooking potential talent internally and externally.

The trustees' role in CEO selection is critical. They play a major role in defining the director's role because they usually design the position description, define the selection criteria, and short-list the candidates. This process is fraught with difficulties if the trustees themselves are struggling to come to terms with changes for the 21st-century museum. For example, the director of the Harvard University Art Museums described a range of issues as a participant in a search process for another U.S.-based museum—a shallow pool of candidates, uneven selection processes, and difficulties identifying and agreeing on candidates.[10] One trustee involved with the process eventually dedicated a substantial sum of money to design a director development program to increase the talent pool in the United States.

## EVOLUTION OF THE ENTREPRENEURIAL MUSEUM

The 21st-century museum has evolved into more than a place to warehouse objects for scholarly study and public exhibition. Continual cuts in government funding mean most museums have repositioned themselves as business enterprises. According to the director of the Saint Louis Art Museum, "For museums, taking care of business has changed greatly in the last decade: we are in an advanced stage in the evolution of museums from repositories of cultural property to the service of public constituencies."[11] The director of the

Art Institute of Chicago (AIC) agreed that museums are evolving from places that used "elite aesthetic standards based on eurocentricism to an undefined state where there is no model for what is next."[12] According to the director of MoMA, "Museums can not rely on their past history for the future."[13] The director of the Museum of Fine Arts in Houston (MFAH) commented on how the 21st-century museum had evolved into an organization that combines historical qualities in radical new ways:

> By the 20th century, tax codes made a clear distinction between for-profit and nonprofit organizations. The distinction was that nonprofits were to supply a service to society like hospitals, churches, and museums. What has happened in America, at least, is that the identities of the nonprofit and for-profit enterprises now overlap. The distinctions are blurred regarding role, profit-making activities, and function. We will continue to see major changes in nonprofit organizations. Hybrids will form. A museum director could be seen as one of those hybrids. The director forty years ago would not recognize the museum today. Today they mix nonprofit and for-profit strategies. That mix needs to be recognized and managed effectively.[14]

An Australian freelance museum consultant described the development of hybrid museums as a softening of boundaries between art galleries, cultural centers, and museums. She suggested that museums need to look for new forms of training and career paths to complement what she called a hybrid museum:

> These new hybrid museum forms pose challenges for traditional museum practice. Staffing these facilities calls for an adventurous mix of skills, which must begin to redefine conventional museum training and career paths. It may be that community artists, with their training in working with communities, will emerge with the best skills for making these new places work. The creative skills of artists are now widely used in museums to tell stories and present ideas that are not so easily explained through collections.[15]

The most pressing need is for current and aspiring directors to think creatively about the value of the museum and how they communicate this to the public. Anyone with aspirations to museum leadership needs to feel comfortable reconciling dichotomies in the new skills mix. Historically valued curatorial skills like

independence, scholarship, and orientation to detail may feel at odds with the strategic vision required of directors. Candidates need to be visionaries capable of positioning the museum for long-term survival, which includes representing the museum's story in a way that advocates its worth as a social institution. Candidates also need to feel comfortable and excited about the museum as a business. Museums are in the business of creativity, and doing business is a highly creative process.

## CHANGES IN SELECTION CRITERIA FOR DIRECTORS

According to an executive recruitment consultant with the search firm Heidrick & Struggles in New York, finding directors for 21st-century museums is "not easy because the criteria has changed."[16] This particular recruitment consultant was responsible for director appointments at MoMA and other key museums in the United States, and had considerable insight into past changes and future implications for directors. The director of the Fine Arts Museums of San Francisco agreed that director roles had changed to such an extent that fewer people were actually interested in the position:

> Over the last ten years, there are more vacancies for directors of galleries and museums because people are not interested in audits, research reports, and unions. They are not trained for this role. Let's use an "anonymous" curator as an example. He is a chief curator, which means he has to have the skills and leadership to head the curatorial department. The chief curators are the "stars" in a museum. Their role is art related and closer to the old job of the director. People will opt out of being directors because they can't be what directors underneath really are . . . a bunch of cowboys. They don't like rules and constraints. It is the same thing for creative people in other creative organizations![17]

The reference to creative leaders in other creative industries reminded me of Richard Branson, CEO of the Virgin corporate empire. Over the last ten years (1992–2002), Branson has managed similar changes: pushing for profits with public and staff blessings to achieve his aim of creating not the biggest brand in the world but the most respected.[18] Branson has shaped a range of entrepreneurial enterprises with the same do-the-right-thing philosophy advocated by museums. Museums are not the only organizations that are caught up in the push for entrepreneurism. Over an eight-year period, I worked with several major organizations on executive development for succession planning. The

leadership pool included economists, scientists, accountants, engineers, and business analysts. They were all trained as experts in a particular domain, grappling with the same change challenge. They had reached the junction point on their career paths that confronts every leader: remaining indirect leaders in a domain of excellence or moving to direct leadership for the organization as a whole. For example, I worked on a team-building project with a group of scientists from the Commonwealth Science and Industry Research Organization in Australia (CSIRO) over a two-year period in the 1990s. As highly trained research technologists, their change challenge was the same one that confronts museum directors. Funding cuts to research bodies like the CSIRO meant the team had to redefine themselves as entrepreneurial technologists and find viable markets for their research work. The team leader had to make the choice to step into a broader leadership role with a marketing and entrepreneurial focus.

While the comparison between museums and organizations like Virgin and the CSIRO may not sit well with the cultural industry sector, it illustrates how leaders share similar change challenges with the push for entrepreneurial enterprises. Old philosophical tensions between nonprofit and for-profit orientation have been swept away with the focus on customer service delivery. For example, the audience research center at the Australian Museum in Sydney released a report in 2002 urging all museums to pay more attention to a significant change—visitors over age sixty-five. The report described how this age group will continue to grow as an audience of well-educated, articulate, aging baby boomers with an interest in lifelong learning who can't read the small-print labels in museums, can't see because of the dim lighting, can't hear the guides, and can't get up from the low-set seats.[19]

The evolution of the entrepreneurial museum has seen an increasing reliance on marketing principles taught in MBA programs. Old tensions between museums and management theory were detected.[20] For example, the director of the Solomon S. Guggenheim Museum in New York was charged at one stage with selling out the integrity of the art museum through his MBA approach to museum management. The director of the J. Paul Getty Museum in Los Angeles pointed out that the director of the Guggenheim Museum held his job with the full support of the board of trustees:

> The problem is not with the MBA. [The director] has studied art, a fact the art media keeps neglecting to mention. The problem may be that systems drawn

from the business world may not match up with the character of a cultural organization like an art museum. The quality of a curatorial "product" may not be a "product." New directors in the future will have thinner curatorial and art history backgrounds. As a consequence, there may be a decline in the origins and seriousness of the museum but the new breed will pull the museums through what is currently a very difficult phase for museums.[21]

## SUCCESSION PLANNING TENSION

While some will remain suspicious of an MBA approach and whether it suits the museum's organizational culture, there is one requirement that museums share in common with CEOs in other industry sectors. The entrepreneurial organization needs a leader. Leaders in any organization must take an intellectual stand, demonstrate integrity, and create a story about the organization that attracts stakeholder investment. Although leadership roles across industry sectors are similar, museum directors in the 1990s felt distinct dichotomies, according to the director of the Maritime Museum in Sydney:

> The museum director has to safeguard integrity, increase income, save the staff and the collection. Directors are at risk with charges and labels of mis-management, which means they often end up being scapegoats for issues beyond their own control. The museum today is somewhere between a university and a department store. They still require academia and at the same time an understanding of the visitor as a customer with needs and aspirations. The cheque book makes decisions. Directors are in a crisis! The question is, how to plan exhibitions and manage with integrity when staff are charging the director with "selling out" and the government labels them as "stodgy."[22]

One Australian arts writer described the tension in the race to find new visionaries to take the helm of leading museums.[23] The writer summarized several changes and issues for Australian art museum directors that were identical to those in the United States and England. The conclusion was that the range of leadership competencies was too broad for one person to fit the bill: the director's role needed to be redefined, split, or redesigned to take account of unrealistic expectations. When this possibility was raised with the director of the Museum of Contemporary Art (MCA) in Sydney, he said, "You absolutely have to have people running galleries who, as well as being gifted administrators, know art inside out and can inspire the public."[24]

The ability to inspire the public is a key leadership skill. It is a skill that does not necessarily require expertise in museology or business but a range of characteristics I explored with the recruitment consultant from Heidrick & Struggles in New York. With a PhD in art history, the consultant was very sympathetic to the need for art museum directors to have a "passion for the arts" and she outlined a completely new selection criterion:

The era of the pipe-smoking scholar and dilettante director is finished. We can no longer afford to have this image of a director. The director criterion has indeed changed. There are only three to four directors of the United States' top art museums who are directors of the future. What shapes a director for the future? An art history background is still preferred for particular reasons, followed by going to business school. They need to learn about how to read financial accounts and statements. They need to know how to manage the complexity of loans across country lines, which needs very sophisticated dealings at all levels for legal, financial, and cultural reasons. Curators will only be successful as directors about 10 to 20 percent of the time. They do not have the personality for the job. A director has to have high energy, be extroverted, and have a broad level of social skills. It is rare to see a curator with that profile. One particular director, a model director, combines art history with being a very savvy businessman. He has high energy and is elegant. Even if a director is not a business manager, they still have the ultimate authority so they need to understand money and management. This director does just that. Boards are just coming to terms with the fact that potential directors must be capable of raising money, cultivating donors, being able to do an "ask," exercising exceptional social skills. Social skills are absolutely necessary in the mannered world of patrons and corporations. Another model director with similar skills is also very knowledgeable [PhD in art history], has high energy [resilience], is elegant, and, most important, interacts well with the corporate sector. The model for an art museum director ten years from now will be based on this criterion. Most important will be high energy [resilience]. The job demands it.[25]

That prediction was made in 1996. As we move further into the 21st century, I wonder how that prediction has influenced selection processes. I wonder how curatorial career paths have accommodated changes in expected skill sets and if museum studies programs and professional development workshops are advocating curatorial excellence *and* an understanding of business, finance, skills in relationship management across diverse audiences, and strategies to increase resilience under pressure.

Although experience in the particular domain of expertise is desirable, high energy or resilience, a passion for the arts, and the ability to communicate that passion to the public are vital selection criteria. One Australian art critic stressed that "we must allow the possibility that art is a special form of social activity, enjoying strong affinities with magic and religion."[26] He described how art fulfills some irrational human need and how its role is difficult to define in a society increasingly ruled by logic and rationality. The director of an Australian recruitment firm for boards of trustees was adamant that museums need to appreciate this special form of social activity and select directors who can convey that story to society. He was passionate about the need for directors of cultural institutions to fully understand the essence of art, whether they are art historians or not. He stressed that art museums were underestimating their true power and that leadership was missing the point:

> What is art anyway? It is the social expression of the soul: the feeling, emotion, interpretation, and celebration of joy. It is the release of the greater part of the human soul for others to enjoy. Art museums should open at night, not from 9 to 5, so people who work during the day can go and enrich their souls in the evening. Curators need to go beyond their scholarly roles to sell and deliver programs that bring a richer source of understanding to audiences. The power games and struggles have to be overcome in the creative industries so energy can be put into stewardship of organizations that are really quite unique and terribly undervalued.[27]

It was predicted in 1991 that the 21st-century museum director would be a global manager with superior management skills and a deep respect for and sensitivity to the arts.[28] How do we transform that prediction into reality? The director is the intellectual leader for the museum, its chief public advocate, and its most visible fund-raiser. Finding expertise that combines passion, entrepreneurism, public advocacy, fund-raising skills, and intellect is not easy. The challenge led some, such as the president of the Field Museum of Natural History in Chicago, to look "outside" the museum field:

> The pool [of leaders] is smaller in museums than in other nonprofit organizations. In larger, more complex organizations, there are many opportunities for an individual to develop as an effective administrator. In the university world, a person can be an assistant chairman, chairman, assistant dean, dean, assistant

provost, provost, and finally president. While faculties eschew training for university administrators, museums would do well to provide time for staff members with leadership potential to enroll in management programs. Looking elsewhere . . . why look elsewhere? The answer: the museum candidate pool is small and does not contain enough members who are willing and able to serve. In going beyond the pale, the search needs to be imaginative as to sources and careful as to candidates. If you are going to the "barbarians" you should be sure to tell them what it is like inside.[29]

An artificial demarcation line about who belongs in a museum and who doesn't undermines effective change management. Given the limited pool of potential candidates willing to take on the job, it would be wiser to expand rather than restrict leadership searches so that unexpected talent is not overlooked.

## INTEGRATING CLUES

In the initial search for cues and clues about change in the 1990s, two themes emerged. First, museums must evolve a new organizational model that answers the question *Why are we here?* Funding cuts in the 1990s pushed the need for greater self-sufficiency and pressured museums to attract new audiences in a competitive leisure industry. Although the new entrepreneurial museum model has emerged, there needs to be ongoing collaborative research to track how these changes are influencing leadership roles. This goes hand in hand with regular audience research so museum leaders can confidently affirm the museum's value in society.

Second, museums must monitor and respond to changes in the leadership selection criterion so they can answer the question *Who do we serve?* The 1990s leadership crisis was a combination of a shrinking talent pool and changes in leadership roles. As outlined in the introduction, there are several different ways of defining *leadership*. I use the definition that to lead is to *serve*. To serve combines vision and a willingness to perform different roles on behalf of the organization. According to researchers at the London Centre for Psychotherapy, leading involves "being able to conceptualize a vision, having the authority, energy and clarity to communicate the vision, and the resilience to sustain the work program necessary to bring the vision to reality."[30]

Changes tracked in the 1990s revealed complex changes around leadership roles with major implications for succession planning. I liked what the

director of the Please Touch Museum in Philadelphia had to say about adapting to change and the leadership *vision thing* when she described her fourfold leadership role:

> Leadership is a *vision thing*. There are few leaders who can combine artistic direction and vision. Leadership is different from managing. If I can be a leader, others can then manage their own way there. My role is fourfold. First, I give an external presence to the museum. When people think of the Please Touch Museum, they think of me so the director has to be out there. I am then the cheerleader, team builder, and hit person. I let people get on with macro management. Third, I am the fund-raiser. I am talking up this museum 100 percent of the time. Fourth, I manage the board.[31]

This description provides the framework for the chapters that follow because it is the best translation I know of leadership theory into lived experience.

## NOTES

1. Tunney 1997: 12–13.

2. Potter 1989: 17–24; Schein 1985; Sola 1994: 61–65; Speiss 1996: 38–47; Zeller 1996: 48–59.

3. Garfield 1995: 56.

4. de Montebello 1996 (I).

5. d'Harnoncourt 1996 (I).

6. Abruzzo 1991: 41–43; Case 1996: 22–23; Hudson 1987; Karp, Creamer, & Lavine 1992.

7. Latos-Valier 1996 (I).

8. Rolla 1996 (I).

9. Riley and Urice 1996: 48–64.

10. Cuno 1996 (I).

11. Burke 1994: 1.

12. Wood 1996 (I).

13. Lowry 1996 (I).

14. Marzio 1996 (I).

15. Winkworth 1994: 4–6.

16. Nichols 1996 (I).

17. Parker 1995 (I).

18. Elder 2002: 23–25.

19. Horin 2002: 2.

20. Editor 2001.

21. Walsh 1995 (I).

22. Fewster 1996 (C).

23. Jones 1994: 10.

24. Paroissein 1995 (I).

25. Nichols 1996 (I).

26. McDonald 1997a: 14.

27. Beech 1995 (I).

28. Abruzzo 1991: 41–43.

29. Boyd 1995: 180–83.

30. Khaleelee & Woolf 1996: 5.

31. Kolb 1996 (I).

# 2

# Passion
## *Representing the Organization*

The director for the Metropolitan Museum of Art in New York was adamant: "Passion is what sells the museum. The development office paves the way and the director's charisma and passion makes the difference."[1] Passion is energy. Energy is the baseline for new-breed directors outlined in chapter 1. And energy plus passion is the foundation for the first part of the fourfold leadership role—representing the organization internally and externally. To represent the organization, directors in my research shared a common strategy—the need to keep passion alive by remaining connected to some part of the job that has *heart*.[2] As the director of the Isabella Stewart Gardner Museum in Boston said:

> To keep passion alive in trying times, you have to think, read, write, and see contemporary work. Practice your own area of creative talent. Feed yourself, as only then can you feed the organization. Do not lose your own sense of creativity. Maintain relationships with people, friends and colleagues, who continue to inspire you.[3]

Keeping passion alive requires a deeper understanding of the underlying energy. In this chapter, we will explore passion with reference to flow theory and the conditions for flow that need to be in place for leaders to experience pleasure in their work. I will also introduce what has now been called emotional intelligence, or EQ, to illustrate what leaders draw on to transform passion into stories that engage the hearts of others.[4]

## PASSION MAKES THE DIFFERENCE

When I launched the course *Leading with Passion* in Australia in 1998, one of my first potential clients was in the banking sector. The client asked a question that reflected confusion around the word *passion*: "What does sex have to do with leadership?" Another client in the government sector asked to modify the name of the program. The client was concerned about media reaction to senior government members working with passion. What is passion? The general definition for *passion* describes feelings and emotions such as hope, joy, fear, anger, love, and a desire that is a compelling force. Passion is also a strong and extravagant fondness or enthusiasm. To be passionate is usually a force for good, but it also has negative connotations. When we feel passionate about something, we extol what we love. If we feel our passion (for a person, place, or object) is being threatened in any way, we defend it. On one hand, passionate people have contagious enthusiasm. On the other hand, they can be angry, quick tempered, and irascible.

Passion is a force full of volatile emotions. That is why the directors described working with passion as a balancing act. The director for the National Gallery of Canada demonstrated this:

> Leadership depends on the willingness to change and knowing your subject well. To see that means developing a passion for some part of the arts so that it becomes an anchor in you. Having that anchor in what is important means you can feed and sustain yourself. Looking at art is developing nonlinear thinking. That is art's greatness. Business and medicine are only just now looking at the concept of nonlinear thinking.[5]

Managing turbulent emotions and moods and mediating the influence of feelings on decision making is hard work. Despite the hard work, when we don't allow passion to guide us, we experience a stressful life and create stress for those around us. Many organizations struggle with the idea of incorporating emotions into the business world. In most workplaces, the word *professional* means unemotional. According to the Australian Institute of Management (AIM), the discussion of passion in the 21st-century workplace reflects a wider sociological change.[6] AIM described ambivalence about how many organizations would or could incorporate emotions into the business culture despite research that describes the passionate worker as a valuable

asset. A passionate worker is more fulfilled, is more supportive of the organization, takes responsibility, advocates for the organization, and makes commitments to wider organizational goals. When people feel a sense of purpose and meaning in their work, they are more willing to support the organization overall. AIM admits that work is rarely just a place for earning an income, but they are ambivalent about how to balance the head and the heart.

In my experience, ignoring passion means ignoring the heart. Successful change management is like alchemy—it blends logic *with* imagination *and* the emotions to make magic happen. Logic only goes so far, and after that people follow the leaders who engage the hearts of others. Logic creates perfection and that is not what life is about. Leading with passion means allowing feelings to guide change in an emotionally responsible way. Some leaders are more adept with this than others. For example, the director of the National Gallery of Victoria in Melbourne described taking "pleasure in drawing together diverse experience and doing lots of things at once. To be creative is emotionally satisfying. To set frameworks is analytically satisfying."[7] Balancing the emotional with the analytical is not always a controllable process nor does it create a life without tension. The director for the Art Gallery of New South Wales in Sydney described it as a process of "keeping things slightly on edge—a slight tension keeps things creative—one must keep imbalances to maintain energy."[8] This is a volatile process. The cultural industry sector seems to attract passionate people. Attracting and directing passionate people toward a shared vision can be tricky. The director of the Yale Center for British Art in New Haven cautioned:

> Museums tend to fragment without good direction. They are volatile organizations. You have to have people with imagination in an art museum and that has volatility. People with imagination believe in the rightness of their intuition. But passion does not equal the rational! Feelings are volatile and unstable. A successful museum depends on the interaction of the many. For example, communities, audience, and staff. It is about relationships and how they are managed.[9]

Is there a place for passion in organizations? Can leaders blend passion with logic to represent their organizations more effectively? In my experience, the answer is yes—there is a place for passion. Leaders can learn how to sustain and manage passion productively using two theories: flow and emotional

intelligence. Flow theory provides a rational framework for the irrational emotional energy called passion.

## FLOW AND PLEASURE IN WORK

From 1989 to 1998, I worked with a technique called Career Path Appreciation (CPA), pacing individual growth in capability with organizational challenges. During that time, I worked with over two hundred people for executive performance development, succession planning, and organizational development. As described in appendix 1, I used a modified version of CPA to conduct the research on change management with museum directors. Flow is one of the key theories embedded in the CPA process. People feel "in flow" when challenges are paced with an individual's growth in capability over time. This is good news for organizations. When people are in flow, they exercise better judgment for the myriad decisions that leaders must make. When people are out of flow, decision making and judgment become erratic. Performance drops off and passion evaporates. The individual and the organization suffer.

Mihaly Csikszentmihalyi, a cognitive research psychologist in the United States, has spent decades researching and writing about flow. He describes flow as a process of successfully rethinking skills to adapt to change over time through positive human experiences such as joy, creativity, and a total involvement with life.[10] Many different kinds of activities can potentially generate flow: work, play, sport, and interpersonal relationships. Csikszentmihalyi's original research began in 1965 with artists and their creative process and expanded to study creativity and happiness with biologists, economists, business people, and politicians. Flow theory is a set of principles that people can use to create more joyful lives overall.[11]

Flow does not just happen. Conditions must be created for a passionate life. In my experience, flow combines opportunity, emotional and cognitive awareness, task-related skills, and an achievement outcome that results in feelings of pleasure. People can develop an attitude to life that encourages flow more often when they become adept at adapting to change. The director of the National Gallery of Canada in Ottawa described this as "a willingness to change, grieve, learn, and live. It is a process of growth, making mistakes, and living through them."[12]

It became readily apparent in my research when leaders felt in flow. They talked about their work and their organizations with energy. They seemed to

love what they were doing and talked about their work with reference to *passion, heart,* and *love.* Their behavior reflected what flow theory describes: an effortless control over what they were doing, responses attuned to the changing demands, and less cognitive effort.[13] I wondered how they had created the conditions for flow that seemed to be enabling their ability to cope with all the changes. To achieve flow, five principles or conditions need to be in place.

The first principle involves intentions. When intentions are clear, people can immerse themselves totally in the task at hand. Clear intentions mean clarity about the leadership goals, what others expect, and who will be involved with the tasks. A clear intention helps leaders focus their energy.

The second condition for flow involves caring. People need to know there is someone around them who cares and is interested in what they are doing. This includes providing material resources and moral support. Leadership can be an isolating job. As the director of the Tate Gallery in London said: "I do realize that often I am very alone. It is frightening that there are only one or two people around the world one can share one's ideas and thoughts with."[14] It is particularly important for the leader to have the support of the board of trustees and other senior management. Without support, people lose momentum and passion. For example, the director of the Asian Art Museum in San Francisco described feeling distressed by constant demands and the need for support from the board of trustees.[15]

The third condition for flow involves discretionary decision making. Leaders need to be able to exercise their judgment knowing that others trust it. Discretionary decision making means being in control of all the choices involved with the tasks, including taking full responsibility for the outcomes. Maintaining control of discretionary decision making can be a problem, according to the director of the Yale Center for British Art in New Haven, who described situations where confusion over decision making had led to decision-making paralysis and dysfunctional leadership for museums as a whole.[16]

The fourth condition for flow involves trust. Total involvement with leadership tasks can only happen in a trusting environment. Leaders need to feel psychologically and physically safe. When the organizational culture is not based on trust, leaders lose valuable emotional energy. They can get caught up in trying to protect their backs from political infighting or trying to preserve their platform for action from what Australians call "white ants." Flow requires a work environment that people can rely on and trust so they can get

on with the job. Potential job loss undermines trust. Relationship conflicts and industrial relations problems undermine trust. Lack of trust deflects energy from achieving agreed goals. For example, the director of the Fine Arts Museums of San Francisco said: "I continually have to suppress my creative judgment to deal with power struggles, which is frustrating and results in great anger."[17]

The fifth condition for flow is the need for new challenges over time. We need new challenges to provide ongoing stretch and a sense of achievement. The challenges need to be just that bit beyond the current level of capability—not too much or too little, or flow is disturbed. Too much stretch over sustained periods of time and passion drops away. For example, after an intense period of developing strategies to cope with severe funding cuts, the director of the National Gallery of Art in Washington, D.C., said: "It would be nice to have a little fun again."[18] Too little stretch and people get bored, and boredom leads to stagnation and cynicism.

When leaders are in flow, their passion becomes a source of contagious enthusiasm as they represent their organizations. Contagious enthusiasm creates a powerful presence for the museum. For example, in 1996 when the director of the Art Gallery of New South Wales (AGNSW) in Sydney addressed a public forum on collection development, he did not shy away from his passion for the arts. He described his passion as the driving force behind his commitment to collection development based on "art's ability to reflect values that touch deep places in the heart."[19] The director was very at ease talking about heart, feelings, and the powerful emotions that art aroused in him. In 2002, the AGNSW was still ranked as one of the most successful museums in Australia, and the director's passion was still evident:

> Future generations will not remember us for the building and publications and exhibitions. What we will be remembered for are the acquisitions. They are the platform on which all others things are performed. They form the core of the intellectual and emotional heart from which everything else happens.[20]

## EMOTIONAL INTELLIGENCE, OR EQ

In 1872, Darwin published the first attempt to classify the human emotional heart by dividing emotions into six types: anger, fear, sadness, disgust, surprise, and enjoyment. Although emotional triggers are culturally dependent,

the expression of core feelings like anger, happiness, sadness, and surprise are universal and recognizable by anyone from another culture. Recent evidence demonstrates there are 412 distinct ways in which we feel, and the first visual dictionary of the heart has been produced.[21] Psychologists have been able to illustrate that although we find it difficult to describe many emotions, we instantly recognize emotions when we see them. And the good news is that just as we can learn how to create conditions for flow, leaders can learn how to read and express emotions. The development of this ability, along with a range of specific behavioral skills, is called emotional intelligence.

Recent research describes how people with high emotional intelligence experience greater daily levels of life satisfaction and pleasure in work than do others.[22] Rather than being at the mercy of their feelings, they use their emotions and trust their intuition to guide choices for change. A decade ago, when the idea of emotional intelligence began to surface in the business and popular press, it rang a bell for many people. Emotional intelligence, or EQ, provided a way to describe an inner wisdom that informs our actions, if we know how to access and use our feelings. In more concrete terms, EQ creates a neatly defined way of describing what we sense in ourselves and observe in others— the influence of feelings on behavior. In the 1990s, the importance of feelings in the workplace took on new credibility through ground-breaking work on EQ.[23] The term *EQ* was popularized by Daniel Goleman, a New York psychologist and journalist, who described EQ as a mix of self-control, zeal, and persistence; a basic flair for living; and the ability to motivate oneself, read another's innermost feelings, and handle relationships smoothly.[24] Goleman suggested that an emotionally intelligent leader expresses unspoken collective sentiments, guiding a group toward its goals in a way that is emotionally nourishing and a pleasure to be around.[25]

Ongoing experience with EQ development programs convinces me that emotions play a far greater role in thought, decision making, and personal success than originally understood. While IQ relates to rational thought and the ability to think abstractly, EQ relates to an ability to deal with emotions, to perceive, understand, and manage them in a way that serves the individual and relationships around them. Relationships and how they are managed make emotional intelligence competencies highly relevant for leaders—it's about relationship management. Leaders cannot do everything themselves; they rely on others to help them achieve agreed goals.

Individuals with high EQ are more likely to be happy and in flow because they have an ability to maintain a positive mood, manage negative feelings, and create positive social exchange. Knowing when and how to express emotions is an EQ skill. Individuals with low EQ skills have trouble reading social cues, understanding body language, sensing their own and others' feelings, and expressing emotions in a way that deepens rather than damages relationships. Research shows that leaders with low EQ use iron fists and fixed paths that deliberately create distance between themselves and others. Leaders with high EQ motivate others through persuasion, effective teamwork, and encouragement to reach for pleasurable achievement. Women generally have higher EQ than men, although there are men with well-developed EQ skills who are comfortable with their own and others' feelings, trust intuition, and actively nurture others in an emotionally enriching way.

EQ has emerged as an important skill, and skeptics have asked for more research to test the connection between EQ and organizational performance. Some of the criticisms include the need for more empirical studies, difficulties measuring EQ, and doubts about whether adults can actually develop the skills. In response to the critics, there are an increasing number of projects that test a positive link between EQ and performance as well as studies that compare different ways of measuring EQ.[26] Difficulties measuring EQ are being reduced with the design of EQ instruments such as the Emotional Intelligence Test, developed by Swinburne University in Melbourne; the Emotional Competence Inventory, developed by Boyatzis and Goleman in an alliance between Case Western Reserve University in Cleveland and the Hay/McBer Group; and the EQ Map, developed by Esther Orioli and colleagues through Orioli Essi Systems in San Francisco.[27] A colleague at the University of Technology Sydney, in Australia, is fond of saying: "In many ways, it doesn't really matter what tool you use to reflect on your own behavior and it's impact on others as long as it increases self-awareness, insight, and interaction."[28] While there is scope for much more discussion on the EQ research literature, it is important to move on to EQ in action.

Doubts about whether adults can actually develop EQ skills have been put to the test since 1994 in skills programs taught at the University of Technology Sydney and since 1998 in the *Leading with Passion* course. Developing EQ as an adult takes time but it can be done.[29] A tool used in the *Leading with Passion* course describes EQ in action as the ability to sense, understand, and

effectively apply the power and acumen of emotions as a source of human energy, information, trust, creativity, and influence.[30] The tool encourages users to explore, develop, and follow emotional sources in work and life as a way of creating sustainable relationships, more engaging heartfelt performance, and what I call a passionate spirit. Orioli's EQ Map translates twenty scales into three categories that relate to optimal performance: creating the future, building trusting relationships, and increasing energy or resilience under pressure. The most exciting aspect is the language used to describe EQ. The museum directors used similar language to describe what it takes to put passion into action: self-awareness, intuition, trust, interpersonal relationships. The EQ Map is not a psychological test; it maps values and beliefs, the environment, EQ competencies for performance, and life outcome measures.[31] Out of the twenty scales, eight scales strongly correlate to leadership qualities and are briefly summarized here as they are reflected in the leaders' stories in this chapter:

- Intentionality: acting on purpose; accepting responsibility for one's own actions
- Creativity: tapping noncognitive resources to envision new ideas; thinking in visual images
- Intuition: using a higher reasoning; tuning into noncognitive cues; developing right answers without facts
- Compassion: appreciating and honoring others' feelings and points of view; forgiveness
- Interpersonal connection: creating and sustaining a network of supportive people
- Constructive discontent: handling conflicts in a creative and empowering way
- Resilience: using rest and renewal to build energy, overcome obstacles, and maintain hope
- Trust radius: trusting others until there is reason not to

After nearly a decade of working with cognitive complexity for leadership succession planning, I came to the conclusion that a leader with high EQ is more effective than a leader with high cognitive capability. Leaders with high EQ know and understand the secrets of the heart. They have developed what

I call an educated heart, a sense of personal and social responsibility. In my experience, EQ paves the way for a new system of learning and development for 21st-century organizations. The old way ignored feelings, which created low trust, low compassion, and low integrity within organizational cultures. EQ reveals the secret places of the heart where the real mainsprings of individual action are shaped. According to EQ researchers, knowing something is right in your heart is a different order of conviction or truth.[32]

## PASSION, FLOW, AND THE REPRESENTATIONAL ROLE

Building on Gardner's leadership research, representing an organization from the heart and in a way that engages the hearts of others depends on the leader's ability to create and live out a story that makes a difference and creates meaning for self and others.[33] Credibility and conviction hinge on whether leaders embody their stories—living a way of life that reinforces themes reflected in the stories. In this case, museum directors described various ways personal passion creates meaning in their lives and influences how they represent their organizations. I came to the conclusion that part of their success involves skillfully managing four challenges. First, create conditions for flow so passion and pleasure in work are nurtured. Second, understand the constants of leadership described by Gardner such as the relationship between stories, audiences, the organization, direct and indirect leadership, and issues around expertise.[34] Third, anticipate and deal with change. Fourth, appreciate the paradoxes in the practice of leadership, and use EQ skills to manage what Gardner calls leadership markers:[35]

- Speaking skills
- An interest in understanding people
- An interest in the current domain of expertise as well as other domains
- A willingness to confront individuals in authority in a way that creates respect
- A concern with ethical issues
- Active development of personal relationships
- Travel in early years that shaped a worldview

Several of the leadership markers will be evident in the stories that follow. Leadership stories take many forms. As humans, we share information through

stories; a story is the most basic element of human communication. Learning the basic structure and form of the story is essential, and communication or speaking skills are part of successful storytelling. According to the director of the Phillips Collection, "The director has to use words and ideas as tools to advocate, persuade, and draw together the complex strands and dimensions of an art museum."[36] The link between representing the museum, storytelling, and advocacy was reinforced by the director of the Cleveland Museum of Art who pointed out: "To be an advocate, the director has to use words and ideas—my ability to persuade and sway opinion is embarrassingly high. Directors actually have tremendous respect in the community at large."[37] When the directors' interviews were analyzed, it became apparent that directors shape their advocate role, internally and externally, guided by personal passion. Five themes emerged that provide anchors so leaders are not swept away by constant changes. The themes also reflect and contribute to a new understanding and appreciation for the role museums play in our communities.

**A Passion for the Primary Product**

Leaders with a passion for the primary product in the museum sector are masterful connoisseurs. A connoisseur is someone who looks at and enjoys a product with the ability to make fine discriminations, recognize style, and render evaluations.[38] The director for the Victoria and Albert Museum in London described this as a "love of objects, design, and aesthetics."[39] He used art objects as a communication tool. A love of art objects provided an endless supply of stories to use on behalf of the museum. The art objects shaped the museum's mission, vision, and policy development—collecting, conserving, exhibiting, and educating the public using the objects. The director of the Yale Center for British Art described a passion for objects as a unique kind of obsession:

The director has to believe in the institution or people won't give money! Neither the staff nor I can come to work unless we believe in the museum, the collection, and access. Most important of all, works of art inherently contain values of imagination that we have to have in society. To do the director's job well, you have to have the desire to communicate the beauty and power of art. To communicate about context and people in different ways. To be passionate about this form of human greed which has no social drawbacks! And you have to have pleasure in what you are doing. To be a director, you have to look at lots of

works of art. To love things and objects far from your own taste. You have to want to communicate about objects. You have to have ideas about objects and how they relate to one another. It is a unique area. It provides the opportunity to combine thought and action in a way like no other job.[40]

The art museum is actually a unique business because it deals in spatial intelligence. Spatial intelligence makes it possible for people to perceive and transform images and recreate them from memory.[41] Visual artists possess spatial intelligence, and with skillful interpretation, visitors to museums learn how to interpret visual objects using spatial intelligence to see the world in a new way. The director of the Art Gallery of Ontario described his role as caretaker and interpreter for the visual artist:

> My passion? The visible pleasure of people in front of a painting. I am steward of thousands of artists, alive and dead. I feel an obligation to make their vision understood by our visitors. There are thousands of voices and visions in this gallery.[42]

The director of the AGNSW in Sydney shared the same passion and pleasure in the emotional power of the visual arts. He encouraged the curators, public program staff, and volunteer gallery guides to act on his behalf—to create a bridge between his passion for art and the public. He used contagious enthusiasm, urging staff and volunteers to create an ambiance in the museum where people could enjoy art the same way he did:

> I love the visual world of design, architecture, buildings, and paintings. If I had to lose any of my senses, the one that would distress me most would be the power of sight—I see my job is to get people in to enjoy this place. My job is to instill ideas, to shuffle the pack. We have to have a new breath of air in the place as people get used to breathing the same air. Take music in the Old Master's Gallery, for example. This changes the atmosphere—people can see and hear things differently. Pictures become an ancillary to music. The performance has an effect on the people and they never see the art work the same way again.[43]

On a slightly different note, the director for the Art Gallery of Western Australia in Perth described a passion for the space created for the objects, rather than the objects themselves. Her belief was that the art space was and should

be used for spiritual renewal. She described how important it was for volun-
teer gallery guides and public program staff to translate the language of art
into a meaning-making experience with the public:

> My passion is about bringing great experiences to people through great art.
> Bringing people in touch with the real thing. In a world without enough time
> for "drift," full of simulation and laminex. We need to see a labor of love, great
> beauty, and evidence of great ages. This is what it's all about and it needs to be
> supported by an intelligent way of helping people to *see* it. We tend to expect
> everything to be self-evident but there's no time to decode and without a code
> you can't see it. How we use our eyes has changed. Static works of art are not as
> visible as movies. So we, the art museum, provide "revelations" through tours
> where people actually *see*. The volunteer guides open people's eyes to world
> change! We are about being a catalyst for changes in perception, for how we see
> our world.[44]

A passion for the primary product aroused deep feelings of pleasure for the
director of the Art Institute of Chicago. He used the museum's mission state-
ment to balance the tension between his passion and a rational approach to
leadership:

> I get my pleasure from how art looks and works in a museum. I am also the one
> who has to decide whether what the curators recommend fits or not. This can
> be chaotic! The decision has to be ordered through a mission or belief about
> what the Institute stands for which is to show original art of high quality to
> broad audiences. If any decisions are out on the chain or contradict function
> and respect for the object, then we know we have overstepped the line. We have
> to continually review the mission. Is this a coherent process? No! It is chaotic!
> There is stability in the mission which is being continually balanced with the
> object and the scholarly commitment to audience. It demands a continual
> reference.[45]

A passion for the primary product (art) moves leaders in profoundly emo-
tional ways. Their deeply emotional response shapes their desire to share the
joy they experience. They are in love with the way artists see and interpret the
beautiful world around us. To understand what drives such a passion, I sought
advice from a therapist in the San Francisco Bay area who works exclusively
with artists. He said people who work in and around the arts are pursuing

their own form of artistic creativity.[46] Leaders with a passion for the visual arts use creativity (an EQ skill) to direct and lead the museum as an expression of their own creative drive.

### A Passion for Social Principles and Romanticism

The term *romanticism* comes from medieval tales called romances. Romances described the power of passion and proclaimed that feeling is all.[47] Romanticism is marked by a belief in an inner divinity tapped through instinct or intuition. One Australian art critic described romantics as people with a deep inner sense of the divine, a philosophy based on nature, a contemplation of the universe in which God is seen in what has been created as "a diffuse and vast presence behind the screen of natural facts."[48] Another Australian museum educator defined romanticism with reference to the dichotomy between classicism and romanticism:

> A leader with a leaning toward classicism experiences the world as objective, rational, in control, analytical, cool, dispassionate, intellectual, structural, academic, and with a carefully considered objective approach to life. Romanticism is idealistic, hot, passionate, subjective, emotional, personal response to the world with a deep concern for people. Romanticism colors the fundamental irrationality of emotions with a sense of mystery and encourages truth to individual experience. People with a passion for romanticism place the artist (writer, painter, or social revolutionary) at a distance from others based on a belief that artists have a prophetic insight into things that ordinary mortals may not understand.[49]

Leaders with a passion for romanticism represent their organizations with a heroic commitment to the museum's special role in providing social vision. The director of the Maryhill Museum in Goldendale, Washington, described how a passion for romanticism led the original founding director to shape a place to inspire social principles:

> One advantage of being a small, private institution with small staff numbers means we have opportunities for increased creativity. We have grappled with what this institution is. All of the erratic components need to be seen as a pre–World War I view that was truly quite a philosophical one. It was a time when people had more hope and a more hopeful philosophy. The museum

represents that by offering something for the heart. That was the history of this institution. We don't want high technology. People experience Maryhill as a museum with human scale because it was originally built to be a private residence. Massive, yes, but a home nevertheless. In this way, people sense their ability to actually participate in it. It is graspable, personal, and embraceable in such a way that people can use their own ability to have a personal insight. Maryhill is about providing illumination as an institution. We must not lose [the founder] Sam Hill's vision for this place. It is lived out by the affection people have for the institution, which actually surpasses the knowledge that it offers. That affection is expressed in very unexpected and creative ways. For example, one of our visitors was a composer from Chicago who was inspired to do an opera on Sam Hill.[50]

Leaders with a passion for romanticism represent their organizations with a keen sense of social vision. For example, the 1960s was a decade of social revolution and experimentation in the United States—the civil rights movement, challenges on university campuses over authority and control, expanded consciousness, and new ways to relate in personal relationships. A few directors with a passion for social principles influenced and shaped extremely beneficial ideals about museum leadership overall, according to the coordinator for the American Association of Art Museum Directors.[51] For example, the director of the Cleveland Museum of Art described the 1960s as a major influence on his leadership vision:

After fifteen years, I know organizations and communities have genius loci. The director's job is to recognize the inherent structure of these entities, including the museum. My job is to coax and coach genius to the surface. The first dawn of realization is my passion. My democratic spirit is based on the spirit of the 1960s. That spirit was based on a passion embedded in works of art that are messages about humanity over time. My passion is to reveal those messages— to express a democratic spirit by sharing widely. First of all, it is a difficult job and without passion, you just cannot do the director's work. You come to work for the heart of it. Like a musical conductor, to create harmony. I am a mediator, a builder of bridges, a coordinator of $x$ and $y$ who then get sent on their way.[52]

The director of the Phillips Collection in Washington, D.C., reflected on another aspect of romanticism, the importance of carefully choosing the words

used to represent the museum's social role in the community. He described an intuitive sense, a special presence behind the screen of natural facts, that influenced his judgment:

> Literature was and still is my great love. I am anchored with the written word. A director has to use words and ideas as tools because you have to advocate, persuade, and draw together complex strands and dimensions in an art museum. The process is about getting and making the best product. It is about outreach and marriages which have not been attempted before in response to the push to serve communities with exhibits. It is about giving new life to the arts to enrich people's lives. The director has to be a multitasker with a range of projects. This is a vibrant business! There are many aspects of the unexpected, which the director has to deal with. I follow the Star Wars philosophy of the "Force be with you" to judge situations. I look for the differences in the way people use words, distinguishing a word artist from a crafter of words, to judge their ideas.[53]

A passion for romanticism influences how directors represent the museum as an organization that carries a hopeful message about humanity over time, a place that provides an opportunity for life enrichment.

### A Passion for People and Education

Leaders with a passion for people and education shape museums as sites for discovery. They take great delight in the world around them and see education as a process of discovery, created through trusting relationships. With trust, they are able to draw forth, bring out, lead, and develop others.[54] The director of the Dennos Museum Center in Traverse City, Michigan, used a passion for discovery to create a museum that invites the public in with the enticing phrase "Come Alive Inside." He reflected that

> My passion is prompting people to question, how does this relate to me? It is about the act of discovery! Pure visual art has a limited appeal in the community due to the art world's focus on contemporary art and a lack of audience access to this form. The community in general does not have the visual language to understand art, particularly contemporary art. Combining a visual arts program focused on state-based artists with an international music program has been hugely successful. The center continues to offer "discovery" themes of interest to the community based on active research. For example, environmental awareness was imaginatively explored through

literature, visual arts, and chamber music specifically composed for a series of performances at the center.[55]

The director of the J. Paul Getty Museum explained that his original career path was in education and teaching. He represents the museum based on the pleasure he still feels when teaching and unleashing ideas in others:

> It's about connections. Connections are people to tasks, relationships between the museum, people, things out there, ideas for programs, art objects to be bought, exhibitions, colleagues in the business. My role is about connections and potential connections. It's about explaining what the museum does in a hope for more connections. I connect people to tasks. They connect to me and help comes from the top of this organization for people to connect with each other. As a leader, my job is about setting goals that connect our dreams about this museum. These dreams are looked at annually and transformed into objectives and tasks.[56]

The director of the Arthur M. Sackler Gallery and the Freer Gallery of Art in Washington, D.C., described changes in the way directors *represent* their organizations as the biggest change for the 21st-century museum. A director is now expected to extend the museum's influence in ways that can only be achieved through a passionate commitment to some aspect of the organization. In this case, the director had a deep commitment to

> The intrinsic beauty and richness of artistic and cultural expression in all its forms, in the hope of transcending race, representative, interpretative, and audience barriers. As a college student, I never thought I would like to work in or lead a museum. I liked to teach. The opportunity to be a director, though, was ideal. Our duty here is to make the museum interesting for the family groups who come. The Freer Gallery was opened in 1923 as a walled garden for Asian art. We now have to open to the public as we have no right to be a walled garden. We need to serve well, to be accessible. Having taught for fifteen years enables me to excite others about Asia through Asian art.[57]

The Hirshhorn Museum and Sculpture Garden is part of the complex Smithsonian Institution in Washington, D.C. The Smithsonian's overall vision is played out through a specific mission—to achieve the greatest diffusion of knowledge possible.[58] This mission provided the director of the Hirshhorn

Museum with the perfect place to express his passion for education. Early ex-
perience as an arts educator influenced the way the director represents the
museum:

> This job is basically fun! Some parts are more enjoyable than others. If I don't
> have certain kinds of information, it presents a challenge to find the what, why,
> and how to operate. Works of art are all different. When different pieces can be
> put together to create a dialogue, the art museum is then a place of ideas.[59]

The director of the National Gallery of Canada shared a similar commitment
to dialogue between art and people. Others described this director as a leader
who could think on a broad canvas full of complexity without becoming flus-
tered. She was passionate about people:

> A good director has to like people and the process of bringing them in touch
> with art. You have to like even the pompous people. You have to be excited about
> the work with the public. This can only be based on understanding the great-
> ness of the art objects being worked with.[60]

The director of the Museum of Fine Arts in Houston developed a passion for
people through an early childhood experience where art became a lifesaver.
He used that passion to represent the museum as a site for the development
of social capital and community life:

> Our goals are to strengthen the endowment so we can serve people by getting
> art into their lives. We want to increase visitor attendance and membership. We
> are serving our local community. Why the people focus? I am here to serve poor
> people. I was raised by my mother's brothers in a lower middle-class Italian im-
> migrant family. I was the first person with a high school diploma in the family.
> I got a football scholarship to go to university. In my first semester at university,
> I got four Fs and a C. My roommate told me I must have been concentrating too
> much on that one subject. About this time, a professor in one of my classes used
> a slide on Goya's painting *The Forge*, and I responded. For the first time, I re-
> sponded. The professor said to me, "If you go to the Frick and write a paper on
> this, it will help your grades." This was the first time in my life that I felt like I
> knew something. Through this process, I discovered that social welfare does not
> work but art can make a difference. The connection between my role and
> the mission for the museum is easy to answer—make the art museum an

institution of everyday life. To evolve into a broad-based cultural center rather than a place where beautiful art is kept secure. Everyone can then think art museums are part of the environment. This can be done in a number of ways. This museum sponsors an annual run with 5,000 runners over a five-mile course. It starts and finishes in our sculpture garden. It is a big success. We also stage a singles night that attracts 5,000 people each year. We sponsor clay pigeon shoots. Other museum colleagues laugh at some of the things we do. I love the idea that people can come here for all sorts of things.[61]

The director of the Please Touch Museum in Philadelphia described a passion for children and their journey of discovery based on her early training in education. This passion was a source of personal pleasure and organizational strength. She described how leaders at the opening of the 21st century were confronted with challenges totally unrelated to their original domains of expertise. It takes EQ resilience and energy to maintain confidence in the face of challenges like capital campaigns and complex staff issues. Keeping passion alive inside and outside of the museum was recommended as a survival strategy:

The director is the leader. You just can't order other people to do things. As a leader, you have to have a deep commitment to what you are doing so the staff will do what you ask them to do. They need to see your commitment. My passion is kids! But it isn't just my passion that sustains my spirit. I am sustained by a gifted, talented group of people dedicated to the museum and loyal to me. This means all of my director challenges are reduced. Directors who are discipline trained may find it hard to keep up confidence, as so little of a director's role has to do with the training of their particular discipline. It is important to have another outlet for energy. Although my passion is kids, my outlet is actually gardening and golf.[62]

Directors with a passion for people and education are shaping 21st-century museums in new ways, combining visual arts with educational strategies to appeal to a wider audience. Collections are being used as stages for public education events, rather than an end in themselves. For example, the Public Program Department at the AGNSW in Sydney designed a series of diverse talks in 2002 exploring Buddhism's influence on Western society.[63] Presented by known personalities distinguished in various fields, the talks drew large audiences to the museum. Many were first-time visitors, such as the new audience

of mountain climbers who were attracted to the museum by the opportunity to hear a Tibetan climber speak about Buddhism in the everyday life of a Sherpa.

### A Passion for Entrepreneurship and Innovation

The shift from nonprofit to for-profit in the 21st-century museum has provided some directors with a new and unique opportunity to express their creativity as entrepreneurs. Those with a passion for entrepreneurism are actively reinventing themselves as leaders of business enterprises. The working definition of an entrepreneur is someone who seizes an opportunity, takes a risk, and makes it financially successful.[64] Entrepreneurs rely on intuition and high levels of creativity to sense a cause or opportunity that can be turned into a profit.[65] Entrepreneurs have an ability to see economic patterns, adapt to changes, create new organizational environments, and enjoy the leadership complexity.[66] The director of the National Gallery of Victoria in Melbourne was comfortable with the entrepreneur's hat because it allowed him to use new tools to create a more dynamic presence for the museum:

> The mission? Merchandising! The bookshop and other chargeable services are all within the mission of the gallery. Given that I am new to the job, I am still developing initiatives such· as new ways of advertising the gallery. We now do cheeky stuff with television ads to attract a younger audience. We stay open in the evenings to draw in audiences committed to work during the day. My job as director is to balance a belief in the institution and the reality of marketing. I am not reluctant to enter commercial activity but we cannot wear the museum's mission on our sleeve in the process of promoting an understanding of the visual arts. We are not exactly about "entertainment and access" but about creating greater understanding so people will want to know more about the visual arts.[67]

The director of the Museum of Contemporary Art in Sydney was adamant that the museum's economic survival depends on entrepreneurial leadership vision. He said bringing the vision into reality involves patiently reshaping the museum's internal organizational culture, shifting it toward greater risk taking and creativity:

> Some of the staff here are absolutely gifted but they don't know how to be entrepreneurial. To me, entrepreneurial means to know how to invest time and

money in anticipation of a return greater than the investment. One has to risk what you have for new possibilities. The way I work is part of a creative drive that is purely personal. I don't do it for public recognition or achievement. It is a drive to create and compete with myself. Life is about creative endeavors. The focus has to be on the fundamentals of creativity in order to cope. My advice is to not be intimidated. We are all mortals, so be bold in the process.[68]

People with a passion for entrepreneurship are able to manage nonroutine, significant, and discontinuous change. They have learned how to manage constructive discontent in response to new business ideas that are not consistent with the way an organization currently sees or represents itself.[69] Research on leaders of learning organizations revealed a passion for innovation.[70] For example, the director of the Isabella Stewart Gardner Museum in Boston was specifically recruited as an entrepreneurial risk taker to guide the museum out of financial strife. The director looked for innovative ways to integrate the museum into the neighborhood so people could walk to it from three local schools. The planning team used learning theory to push the museum's envelope. The approach did not please the trustees. This created an opportunity to manage constructive discontent in a debate over who actually *does* represent the organization.[71]

The director of the Museum of Contemporary Art in Los Angeles (MoCA) stressed that he did not want the museum's innovative presence based on the ideas of one person alone—director or curator. His passion for innovation was based on a desire to work with artists and to be in the contemporary world where all things were open to question. He liked to look for more than one way to solve a problem. The MoCA developed very innovative relationships between artists, the public, and the museum, with measurable positive financial outcomes:

Ideas and energy are the most important characteristics a director of an art museum can have. The director has to be capable of saying "What's next?" in terms of the goals, strengths, and a concept for the museum to make it unique. This means bringing things to life constantly with artists. That is how we keep this place alive. This can be expressed in many ways. For example, we were looking at artists and their roots and decided to meld this by doing something about the LA gangs. We used the LA gangs, hiring one member from ten different gangs on a [set] salary to work as apprentices with a sculptor/bronze

caster. The project involved work on a torso sculpture for a limited number to be sold as fund-raisers for the museum. It was a two-year program. In the first year, we made [a substantial profit] for the MoCA, trained people to be productive, how to make money from something other than drugs, and the project is continuing. In this sense, we can learn how to create new and profitable opportunities from all sorts of other people like artists, ski patrols, and football teams.[72]

The director of the Queensland Art Gallery (QAG) in Brisbane used his passion for politics to shape an entrepreneurial museum with a unique position in the Australian cultural industry sector. By taking a long-term view of Australia's position in the region, the director shaped the now highly successful Asia Pacific Biannual. The event evolved with corporate backing from Asian companies keen to invest in Australia. Sponsorship agreements provided a way for Asian companies to build trusting relationships, or intangible social capital, prior to making tangible business commitments in Australia. Like other directors, the director of the QAG confessed that representing the organization was rarely based on a sense of happy equilibrium. He offered strategies to increase resilience under pressure:

> You can't take yourself too seriously. You have to stay dynamic or it becomes boring. My own personal interest in politics helped me a lot. As a director, you look for what can be done, not what can't. This requires skills and talent in advocacy and maintaining a position of high credibility with the mainstream of the Queensland Public Service. Every institution needs to be a shaper of change.[73]

Directors with a passion for entrepreneurism and innovation have expanded their leadership roles to include marketing, merchandising, and investments. Chapter 6 describes in more detail how ethical entrepreneurism can generate a profitable return when leaders are willing to take calculated risks.

### A Passion for Constructive Discontent

Constructive discontent involves an active appreciation of diversity, difference, investigation, and examination. A director with a passion for constructive discontent sees the organization as a site for debate and a place to create

many possible futures. The director for the Whitney Museum of American Art in New York explained that he represents the museum as a place for personal and community discovery based on a passion for personal development. With a career path ranging from arts journalist to video-art curator to director of university art museums, he had many choices available for how best to represent the Whitney:

> I learned how a museum is a social instrument for use by self and others. I saw museums as part of a community's health, both socially and mentally. I learned how a museum plays a role in the lives of people from different social levels, not just the rich person, which is what I originally thought. I learned that a contemporary art museum is about collecting, recording, reporting, mirroring, and is a site for delight. I fell in love with art, its power and its liability. I was prompted to live an examined life. The art museum is a mirror to an examination of life. It is a place for the *contest* of values and ideas. My job is to present the menu and if the audience likes it, they are the ones who then find their way. I learned all about passion through a project in California. I learned about people who really do "good deeds." I learned what was real, respected, and dangerous, I learned about survival [through a series of potentially life-threatening accidents]. I learned that museums need people with passion, not functionaries.[74]

The director of the Museum of Contemporary Art in Chicago (MCA) described a passion for the museum as a site for exploring known and unknown forces in contemporary culture:

> I am responsible for the definition of the vision for the MCA, marshaling the resources for the vision, and then doing it. This means pushing and shoving tangible and intangible forces. Tangible forces are expectations of donors, trustees, community, staff, our own expectations, the architect, and the city government. Intangible forces are the finite financial base and the fears/concerns/lack of interest in contemporary culture in the USA. I see contemporary art as "on the edge" representing the fault line of culture. The edge and fault line suggests there is another side that is unknown. It's hard to figure out what is on the other side! Sometimes what we do is closer to journalism than history. We are investigating rather than reporting on contemporary culture. The world is one with few compass points. It is about managing ambiguity and uncertainty.[75]

A passion for constructive discontent influenced the way the director of the Museum of Modern Art (MoMA) in New York represents himself as a change agent and the museum as a site for community engagement:

> We need to ask what to create for tomorrow. We need to use our minds and act as think tanks to think abstractly. MoMA was founded with a missionary spirit and propelled over the last sixty-five years with that spirit. We work in a world context, forging common ground between ambitious visions from the staff and the trustees. As director, I am the mediator of this process. Managing change is an apt description of what I do. I am part of a larger pattern of relationships. My focus is on how to take the status quo toward an evolution, balancing roots and history at the same time. This involves creating team leadership with a shared goal and a common vision.[76]

Thriving on change and diversity, the director of the Saint Louis Art Museum encouraged constructive discontent as he continually repositioned the museum in contemporary society:

> I enjoy the interface between individuals, collections, and the roles of museums in the community intersect. I enjoy the link to plural or diverse audiences. I hugely enjoy difference. I thrive on difference. The translation of this passion into the vision for the Saint Louis Art Museum has been a sixteen-year commitment to a publicly owned museum that has a global agenda like the Victoria and Albert [in London]. The founder of this museum in 1879 put no boundaries on what constituted art. He started this museum with an open-ended agenda. This came into play and got lost between 1940–60. It needed to be refound. It made a difference to re-vision the organization with a big, open agenda. If we are able to continue to grasp the excitement of that, then we will continue to be successful.[77]

Directors with a passion for constructive discontent view their leadership roles slightly differently than do other directors. They see themselves as change agents, at ease with the ambiguity and uncertainty reflected in contemporary culture. Change and diversity, representing the museum as a tool to shape social change, energize them. They enjoy working on the edge or cultural fault line, which means the museum's story reflects a site for ideas rather than objects, social debate rather than passive congregation.

## INTEGRATING CHANGE AND THE REPRESENTATIONAL ROLE

Leaders with passion care about their organizations. As leaders, they know what they stand for and how passion influences the way they represent their organizations. As individuals, passion influences the way they draw on and direct energy to make leadership decisions. The five themes emerging from the directors' stories provide new angles to explore: *Why are we here? Who do we serve?*

The first theme is a passion for the primary product. It is no surprise that a love of beauty and the power of the visual arts struck a deep chord for many directors because the art museum was the case study organization. The point here is not whether leaders love art but whether they love their organizations' primary product. The second theme is a passion for social principles and romanticism. This was expressed as compassion for people shaped by a strong social vision. The third theme is a passion for public education as a way of building trusting relationships. For these leaders, education meant discovery—bringing people together for new insights into the world around us. The fourth theme is a passion for entrepreneurism or being a champion for innovation and creativity. Entrepreneurial leaders were on the lookout for calculated risks they could turn into profitable opportunities. The fifth theme is a passion for constructive discontent. Those leaders used the museum as a social tool, questioning and creating ideas about shared futures.

It is important for organizations to appreciate the relationship between passion, EQ, flow, and representing the organization. Several EQ leadership skills are reflected in the directors' stories: creativity, intuition, compassion, trust, interpersonal connection, energy or resilience, and constructive discontent. As an aside, the director for the Minneapolis Institute of Arts stressed that being a CEO means living at test-pace pressure and urged aspiring leaders to build resilience: "Despite a background in sports, the twelve hour days, seven days a week demands energy."[78]

If leaders start to lose energy, diagnose which of the essential conditions for flow may be missing. Are there clear goals? Does the leader feel supported emotionally and materially so he can achieve the organization's goals? Is she able to exercise discretionary decision making? Is his judgment trusted? Is the organizational context safe so the leader can represent the organization from a position of strength? Are the organizational challenges just enough, too much, or not enough? In the diagnosis, we may be surprised to discover that

cultural organizations such as museums hold unexpected keys to leading a passionate life. Csikszentmihalyi described how the need for increasingly refined skills to maintain flow and pleasure is a key contributor to the development of culture: "Great music, architecture, art, poetry, drama, dance, philosophy, and religion are there for anyone to see as examples of how harmony can be imposed on chaos. Yet so many people ignore them, expecting to create meaning in their lives by their own devices."[79]

## NOTES

1. de Montebello 1996 (I).

2. Suchy 1999a.

3. Hawley 1996 (I).

4. Gardner 1983: 237–76.

5. Thomson 1996 (I).

6. Keating 2001.

7. Potts 1995 (I).

8. Capon 1995 (I).

9. McCaughy 1996 (I).

10. Csikszentmihalyi 1990: xi, 1996.

11. Csikszentmihalyi 1996: 1.

12. Thomson 1996 (I).

13. Goleman 1996: 90–93.

14. Serota 1996 (I).

15. Sano 1995 (I).

16. McCaughy 1996 (I).

17. Parker 1995 (I).

18. Powell 1996 (I).

19. Capon 1996a.

20. Capon 2002: 8.

21. Birkett 2002: 9.

22. Margo 2001: 10.

23. Pearce 1992; Gardner 1995a; Goleman 1996; Cooper & Sawaf 1997; Fineman 1997; Downing 1997: 27–44; Suchy 1998a.

24. Goleman 1996, 1998; Cooper & Sawaf 1997.

25. Goleman 1996: 118–19.

26. Fox 2003: 67; Gowing in Cherniss & Goleman (eds.) 2001.

27. Fox 2003: 67; Boyatzis 1998–2000 (I); Orioli 2003 (I).

28. Connor 1995–2003 (I).

29. Suchy 2002b: 15–16.

30. Orioli 1996: 1.

31. Gowing in Cherniss & Goleman (eds.) 2001: 86, 129.

32. Goleman 1996: 8.

33. Gardner 1995b: 27.

34. Gardner 1995a: 290–95.

35. Gardner 1995a: 285–90.

36. Moffett 1996 (I).

37. Bergman 1996 (I).

38. Gardner 1983: 198–200.

39. Borg 1996 (I).

40. McCaughy 1996 (I).

41. Gardner 1993: 170–204; Pennar 1996: 53.

42. Anderson 1996 (I).

43. Capon 1995 (I).

44. Latos-Valier 1996 (I).

45. Wood 1996 (I).

46. Maisel 1992: 6–8, 1995 (I).

47. Strickland 1992: 76.

48. Hughes 1990: 90.

49. Spate 1980: 17.

50. de Falla 1996 (I).

51. Gaudieri 1996 (I).

52. Bergman 1996 (I).

53. Moffett 1996 (I).

54. Delbridge 1982: 389.

55. Jenneman 1996 (I).

56. Walsh 1995 (I).

57. Beech 1996 (I).

58. Bello 1993: 9.

59. Demetrian 1996 (I).

60. Thomson 1996 (I).

61. Marzio 1996 (I).

62. Kolb 1996 (I).

63. Gibson 1995–2002 (I).

64. Ottley 1995 (I).

65. Aburdene & Naisbitt 1994: 319–34.

66. Vecchio, Hearn, & Southey 1995; Glynn 1996: 1110.

67. Potts 1995 (I).

68. Paroissein 1995 (I).

69. Mezias & Glynn 1993.

70. Senge 1990.

71. Hawley 1996 (I).

72. Koshalek 1996 (I).

73. Hall 1995 (I).

74. Ross 1996 (I).

75. Consey 1995 (I).

76. Lowry 1996 (I).

77. Burke 1996 (I).

78. Maurer 1996 (I).

79. Csikszentmihalyi 1990: 213, 235.

# 3

# Context
## Creating a Place

The second part of the fourfold leadership role focuses on creating a context in which others can give their best. A perfect example of leaders with passion creating context was evident when the National Gallery of Victoria (NGV) in Melbourne reopened in 2002. Located next to Australia's most famous sporting venue (Melbourne Cricket Ground), the museum reopened after extensive changes, with a new context and way of representing itself to the external world. The NGV wanted to be known as the people's art museum—a meeting place in Melbourne.[1] Here in chapter 3, we will explore changing contexts in the 1990s and what leaders use to shape the entrepreneurial museum.

When the NGV reopened, the director and the president of the board of trustees both described the museum's vision and purpose to the media in two different but complementary styles. The director, in a suit and the epitome of professionalism, described a new and more open context for staff and the public to enjoy. The president of the board of trustees, in casual dress, led a public program tour with a television camera following through the galleries, introducing some of Australia's most iconic and famous paintings. Evidence of a more open context was reflected in innovations such as text panels for paintings written by children and placed at their eye level. The message was clear: the untrained visitor was being given an opportunity to get a feel for art, help make decisions about what it means, and have a voice in its expression. At the end of the tour, visitors were asked what was different about this art museum. The visitors described a whole new context: less stuffy, more friendly, more open, more able to view art as a part of life rather than a rarified thing, less work for the visitor, more enjoyable.

The perception created by the two NGV leaders was that staff and the public could enjoy themselves in the museum. This was a place where the goal of enjoyment was clear, with user-friendly resources to encourage the public to exercise and trust their own judgment about art. A palpable creative tension suggested that a passion for art could be a shared experience. The leaders had revamped the context and set the stage for what another leadership writer called "creating a domain in which we continually learn and become more capable of participating in our unfolding future—a true leader sets the stage on which predictable miracles, synchronistic in nature, can and do happen."[2]

## A MODEL TO MAP CHANGE

The change diagnosis techniques discussed in this chapter are useful for understanding what leaders need to consider in setting the stage or context. Readers are encouraged to use the information as benchmark data to track change over time with the 21st-century museum. As the director of the Art Gallery of Ontario suggested, in the rapidly changing field of museum leadership, change can be approached only with a handful of preconceptions and assumptions.[3] This chapter explores assumptions using stratified systems theory and the levels of complexity model. Models provide elegant objective frameworks on which to hang subjective experiences. They help shift focus from problem people and problem experiences to ways of making sense of the nonsense that happens in organizational life.

In the search for cues and clues about changes in the 1990s, the level of complexity model was chosen for particular reasons. It provides an objective way for leaders to talk about their subjective experience of changing organizational contexts. Museum leaders in my research felt increasing complexity in the 1990s; the model provides a framework to make sense of the change. Based on my experience with the model and research data, evidence suggests that large state and national museums created a new level of work complexity in response to changes in the economic environment (appendix 2). For readers who may suspect the usefulness of abstract models in organizational life, allow me to share a story from one of the participants in the *Leading with Passion* course. This particular leader used the model with staff to appreciate the matrix of working relationships in their organization:

The level of complexity model was the first and most meaningful concept of leadership in my whole working life. I've read and worked with a lot of management texts but this one model finally made sense because I could actually see what happens in work. Stratified systems theory provided a way to understand the different kinds of complexity and what actually happens in work. As leaders, our attention is running from issue to issue, we have to deal with each major decision and then move on. I didn't understand any of this when I was younger. I used to look up at the leadership or senior management roles and wonder why they weren't doing what I thought I would be doing if I were in their role. I had no insight at all into what actually happens with the leader's time. Younger people at lower levels in organizations or people in organizations without very much complexity just can't see or sense the complexity within senior levels until they get to work at those levels themselves. When I finally got to a leadership level, I understood that you can't understand what Level 4 or Level 5 work looks like from Level 1 or 2. Depending on our own innate level of capability, we might grow into that realization. And, along the way, we need the next level of interface to translate the work and the leadership vision for us because it is very difficult to see and sense otherwise. I can now understand why I was frustrated as a younger manager and make a deliberate effort to translate the work for my staff [to create a context for their work]. The feedback has been positive. They tell me it's the first time in their working lives they've had a manager who can break down what the work is at his level so they can pick it up at their level.[4]

Stratified systems theory and the levels of complexity model have been used to map organizational change and the need for change in many different industry sectors: aviation, health, mining, government, public utilities, education, the military, and financial services.[5] The model provides a very useful way to describe complexity on an individual and organizational level and has been used for restructures, executive development, and succession planning. On an individual level, people vary in the amount of complexity they can successfully manage and still feel in flow. Too much complexity and they feel overstretched; not enough and they get bored. On an organizational level, the model along with stratified systems theory (SST) has helped organizations make sense of work relationships through a natural hierarchy, or seven levels of complexity. Although SST describes seven levels, most organizations operate with fewer levels.

Understanding context and change using the model and SST takes time and skill. One of the tools used in the model to diagnose and understand complexity is called time horizons—the most complex task associated with each

level of work in the model. The time horizon is the longest period into the future a person is capable of organizing and carrying out a task or project. Time horizons involve decision making and how long it takes before the outcome or impact of the decision is fully realized. They are not about what is planned but the length of time it takes for real tasks and decisions to be fully realized.[6] Longer time horizons reflect increased levels of task and decision-making complexity. For example, for tasks and decisions associated with Level 5 in the model, it may take as long as *ten years* before the full impact of the decisions and actions can be seen, felt, evaluated, and understood.

## LEVELS OF ORGANIZATIONAL COMPLEXITY

Each level of work in the model has a theme. The themes are integrated into a hierarchy of complexity that leaders manage, depending on their organization's level of complexity. For example, the theme for a Level 1 organization is quality. The theme for a Level 2 organization is service. Leaders for Level 2 organizations, such as smaller regional museums, manage quality and service. The theme for a Level 3 organization is good practice. Leaders for Level 3 organizations manage quality, service, and good practice.

A brief outline of the first five levels from the complexity model with time horizons for decisions and task complexity follows. A similar outline was used in the sample survey questionnaire (appendix 2). In the survey, the majority of museum directors chose time horizons and decisions associated with Level 3 and Level 4 organizations (appendix 2, table 1). When asked to choose their level of task complexity, the majority nominated Level 4 and 5 organizations (appendix 2, table 2).

- *Level 1: Quality Focus*
  Making or doing something concrete for the museum in a hands-on way. Managing self and resources using continuous practical judgment. Sharing help, expertise, and ideas for improvements. In larger museums, Level 1 staff include security guards, administration, researchers, some professional staff, catering, and retail staff. The time horizon for the most complex task in Level 1 is three months. In other words, outcomes for decisions can be seen in *three months* or less.
- *Level 2: Service Focus*
  Demonstrating the purpose of the museum by managing teams who collect, conserve, exhibit, and deliver public education programs. Assessing and

serving internal or external audience needs. Responding to and resolving particular situations and cases. Explaining why and how work is to be done. Sharing experience and knowledge. Informing and responding to tasks that provide service. Staff examples may include team leaders for conservation, public program specialists, and curatorial staff. The time horizon of the most complex task is *one year.*

- *Level 3: Good Practice Focus*
  Maintaining the various ways the museum realizes its purpose in provision of services or production of exhibitions and related goods. Imagining all the possible practices and systems for good practice, selecting the best solutions, and making the most of the people, finance, and technology to realize what was chosen. Sharing practice and system refinements. Informing and managing improvements as a mini-organization. In some museums, this may be the director's level. In larger state or regional museums, this may be the manager for a division with various teams under marketing, curatorial services, public programs, or specialists such as information technologists and financial systems analysts. The time horizon for the most complex task is *two years.*

- *Level 4: Business Development Focus*
  Managing the relationship between the corporate plan and the mission for the museum. Setting the framework and developing new ways to achieve the mission. Resourcing established services or practices. Eliminating services and practices that are not effective. Developing and sharing innovations. Managing change and continuity for a state-based organization. Staff examples include the director or deputy director depending on the size and position of the museum. The time horizon for the most complex task is *five years.*

- *Level 5: Mission and Strategic Intent*
  The theme for Level 5 is strategic intent through a managing director responsible for a freestanding strategic unit or a director of a national organization (profit and nonprofit). Ensuring the long-term external and internal viability of the museum as a whole in financial and social terms. Guiding the museum through conflicts and modifying plans in relation to external changes. Maintaining a national position and presence. Representing the museum to the external world and to itself. Setting and being the source of current and new business directions and targets. Sharing strategic information. Controlling capital and revenue expenditures as a whole. Staff examples include the director and trustees of a large national museum. The time horizon for the most complex task can take up to *ten years.*

Although the levels of complexity model and stratified systems theory describe seven possible levels in an organization, I did not include all seven levels in my research because no museum functions as an international or multinational corporation. To complete the model, the theme for a Level 6 organization is corporate citizenship through corporate and group executives leading international organizations with offshore offices. The theme for Level 7 is corporate prescience, with CEOs and presidents of transnational organizations defining world systems. For example, the United Nations and the World Bank are responsible for transnational security and global economic policy development.

SST and the levels of complexity model provided a way for directors to reflect on changes in the 1990s. Evidence suggests that many of the leaders in the survey felt they were leading Level 4 and, in some cases, Level 5 organizations. They described increasing pressure from 1992 onward to expand their roles and take on more corporate functions and tasks such as marketing, financial management, and capital development campaigns.

Theoretically, leaders in flow with Level 4 challenges are capable of managing the relationship between the museum's mission and how it can be achieved through new forms of business development. Level 4 leaders can be described as individuals comfortable working with the big picture.[7] For example, the director of the Yale Center for British Art said, "My approach as a director is to span a broad spectrum and focus in detail on certain aspects. Nothing escapes the director's eye."[8] Creativity is expressed by making original links between established or known areas of knowledge. The art of leadership is judging which part of the big picture to work on at what time. When making decisions, the Level 4 leader is aware of what is happening, what is not happening but should be, and what might happen in the environment. Level 4 leadership decisions can take up to five years before outcomes can be assessed.

Leaders in flow with Level 5 challenges sense how each decision sets off a potential ripple effect in a web of interconnected relationships.[9] They sense potential links between apparently unrelated issues and events. Any gaps in understanding are seen as sources of innovation and as a base for creating new knowledge beyond the currently defined field. The approach is one of constantly weaving, shaping, and reshaping interconnections within and between the museum and the environment, in the light of anticipated rather than actual changes. Leaders in flow with Level 5 complexity must feel comfortable

with a high degree of ambiguity and uncertainty because outcomes for their decisions may not be clear for up to ten years.

## INCREASING COMPLEXITY AND CHANGES IN CONTEXT

In the individual interviews, the majority of museum leaders described leadership challenges associated with Level 4 and Level 5 organizations. Most of the leaders were responsible for major state or national museums. Several clues were given to confirm that they were leading Level 4 and 5 organizations. Time horizons for decision making was one of the most important clues. For example, the director for the Fine Arts Museums of San Francisco said, "It can take seven to ten years on important projects like acquisitions to see the outcomes for the decisions I make."[10] The director for the MoMA in New York understood the relationship between time horizons, keeping people involved, and positioning the museum for the future. He said, "We will be dealing with a five- to ten-year timeline that will involve forty trustees, five hundred staff, and 1.5 million visitors per annum."[11] The director for the Art Institute of Chicago divided leadership decisions into three time horizons: "The context and broad view in the museum world is about three years out in immediate financial management, ten years out in building the collection, and fifteen to twenty years out when it comes to understanding or planning for ways to serve the audience."[12] The director for the AGNSW in Sydney also described different time horizons for events internal and external to the museum:

> For events happening within the building it may take three to five years to see the final outcome of the decisions. Outcomes for decisions around events external to the Gallery, such as the upcoming Sydney Olympics, may take seven to ten years to see the outcomes. Even long-term exhibitions require decisions that take at least six years to unfold[13]

The director for the J. Paul Getty Museum in Los Angeles had one of the most complex roles of any of the directors interviewed due to the international scope of the Getty Trust. He described how leadership decisions could take six to twelve years before outcomes are fully apparent:

> Our objective is to set goals that are our dreams about this museum and then to deliver them in an MBO or management by objective style. These dreams are looked at annually and transformed into objectives and tasks. For example, it

takes about six years for my most complex tasks to fully unfold. The actual formation of a collection, though, can take up to twelve years, not so much because of task complexity but because it takes that long to locate and secure works of art in line with our mission. Decisions in this arena have the most permanent consequences because the collection is what we are here for. It defines the museum, otherwise we become a university or theme park. The collection defines us, hence the importance of long-term decision making in this arena. I am reminded of a notion here from David Wilson with the British Museum who said, "Museums are a higher entertainment." It is the overall picture that attracts me; forming an understanding of a problem, its connections, and ramifications. For example, the new museum site project in downtown Los Angeles has involved a process of getting it, developing it, and, more importantly, explaining it to the world. Decisions made twelve years ago are just now coming into view. No other museum in the world is having to deal with the complexity involved with the new Getty museum: conceptual development, design, and placement.[14]

The director for the Museum of Contemporary Art in Chicago was acutely aware of long-term outcomes for financial management decisions. As one of the new-breed directors with business management qualifications, he used this experience to develop financial models to ensure the museum's long-term survival:

I get paid to see the global view. Problems are rarely simple. The global view includes all sorts of issues. For example, the construction of our new building has been a seven-year process from start to finish in 1996. This has required allocation of human and financial resources that vary so I have to monitor and predict the fluctuating rhythms. The long-term impact of the decisions the trustees and I make can be up to thirty-five years due to the financial planning required to develop the museum. A financial model had to be built to project scenarios thirty-five years ahead. Due diligence is required in all museums for these types of decisions, but it is unusual for cultural institutions to have this longer-term view.[15]

### DECISION MAKING, COMPLEXITY, AND INTUITION

An executive recruitment consultant responsible for the director's appointment at the National Gallery of Victoria in Melbourne described the addition of two abilities to position descriptions for directors in the 1990s: the ability to handle high-risk decisions and the ability to take long-term views. I wondered

how directors developed these abilities. What did they draw on to make decisions with such long time horizons? Despite proven validity and widespread use, the SST and the levels of complexity model did not provide the answers. The model describes a hierarchy of complexity that relies on a linear description of the universe. In my experience, linear thinking reflects only one side of what is possible. It became apparent that leaders who successfully managed complexity and created contexts where others were using something in addition to cognitive capability to stay in flow, make decisions, and manage complex changes. They were using EQ skills such as intuition.

I must confess that I did not go into this research with any idea that the door would open into a field of study like intuition. It was a big surprise. I am grateful for Orioli's EQ Map because it includes intuition as a valid scale related to optimal leadership performance.[16] Intuition is knowing the right answer without knowing the reason why, and making decisions based on a conviction that facts later prove to be right. According to neuroscientists, highest reasoning requires emotion and intuition, not just sequential analysis and technical rationality. Leaders who worked with me described how decision making in changing contexts involves a powerful series of interconnections and relationships. They described decision making based on an unseen source of knowledge that makes it easier for them to decide what is the right thing to do. They use their intuition to access this unseen knowledge.

Intuition was described by several museum leaders as the most important influence on their decision making, especially in situations fraught with a lack of sufficient data, excessive complexity, and gray zones or ambiguity. The director for the Fine Arts Museums of San Francisco said he scanned all complex financial data using his intuition to sense whether the numbers were right or wrong.[17] During critical moments, directors described drawing on a deeper level of awareness or knowledge to cut through the problem-solving and decision-making process.

Other writers on EQ and leadership have described intuitive signals as a deeper form of *feeling* that influences decision making in profoundly fundamental ways.[18] Leadership intuition has also been described as synchronicity and as an inner art of being.[19] Prior to the 21st century, there was little or no acknowledgment of intuition as an important leadership skill in mainstream Western leadership theory. As we move into the 21st century, I believe this insight will lead the way toward a more holistic and deeper way of leading.[20] For

example, a graduate from the company director's course with the Institute of Company Directors in Australia described the use of intuition to read complex financial reports and budget sheets:

> The facilitator for financial analysis and management coached us to stand back from the figures and run our eyes over them to see what they told us in a word sense. Imagine a Dali painting which is not straightforward to many people. In your mind, there is a message that comes through but you have to stand back and contemplate it, just like a financial sheet. Is it painting a healthy picture of the organization? Is something wrong? Over seventy-five percent of the financial side is learning how to *feel* the picture. Same as looking at a painting—you have to get a *feeling* for the message before you can get into the detail. If you are blocking feelings or out of touch with your emotions, it is harder to access intuition to make decisions. I think the reason why so many men have trouble with intuition and call it a feminine thing is because they block their feelings.[21]

EQ provides a way to talk about experiences like intuition that have been difficult to describe in the corporate and business world to date. In the *Leading with Passion* course, participants learn how to access and trust intuition using meditation techniques and the Myers-Briggs Type Indicator (MBTI). Meditation provides a tool to quiet the mind and body, preparing a space for a deeper kind of listening. The director of the Phillips Collection in Washington, D.C., described this as "listening, which is hard to do because of preconceptions, so I have to be patient and let the task begin to reveal itself."[22] The MBTI, one of the world's most widely used personality assessment tools, is used to illustrate predictable differences in the way people prefer to use their minds to attend to the world, take in information, and make decisions.[23] People with a preference for intuition are described as being tuned to the full deeper meaning rather than the particular aspects of a situation. As a result, they often express themselves in terms of a situation's future potential, projecting from the immediate situation to its long-term implications.[24] Insights developed through the use of the MBTI will be discussed in more depth in chapter 7.

Developing intuition as an EQ skill strengthens confidence so leaders can handle incomplete information, ambiguous situations, and longer time horizons. Learning how to trust and use intuition makes it easier to create a context for others to give their best. Intuition helps leaders read other people and

develop trust relationships more quickly. Intuitive decision making helps creative breakthroughs, opens up more authentic interpersonal communication, develops better working relationships, reduces problem-solving time, and promotes innovation. Based on what the leaders described in my research interviews, intuition cuts through to answers more easily and effortlessly than relying strictly on rational problem solving. Over 70 percent of the museum directors interviewed described intuition and a sense of interconnectedness as critical parts of their decision-making experience. For example, the director of the Phillips Collection in Washington, D.C., stated: "All parts of the whole are related—you can't tug on one thread without an impact on the whole fabric."[25] The director for the Museum of Contemporary Art in Sydney described his role as "always balancing differing priorities, what is realizable, and realizing that absolutely everything is interrelated or interconnected."[26] The director of the Queensland Art Gallery in Brisbane said, "The uncertainty and ambiguity with a project this large [a Matisse exhibition] means developing and handling opposing points of view around timelines and logistics, maintaining high standards, and realizing that everything is interconnected."[27]

## INTUITION, CREATIVITY, AND NEW CONTEXTS

As leaders assume more complex roles in organizations with higher risk levels, the more they draw on intuition rather than concrete experience to make decisions.[28] Research conducted at the University of Iowa College of Medicine with non-brain-damaged and brain-damaged people with normal intelligence and memory found that normal decision making requires two parallel but interacting chains of events. One involves activating a brain circuit that includes the ventromedial frontal cortices, which store knowledge about a person's emotional experiences called intuition. In non-brain-damaged people, the ventromedial frontal cortices send signals to other parts of the brain that recall the overall facts of a situation, including various options and possible outcomes, and then use unconscious knowledge or intuition to make the right decision. Research conducted through the University of Chicago on creativity and invention with ninety-one respondents concluded that intuition is a vital part of the creative process.[29] A research study on eighty-two of ninety-three Nobel Prize winners over a sixteen-year period confirmed that intuition plays an important role in creative and scientific discoveries.[30] According to researchers, higher reasoning requires emotion and intuition, not just sequential

analysis and technical rationality.[31] The most creative solutions to leadership challenges come when feeling is not separated from the intellect:

> A state when intuition is highly developed [and] you don't have to work to turn it on, it stays on. It flows. It becomes part of the way your heart and senses relate to every experience and circumstance.[32]

Once this happens, directors in my research described leadership decisions as predictable miracles and a form of luck with a different kind of energy than normal opportunities. The director of the Cleveland Museum of Art suggested: "Keeping all options open until the very last minute—as it is at that point that luck so often slips in—[decision making is] a progression of continuous, interlocking elements with an open-ended quality where the decisions get researched, but I am a gut player. I use intuition and the success rate is good."[33] The director of the Dennos Museum Center in Traverse described a special difference between opportunities the director created and ones that arrived unexpectedly at just the right time:

> When we were planning the Center's fifth anniversary celebration, an offer came unexpectedly from a private collector for an exhibition, which was a very exciting proposal. Most of the time, the director's role is one of having to go out and hunt or catch opportunities or particular exhibitions. When we were planning the celebration, this opportunity [unexpectedly] came to us. This has happened before. What seems like lucking out has a different energy level over other kinds of planned programs. The energy of lucking out just has to be responded to—to go with this wonderful flow of opportunity.[34]

Several directors described the complexity of their roles and mentioned using their intuition to balance different demands in unpredictable and highly ambiguous situations. For example, the director of the Museum of Contemporary Art in Chicago confirmed that "the world is one with few compass points—it is about managing ambiguity and uncertainty."[35] The director of the National Gallery of Victoria in Melbourne implied that balancing different demands in an ambiguous environment involves an "uncertainty which has to be allowed to exist—the director is only effective if they have a constructive relationship with uncertainty and can use it as a tool."[36] The director of the Museum of Contemporary Art in Sydney was at ease with uncertainty,

trusted intuition, and made decisions based on a keen sense that everything is interconnected:

> My role as director or leader is about knowing when to act, how long to wait to gather information, when to procrastinate, how to hold your hand, and how to make decisions instantly. I have a great comfort with uncertainty. Intuition has been discredited as a feminine quality but I intuit the answers in uncertainty, gather the evidence, remain open to all messages coming, and then act! I deal with any treacherous uncertainty by working conservatively in those territories. A linear process can not be applied to a museum. A museum as an organization is not about sequential processes. There is no single goal for a museum. In my view, it has three balance sheets: financial, human, and artistic or intellectual. As a leader, I have to move from one to another so there is no single goal or criteria.[37]

The director of the J. Paul Getty Museum also described decision making as a process of balancing the intellect with intuition. He created an overall picture of the problem in a logical way then used an intuitive approach to manage his way through:

> I try to stand back, to see the context, to evaluate how big the problem is, the timing, and the possible consequences. This means I span the broad spectrum and if I have a stake in the solution, then I get involved. My second approach is more intuitive. I don't have the patience for any other way. I leave that to my associate directors so I can "transcend the task" . . . with intuition. It is a sense of an overall picture that attracts me . . . to form an understanding of a problem, its connections, and the ramifications.[38]

The leader of the Minneapolis Institute of Arts described the complexity of the director's job and decision making as an ongoing challenge. A particular challenge was positioning the museum in the community while balancing financial, political, and organizational change over five- to ten-year cycles:

> It is tough to keep it all balanced and in a positive movement toward the mission or goal with the vagaries of personalities, financial, and contemporary history. Each director's task is one card in this big deck, like gin rummy. An art museum director holds 104 cards in the hand daily. Problems have to be web mastered to a central matrix to keep moving forward and on track. You have to be good and work like a devil. It requires intuition. I am often too much of an

intellectual, which means I have to get back in touch with my male and female intuition.[39]

The director of the National Gallery of Canada described the balancing act as a "process called equilibrium in a volatile situation" that requires "risk taking, intuition, knowledge of what's there and what isn't. It is about having a mandate that involves artists and discovery and knowing you can't run a control office on intuition, but that's a large part of how it works."[40] The director of the Fine Arts Museums of San Francisco shared this view, describing leadership decision making as "establishing new relationships between unrelated material, bringing creativity to the role and sensing connections that others don't—I have a highly intuitive response to problems."[41]

## CREATING COLLABORATIVE TEAMS

Learning to use EQ skills like trust, intuition, and creativity for decision making depends on a deeper understanding of essential universal truths so leadership becomes a process of serving others to collectively shape the future. Jaworski called this *servant leadership*, serving with compassion and heart, recognizing that the only true authority for this new era is that which enriches participants and empowers rather than diminishes them.[42] The director of the Harvard University Art Museums supported this view and suggested that leaders "resist the temptation of giving in to pressures and at the same time, giving in to developing the staff by creating and allowing the institution to grow. This means leaders sublimate their own personal desires for the museum in favor of surrendering to the importance of enriching the institution."[43] The director of the Tate Gallery described servant leadership as *collective destiny* by defining the horizons of work so "people lift their eyes from the present toward a larger future."[44] The head of the Tate Gallery's department of communications described the director's approach as one that empowered and encouraged staff to "pick up their own strand to create their department's contribution to the whole."[45] Creating a collaborative context is the leader's job, according to the director of the MoCA in Los Angeles:

I solve problems as a director with greater people than myself. I talk to curators, administration, the development manager, and installation people. I ask these

people what they can contribute to the show. The more people are involved, the more respect they develop for the roles played. It's about creating a context.[46]

According to the museum directors, creating a more collaborative context has challenged the traditional way staff work (appendix 2, table 25). The leader's job as change manager has involved preparing and coaching staff to help create a new context where everyone can give their best. Museum directors predicted that seven particular staff groups will be directly involved in shaping the new context: curatorial services, business development, financial and corporate services, marketing and public relations, public programs, exhibition planning, and human resources. Directors predicted that curators would shift focus toward customer needs, theme-based exhibitions, and exhibitions that reflect racial diversity. They also predicted that curatorial functions would include more administrative tasks. This could diminish the curators' traditional authority, placing less emphasis on scholarship and increasing emphasis on aligning passion with customer interests. Throughout my research, directors described the difficulty curators were experiencing as they tried to change focus from scholarship and objects to customer needs. The director of the AGNSW intimated that, out of all the museum staff, curators were having the most difficulties adapting to changed contexts in the entrepreneurial museum:

> I work with a minimum of preconceptions because things keep changing. Part of my role as director is defining the horizons of the work for curators by pegging boundaries. For example, curators initially blocked the idea for evening lectures with a panel of interesting people to talk about architecture, design, and other things. They kept asking about "fit." I don't want fit! I want an anti-prescriptive idea. The Gallery should be a place or venue for people to have thoughts, unrestricted thoughts. Curators are too set in their ways. I think we should try to see the institution as a place rather than a museum.[47]

Directors predicted changes for business development managers that included an increasing focus on business alliances and business acumen to broaden support for the museum. Changes for finance managers included pressure to increase efficiency with access to financial information through more reliable management information systems. This meant consolidating their roles as financial managers with systems to support decision making.

Predictions for human resource management included increased profession-
alism and the launching of new initiatives such as performance assessment,
career development, stress management, updated job descriptions, workplace
diversity strategies, provision for professional training, and increased use of
volunteers because of cutbacks in museum staffing.

Predicted change for education and public program staff included an ongo-
ing push to attract more audiences and increase access to the museum. The di-
rectors noted an increasing need to reflect audience diversity and to create more
ways to generate revenue so the department could pay for itself. One important
shift was the prediction that public program departments would finally be in-
cluded in long-term planning strategies. Predicted changes for exhibition plan-
ning departments also involved inclusion in long-term planning strategies. The
directors again emphasized the importance of planning exhibitions in accor-
dance with popular demand to attract new and larger audiences.

In my experience, staff and volunteers for education and public program
services are an undervalued asset in many museums. In the past, public pro-
gram departments were positioned as a support to curators or the marketing
department rather than as an independent department creating innovative
ways to increase audience access. Public program departments create the ex-
periences and stories that engage audience attention. They are the translators
for artspeak, as one anonymous museum educator described it. Yet the direc-
tor for the Yale Center for British Art described education departments in
many museums as being the lowest position in the food chain:

> Curators are anxious about not letting standards slip, but the highest level of
> discourse has to be translation to an audience who are not art historians! So, the
> director has to find ways for the education department to translate that does not
> demean either the audience or the museum. As an adjunct to this, docents or
> volunteer guides are usually there to bridge the gap but they are not art histori-
> ans either. Docents need particularly good training. And the museum needs to
> keep their morale up. Despite the fact they do not bring in money, they are an
> important function to the museum. Difficulties with docents are usually based
> on fears that are based on ignorance. Docents tend to complain they are not be-
> ing told things. This is where we need a good museum education department
> that communicates within and ultimately, out, to the various audiences through
> the docents.[48]

These are important points to remember as museums continue to shape contexts that are more collaborative. Most of a museum's stories are created and delivered to the public through public program departments and volunteer guides, yet public program departments and volunteer staff are continually undervalued.[49] The associate director for education at the Met suggested part of the problem involves EQ skills like trust and interpersonal connection. The Met has an outstanding international standing as an educational institution based on sheer size and the number of staff with PhDs. Even with this status, the museum's education department was still struggling to defend the value of public programs because of trust issues between educators and trustees, the director, and curators:

> Great museums are driven by visions. Unfortunately, there is discontinuity between education and curatorship and this polarizes the professional groups. This adversarial environment is not good. Professional dynamics are about human relations, not professional ghettos. I don't contribute to the constraints between education and curators. My job is to provide the framework or language to talk about abstracts. Our problem is knowing how to contribute to the museum's future. My most fundamental challenge as an associate director is the role of education to the museum and its institutional behavior. The trustees and director define education one way. The vision of the museum is one where they see outcomes instantly and never the reality that outcomes are a process of dynamic evolution.[50]

Predicted changes for marketing departments included tuning into specific user groups, continued growth in function and effectiveness, increased visibility, and increased focus on sponsorship management (appendix 2, table 25). The director of the Fine Arts Museums of San Francisco described the marketing department as one of his most important tools to link audience needs with museum programming:

> I learned about the market and audiences through marketing functions over the last few years. Who the audience is, what they like and dislike, their religious backgrounds, income, and spending preferences. Our programs cater for or rest on this information. The director has to work with the relationship between the market and the audiences. I specifically bring in marketing research expertise to this museum for each exhibition. That way we can tell or predict who will come,

from what city, and what suburbs. We even pretest exhibition titles to look at what will attract people. I use staff to collect this information and a consultant to analyze and present the data in a meaningful way.[51]

Marketing is how an organization plans for and responds to changing audience and visitor needs. Marketing trends predicted by the museum directors included increased focus on customer service, increased tourism from overseas and interstate visitors, and increased need to target direct marketing programs (appendix 2, table 31). Other marketing trends included changes in the composition of visitor groups, such as an increase in young visitors and knowledge-based visitors, and changes in the way museums communicate with stakeholders. Although most of the directors deferred to their marketing departments, the director for the National Gallery of Canada saw marketing as an integral part of her role. She stressed that directors for the 21st-century museum must be capable of reading and planning around marketing trends to position the museum appropriately:

My work is about selling and marketing in the "cultural field." The cultural field is about creating, producing, and selling ideas. If we or I am not doing this, then it is the sterile life of the bureaucrat! You have to know what to produce to sell to other museums, the finances required, the cost of exhibits, and the return on the investment. This is a highly volatile field of work that attracts obsessive people who care about detail. This has to be managed with the museum's mission to push and defend and protect the institution. We want to expand areas like education to meet the predicted needs of our market. Visual arts are more difficult than other areas of the arts because there is no live human being there like with dance or symphony for the audience. It requires thought, internationalism, experience, and a focus on the contemporary. We have a major task to educate on the visual arts. We have to ask how to do this in parallel with public schools without getting trapped as an alternative education institution.[52]

The director's change management challenge? Coaching staff on the balance between the traditional focus on curatorial services and what one museum observer called "edutainment." This balance, according to researchers such as Gilmore and Rentschler, shifts the museum director's purpose from custodial services to visitor services with increasingly sophisticated marketing strategies.[53] This shift in purpose creates tension between traditional ways of

running museums and the need for good marketing to ensure the museum's success. One reporter outlined a range of controversies and ethical challenges associated with the shift in purpose toward marketing and concluded that new ways to attract benefactors would inevitably mean some concessions to commercialism.[54]

## PARTICIPATIVE LEADERSHIP AND CHANGE MANAGEMENT

Many clues in the interviews and sample survey data suggested that new leadership styles and stories are being used to help shape and shift changes in context. For example, stories reflected the benefit of working in cross-functional teams and the benefit of a more participative leadership style. Changing contexts provided more staff—exhibition planners, marketing managers, finance directors, and public education—with a voice in decision making, alongside the director and curators. The director for the National Gallery of Victoria said that the most interesting part of his job relied on creative input from reconfigured top teams:

> For example, gaps in the collection can be filled with something new, services can be improved, and scheduling can contain any number of exhibition themes. I use forums to draw out others' thoughts and experiences. The forums are management meetings that include myself, the general manager [administration, personnel, building maintenance], and the two deputy directors. Curatorial meetings, public access meetings, and debriefings after trustee meetings are also held as a way of including people in the decision making.[55]

The use of forums to draw out others' thoughts is another way to describe making provision for others.[56] The director of the Cleveland Museum of Art described making provision as a delicate balancing act, creating a playing field and retaining control:

> I have to get people who can do tasks. Delegating then is not a loss but a gain. For example, when I was directing in Baltimore, the budgets finally balanced after years of deficit and I was very involved in the process. Here in Cleveland, the director for Treasury and Finance runs the budget without me involved. Maturity has bred trust. Directors are often control freaks. Restructuring the task means allowing someone else to define the playing field but retaining control of the situation. For example, curators who can't and won't work together. As a director, I

have a choice—confront the issue? No. The problems with curators are all emotional-based impulses and reason will not help. I have to restructure the interactions to see the problem in another way so we can move it away from the emotion. For example, cases where there have been inappropriate divisions of labor. It is important for a director to not let circumstances define the arena.[57]

Managing the tension in cross-functional teams is not easy, according to the director of the Tate Gallery. He described a vision for the Tate that valued and encouraged equal participation from all staff groups in a move away from what he called scholar kings:

> The Tate is not like the British Museum or the Metropolitan [in New York] with ten fiefdoms or museums within a museum. We have changed toward a whole organization with constituent parts, and this caused problems. The museum world is dominated by cultural scholars and others are seen as servants to these scholars. We need to recognize that there are other forms of experts to run an organization and they are equally as valuable as the curator scholar. For example, communication and development are not set up as service departments but as valuable research units. At the Tate, there are no scholar kings.[58]

A whole organization with constituent parts and teams with equal value membership is a shift in the traditional museum context. This creates a whole new organizational culture. No wonder curators were having a difficult time adjusting to the change. They were learning how to share leadership with other equally valuable domains of expertise such as public education, marketing, and corporate services. Directors in my sample survey indicated that despite a philosophical shift to shared leadership, they still looked to the curators first when making decisions. They then sought input from the board of trustees and the financial systems manager (appendix 2, table 26).

Adapting to changes in context includes learning how to encourage participative decision making, how to value new skills in cross-functional teams, and how to reposition the museum using longer time horizons. The leader's job for a Level 4 or 5 organization focuses on translating long time horizons into missions and tasks that staff can actually achieve. The director of the Yale Center for British Art suggested that "defining the themes or horizons for the museum defines the museums character, articulated by the director in such a way that people feel caught up in a larger drama."[59] The way directors

articulate the larger drama has built-in challenges. They must find leadership stories to link different levels of complexity with differing allegiances into more collaborative enterprises.[60]

As leaders, museum directors use the museum's context as a platform for storytelling. Keeping the platform intact while scripting new stories is a huge challenge. The associate director for education at the Met said: "We live and believe our own myth that we are the best, so the Metropolitan has to be careful not to be complacent, fixed, or inward looking."[61] Barriers that traditionally existed between curatorial staff and education are being dissolved. Directors have created more holistic organizations as a response to accelerating change. Holding down the fort while changing it at the same time prompted the director of the Museum of Contemporary Art in Chicago to say: "It is like repairing a water tunnel without turning off the water."[62] The director of the Tate Gallery described shaping new stories to reflect new contexts as the most demanding part of his job:

> One of my most complex challenges is to find ways to break down practices for cross-department structuring, not within department structures. It is more complex than a team approach. I envisage one department seconded to a project and the loyalties will have to be divided. I am trying to free people up to move beyond the *my department* attitude.[63]

Understanding the phase or cycle of change an organization is experiencing can help directors create more coherent leadership stories. Different phases of change require different leadership styles and different stories to guide the organization as it adapts to change.[64] In theory, the choice of leadership style depends on how fast the organization needs to change, how positively staff perceive change, and how capable the leaders are in adapting their style.[65] Museum leaders were asked in my survey to choose one of four different leadership styles to describe their current approach. The majority chose the participative style, which is associated with a growth phase or a new acquisition in an organization (appendix 2, table 4).

- **Participative:** The leaders are seen as visionary strategic thinkers and financial planners. They balance priorities for stability with growth. They use team-building skills, organizational skills, crisis management skills, and

people management skills. They are moderate risk takers with a development orientation and have high energy levels.

- **Charismatic:** The leaders are seen as visionary strategic thinkers with a hands-on, take charge approach. They have in-depth technical know-how and analytical, organizational, and negotiation skills. They have a breadth of knowledge about all functions of the organization including human resources. They are charismatic communicators and risk takers.
- **Directive:** The leaders know the business. They have administrative skills and are systematic thinkers who find problems and solve them. Efficiency rather than growth is the main orientation. They set high standards and use a tell-and-sell approach to minimize risk.
- **Coercive:** The leaders instruct, persuade, and have good political skills. They are risk takers, tough-minded, and determined, with strong analytical skills and a cost/benefit orientation. They need respect, not affection. They are paternalistic people managers.

When museum directors were asked to describe which of six possible phases in an organization's life cycle described their museums (appendix 2, table 5), the majority chose the growth phase or new acquisition phase.

- **Start-up:** Creating a vision for the organization. Establishing core technical and marketing expertise. Building the museum team.
- **Turnaround:** Rapid and accurate problem diagnosis. Fixing short-term and ultimately long-term problems.
- **Existing business:** Efficiency. Stability. Succession planning. Sensing signs of change. Making the most of what is profitable for the museum.
- **Growth:** Increasing audience reach. Managing rapid change. Building long-term health based on a vision for the future.
- **Liquidation/divesting:** Cutting losses. Making tough decisions. Making the best arrangements possible for a poorly performing organization.
- **New acquisition:** Adding a new outlet/activity to the organization. Integrating the new with the old. Establishing sources of information and control.

Organizations in a growth or acquisition phase where the perception of change is positive benefit from a *participative* leadership style. When the

perception of change is negative, a more *directive* style is required. A directive style is also required when an organization is rationalizing and maintaining an existing business. A directive style emphasizes business skills, systems thinking, and risk minimization. Changes that are large, are fast, and involve paradigm shifts like inventing an entrepreneurial museum can require *charismatic* leadership. A charismatic style emphasizes technical knowledge and negotiation skills and is associated with start-up and turnaround phases. If fast-paced change is viewed negatively, a more *coercive* style is recommended. A coercive style is required in organizations experiencing mergers; the tough-minded approach keeps old and new business moving along.

Research on teams and decision making describes beneficial outcomes for leaders who use a participative style of leadership—increased commitment to the ideas leaders may use to guide change.[66] Participative leaders are capable of balancing priorities for stability with growth using effective team-building, organizational, and crisis management skills. A participative leadership style involves moderate risk taking, people management skills, and a development orientation. It also requires resilience or high energy, which was a bottom line described in previous chapters.

Creating coherence between an entrepreneurial vision for the museum and the context to achieve that vision requires adaptability. Adaptability means a willingness to embrace the excitement of the unknown and a positive attitude toward change.[67] When organizations need to move quickly, leaders must quickly adapt their leadership styles and stories to suit changing contexts. The director of the Victoria and Albert Museum describes it thus:

> My first action on a problem is to create an overall picture. I then fit the problem into the general context or vision for the museum as the first filter for each problem. When I first got here, the previous director had a democratic system of committees for all of the museum's activities. I abolished the committees as no decisions were actually being made through the committee process. It's better for the director to have a major role in decisions with more immediate conclusions so the museum can move on with its business.[68]

Moving on with the business means creating a context that integrates the new with the old. The director for the Tate Gallery managed to integrate the old Tate with an extension branch in southern England called the Tate Gallery, St. Ives, along with managing the design and opening of the Tate's new contemporary

museum in London. The St. Ives branch required shared leadership roles between the director in London and the administrator in St. Ives. The director described how previous change management experience laid the foundation for current changes:

> I took on the Whitechapel Gallery at a point in time when it was under severe threat of closure due to a lack of leadership and funding problems. At the same time, Whitechapel was perceived to have a unique part to play in the art world. I worked with the Gallery for twelve years. These years are quite clearly delineated as I had three distinctly different jobs or leadership roles to play. The first three years were devoted to stopping the Gallery from actually disappearing. For example, putting a roof on the place. The next four years were devoted to showing the Gallery what needed to be done and getting the refurbishment. The last three years there were focused intently on proving what we did could indeed work and that we had actually survived.[69]

Other directors described the benefit of previous change management experience as they adapted stories and styles for the 21st century. The director of the National Gallery of Australia said that over "the last five years, the Gallery has been moving from a growth mode to a new phase where we have no experience to draw on to deal with the trauma of cutbacks, so we had to focus on strategies like multi-skilling."[70] The director of the Isabella Stewart Gardner Museum was specifically recruited to lead a turnaround phase for the museum after a series of financial setbacks. The director devised a long-range plan and worked with the trustees to create a development and business office for capital campaigns and extended the programming division to include new scholarly, public, and music programs:

> The Gardner's [new] benchmark for success was excellence in programs that appealed to the public. We established programs that were totally unique such as a symphony composed or based on the history of art and architecture in 16th-century Spain. My vision was for excellence in imagination as a niche player in the market. One of the constraints identified at the Gardner was the closed collection. It could not be changed. We took that constraint and turned it into an advantage.[71]

## GENDER DIFFERENCES AND THE INFLUENCE ON CONTEXT

Gender influences the way leaders create a context where others can give their best. Although it is rare to find a female museum director, there were a few in

CONTEXT: CREATING A PLACE

my research. They used a particular approach that embodied EQ skills, building strong interpersonal relationships with compassion to support their own and others' resilience.[72] According to Weil, a respected museologist with the Smithsonian Institution, gender differences influence leadership roles: "Male directors see boards of trustees as father roles which may evoke defensiveness, competition, and a tendency to rebel."[73] Women have less antagonistic relationships with boards of trustees because they invest more energy in developing relationships, according to the director of the Philadelphia Museum of Art:

> Women and men are different. Women and men are also very diverse so it is hard to generalize about any of this. My experience has been that women bring consensus to their management style. They work things out with diplomacy and arrive at agreements easier than men. My gender has been useful in that the museum is part of the larger community with an increasing number of relations that have to be built and maintained. Women represent over 50 percent of the population and that reality needs to be reflected in our organizations. In the end, effective museum management reflects how an organization and a community work together, rather than how one woman works.[74]

Over the last two decades, it became politically correct to ignore gender differences in the name of equal opportunity. The invention of the androgynous manager was an early attempt to reduce gender differences by blending feminine and masculine traits in leadership roles.[75] But by the mid-1990s, feminine traits like people skills resurfaced as success factors in 21st-century organizations.[76] The feminine focus on team building and consensus decision making was referred to as a desirable leadership skill.[77] Investigations into innate gender characteristics concluded that we need to appreciate differences for what they are rather than attempt to blend them artificially.[78] Linguistic researchers and popular gender psychologists celebrated the differences with strategies to build bridges between two worldviews.[79]

In my research, the skills women develop through traditional social and parenting roles enhance their success as creators of context. As one director pointed out, women usually come from situations where they are responsible for child rearing, home management, and career management all at the same time. Managing several levels at once requires adaptability, flexibility, and self-discipline, which are leadership characteristics in any organizational context. Despite social and policy changes over the last forty years designed to value

gender in the workplace, there are still traditions that support and favor males. The director of the National Gallery of Canada suggested that men are still flattered and spoiled by women, which means they don't do the same amount of work that women do. This director believes: "Women are more flexible, better organizers, can show their emotions, are less hierarchical, and are more pragmatic, seeing problems right away."[80] The director of the Art Gallery of Western Australia supported the importance of a feminine communication strategy:

> Women tend to be more consultative, supportive, and collaborative. They use affirming skills and these are the skills an organization actually needs to conquer on behalf of the museum. I couldn't live with myself if I used the old dictator style of management.[81]

The director for the National Museum of African Art in Washington, D.C., suggested that a feminine approach to creating context has its strengths and weaknesses:

> Male directors seem to be or feel the need to be more decisive. They seem to feel compelled or pushed to make quick decisions and to stick to them. I see women directors more in the process of considering or comparing the merits of options, which seems to be interpreted as weak by others. But the museum is full of interpersonal complexities and one has to ask if, as director, it is more effective to tackle things head on or to be less direct.[82]

Specific legislation supporting workplace diversity and affirmative action has been in place in Australia, Canada, the United States, and England since the 1980s. Nevertheless, gender fences still exist in all organizations. Gender issues led one U.S.-based consultant to comment that creating a context based on equality starts first by breaking down the "permanent women's ghettos [in nonprofit organizations] where women do the socials and men do the money management for the organization."[83] The director of the Isabella Stewart Gardner Museum suggested that part of the problem involves the way women continue to care for others and feel less entitled to leadership roles:

> Lack of entitlement to a management role often gets acted out in doing the detail and the dirty work. These are not useful habits. On the positive side, women

in CEO and leadership roles are more teamwork oriented, less focused on hierarchies, and much more collaborative. They are more willing to share information and resources.[84]

Women aspiring to leadership roles are wary and weary of gender fences and the frustrations they create. In 1992, the United Kingdom conducted a national survey of museums to plan training and development for the next decade.[85] Survey responses came from 914 museums and revealed a startling gender pattern. Women made up more than 50 percent of the workforce but there were *no* female museum directors. There were few women in senior curator roles, and few female arts writers. As a benchmark for change, the study can be used by museums to conduct update studies tracking change, gender issues, and context. The director for the Please Touch Museum suggested that as she matured, some of the frustration with gender issues eased but challenges were ongoing:

> Society has a very strong ability to shut women down in very successful ways. Women are losing ground in the corporate world as they burn out and leave. We really need to do something about this now. Men don't know how to deal with women in management. As I have matured, it has become easier. I intimidate the board now as I'm old enough to be most of the board members' mother and they just won't take me on anymore! For some reason, women have trouble being taken seriously in the business community. People think they can walk all over you.[86]

A recruitment specialist for boards of trustees in Australia suggested that creating a context that supports women in leadership roles may involve testing assumptions and appreciating gender differences.[87] In the past, fewer women were trained in hard sciences like engineering and economics. Although some were trained in law and accountancy, there was an assumption that hard science training contained core professional subjects more useful in leadership roles. Professional development in any domain of expertise involves a similar process of problem solving and knowledge management. This insight combined with the new focus on EQ skills means old criteria must give way to an appreciation of what women have to offer.

The assumption that women have a right to leadership roles must be balanced with the fact that one doesn't earn the right to be a director (or a trustee) without proving oneself. It is tempting to coach women with old

strategies such as gain more experience on boards, read and understand balance sheets, and cultivate more exposure to the business world. This is practical coaching advice. But an Australian report in 2002 indicated that although more women were completing courses at the Institute of Company Directors, over 70 percent of board appointments were still using the old "who do we know" game, with men still winning more appointments.[88] This was the same outcome reported in 1997, with just fewer than 70 percent of board appointments made through networking or personal recommendations within the corporate world.[89]

In 2001, the International Labour Organization issued a report on glass ceilings in organizations and the barriers women continue to face on the journey to senior management roles.[90] When women hit the glass ceiling, they tend to quit and go into their own businesses, which is a great loss to an organization's potential talent pool. Women have not been comfortable with contexts designed on traditional gender-based rules and rigid hierarchies. Shaping a context in which others can give their best in the entrepreneurial museum relies on EQ skills to facilitate collaboration, teamwork, consultative decision making, open communication, mentoring, and interpersonal connection. Women possess wonderful skills in communication, networking, and caring. These skills need to be appreciated.

### INTEGRATING CHANGE AND THE CREATING CONTEXT ROLE

Changes in the museum context suggest that, organizationally, larger museums have shifted into a more complex level of work based on the levels of complexity model. This shift challenges leaders to reassess how they create a context for others to give their best. Additional levels of complexity mean leaders are making decisions with longer time horizons, trusting and using EQ skills like intuition. Directors described and predicted how old work practices gave way to a more participative leadership style with cross-functional teams. A growth phase for many museums means directors are adapting leadership styles and stories to guide changes in context.

Many of the changes in context have not been easy for staff, especially curators. Curators shifted roles as indirect leaders of highly specialized scholarly domains to direct leaders for cross-functional teams in high growth organizations with a customer delivery focus. Difficulties with the shift provided a significant clue for the diminishing pool of potential leadership candidates.

According to Gardner, the shift from indirect to direct leadership involves a choice and costs: "It is almost impossible to meet the quickly changing needs and demands of a specialized domain on the one hand, and the far less rigorous, though often equally fickle, demands of a heterogeneous unschooled audience on the other. In the end, leaders must cast their primary lot either with a domain or with a wider society.[91]

Leaders who cast their lot with the entrepreneurial museum learned how to identify the museum's phase of change and how to adapt leadership styles to match. Some leaders have been accused of commercializing their museums by embracing the MBA marketing approach, but managing tension and paradox distinguishes a skillful change manager. The director of the Museum of Contemporary Art in Chicago described implications for the next two generations:

> I am the first generation of directors with a business background. The Museum Management Institute was just the beginning. It has grown. I had done an executive development program at Columbia University that helped. There are very few colleagues who have art history and an MBA—it is rare. As a consequence, the director's role has often been split between art history director, financial director, and board of directors. Younger people will be entering the field with an MBA and there will be suspicion both ways. The business types focus only on money. Curators [art historians] only focus on the quality of work, not money. My role will be to manage this tension, as there won't be any bridges built either way.[92]

Creating a context where business acumen is respected along with a passionate commitment to the arts is a high-wire act. Directors described the need to balance emotions and intuition with the rational, logical aspects of leadership, using EQ skills to create organizational cultures that value cooperation, communication, collaboration, and teamwork.

## NOTES

1. Australian Broadcasting Corporation 2002.

2. Jaworski 1996: 182.

3. Anderson 1996 (I); Deal & Kennedy 1982; Galbraith 1982.

4. Barnes 2002 (I).

5. Jaques 1956, 1989; Jaques & Clement 1991; Jaques & Cason 1994; Stamp 1989, 1993.

6. Jaques & Clement 1991: 50–51.

7. Stamp 1989: 34.

8. McCaughy 1996 (I).

9. Stamp 1989: 35.

10. Parker 1995 (I).

11. Lowry 1996 (I).

12. Wood 1996 (I).

13. Capon 1995 (I).

14. Walsh 1995 (I).

15. Consey 1995 (I).

16. Orioli 1996: 15.

17. Parker 1995 (I).

18. Goleman 1996: 53.

19. Jaworski 1996: 9–14; Senge 1990.

20. Anderson 2000: 46–63.

21. Ayers 2002 (I).

22. Moffett 1996 (I).

23. Myers & Myers 1993.

24. Margerison & Lewis 1981; Isachsen 1992; Myers & Myers 1993.

25. Moffett 1996 (I).

26. Paroissein 1995 (I).

27. Hall 1995 (I).

28. Stamp 1993; Jaques & Clement 1991; Jaques & Cason 1994; Editor 1997: 10.

29. Csikszentmihalyi 1996: 413.

30. Cooper & Sawaf 1997: 41–62.

31. Pearce 1992; Goleman 1996; Cooper & Sawaf 1997; Fineman 1997; Suchy 1998a.

32. Cooper & Sawaf 1997: 209.

33. Bergman 1996 (I).

34. Jenneman 1996 (I).

35. Consey 1995 (I).

36. Potts 1995 (I).

37. Paroissein 1995 (I).

38. Walsh 1995 (I).

39. Maurer 1996 (I).

40. Thomson 1996 (I).

41. Parker 1995 (I).

42. Jaworski 1996: 60, 171, 175–77.

43. Cuno 1996 (I).

44. Serota 1996 (I).

45. Whitmore 1996 (I).

46. Koshalek 1996 (I).

47. Capon 1995 (I).

48. McCaughy 1996 (I).

49. Suchy 2001b: 25.

50. Lydecker 1996 (I).

51. Parker 1995 (I).

52. Thomson 1996 (I).

53. Gilmore & Rentschler 2002: 758.

54. Editor 2001.

55. Potts 1995 (I).

56. Stamp 1993: 26–30.

57. Bergman 1996 (I).

58. Serota 1996 (I).

59. McCaughy 1996 (I).

60. Gardner 1983: xxiv.

61. Lydecker 1996 (I).

62. Consey1995 (I).

63. Serota 1996 (I).

64. Burdett 1990; Devine 1990; Fraser 1990; Galagan 1990; Kraut & Pedigo 1989; Levenson 1988; Morgan 1988; Peters 1987; Schriesheim & Neider 1989; Suchy 2001c.

65. Gerstein & Reisman 1987 (a model on strategic selection of executives matched to business conditions, enhanced by Dunphy & Stace in 1990).

66. Carlopio, Andrewartha, & Armstrong 2001.

67. Reynolds 1992: 16–18.

68. Borg 1996 (I).

69. Serota 1996 (I).

70. Churcher 1995 (I).

71. Hawley 1996 (I).

72. Kolb 1996 (I).

73. Weil 1996 (I).

74. d'Harnoncourt 1996 (I).

75. Sargent 1981.

76. Karpin 1995: 10–14.

77. Aburdene & Naisbitt 1994: 338.

78. Durden-Smith & de Simone 1983.

79. Tannen 1990; Gray 1993.

80. Thomson 1996 (I).

81. Latos-Valier 1996 (I).

82. Fiske 1996 (I).

83. Barbeito 1995 (I).

84. Hawley 1996 (I).

85. David 1993.

86. Kolb 1996 (I).

87. Beech 1995 (I).

88. Bridge 2002 (C).

89. Potts 1997: 67.

90. Low 2002 (C).

91. Gardner 1995a: 294–95.

92. Consey 1995 (I).

# 4

# Entrepreneurism
## *Selling Integrity*

In chapter 1, we defined the third part of the leadership role as being a fund-raiser—*talking up* the organization 100 percent of the time. Leaders in my research and the EQ leadership program describe talking up as selling the integrity of the organization. To them, selling is not a commercial activity but an entrepreneurial practice. They look for opportunities aligned with an organization's mission or purpose that can be turned into profitable activities. We call this ethical entrepreneurism, inspired by the philosopher Peter Singer who suggested that society's narrow pursuit of self-interest is the norm and a shift to an ethical stance is a radical change.[1]

In this chapter, we will explore what happens when leaders use EQ skills such as creativity, trust, interpersonal connection, and constructive discontent to adapt to economic changes with an entrepreneurial approach to fundraising. Terms like *ethics, entrepreneurism, integrity,* and *social capital* will be used. Reference will also be made to the museum directors' survey results and predictions made in the 1990s, which once again can be used to benchmark change over time.

Some reviewers who sensed a contradiction in the combination of entrepreneurism, selling, and integrity thought the title of this chapter was misleading. They defined integrity as adherence to values, obligations, and trustworthiness. Selling meant delivering services for money and managing for profit, which did not fit the current perception of the museum's organizational culture. They questioned how anyone could actually *sell* integrity. Others were annoyed with the term *entrepreneur*—the museum was about much

more than making money. One critic took offence to the linkage between selling, integrity, and the museum sector. This person thought the corporate sector lacked integrity and wondered why the focus wasn't on that.[2]

Defensiveness and confusion over terms such as *entrepreneurism, selling,* and *integrity* in the museum sector call for the EQ skill constructive discontent. Some of the most creative and productive change comes from situations where people respectfully disagree with one another. Rather than seeking ways to create harmonious conclusions to avoid disagreements, I suggest we explore the entrepreneurial museum thoughtfully using constructive discontent. Readers are asked to remain true to their own positions. Take note of feelings and reactions—stay open to differing points of view offered in this chapter.

## MAINTAINING FLOW DURING ECONOMIC SHIFTS

How do leaders adapt and stay in flow with changing economic landscapes? Kevin Mulcahy at Louisiana State University suggested that every cultural institution has had to learn how to generate income and to appreciate that sponsorship is not philanthropy, it is advertising.[3] Opinions differ as to when the economic environment changed globally from continuous growth in public sector expenditure to continuous decline. The change had a major impact on museums and on universities, hospitals, and other social service organizations. Some observers suggested changes started happening in England before the 1980s, with museum directors coping with rapidly changing economic and political agendas. Other analysts said the 1980s marked a discernable global change for cultural institutions.[4] This was the decade when government grants became government contracts. Free market principles, user pay systems, and enterprise bargaining influenced the interface between government policy, public sector organizations, and private sector organizations in three of the countries in my research (the United States, the United Kingdom, and Australia).

When directors were interviewed, 1990 stood out as an international turning point, with cuts in government funding and a decline in corporate sponsorship. The turning point triggered competition for funding dollars and audiences. The main competitors were other museums and cultural entertainment like symphony, opera, theatre, and sport. Evidence suggests that complex economic patterns happened after the collapse of the stock market in 1987, with real financial pain felt by 1990. As a result, museum directors had

to become adept at talking up the museum, expanding audiences, and attracting committed stakeholders with bequests to ensure the museum's future financial viability. The situation was described as a constant fiscal nightmare by the director of the Phillips Collection, who had to raise U.S.$20 million for an endowment to ensure the museum's continuity.[5] The director of the Philadelphia Museum of Art described how the turning point resulted in corporate budget cuts, increased private donations, and the need to put more energy into relationship management to ensure the success of capital campaigns and fund-raising drives:

> We get great press for our programs both in the community, internationally, and in the broader arts community. Attendance is waning at performing arts so we need to increase interest in museums by creating a sense of greater access.[6]

The director of the Art Gallery of New South Wales in Sydney described the same critical changes but adamantly resisted being defined as a fund-raiser:

> Ten years ago, we didn't have to worry about money, the building and personnel but that's changed. We have to do things now! This means having to do extra things to absorb the extra responsibilities. I don't go out to raise money but to raise interest by *selling the integrity* of this museum. That is my real job, to sustain and satisfy interest in the gallery. My objective is to fulfill that role, not to raise money.[7]

Other directors described how changes in government policy created uncomfortable tensions. For example, the director of the Hirshhorn Museum and Sculpture Garden said, "The new Secretary for the Smithsonian wants fund-raising goals with 60 percent government and 40 percent private contribution. Unfortunately, this means more money coming from private funding results in less money approved from public funds."[8] The director of the National Gallery in the United States added, "There isn't a clear picture for what the Federal government will do with the budget. There is limited money, which means there is a limited role to play in areas like the national lending service to museums around the country."[9]

Directors who adapted to change during the economic upheavals managed by staying anchored in their passion. They developed new skills, activities, and financial strategies.[10] They grappled with funding cuts in unique and creative

ways. For example, back in 1996 the director of the Victoria and Albert Museum in London used the cuts as a catalyst to question perceptions and to overhaul approaches to revenue generation:

> I have had to work with a minimum of preconceptions based on the premise that the museum has to change due to funding constraints and audience differences. These changes have challenged the museum to look outside itself. In the national museum sector over the last ten years, funding has been on a pound for pound budget basis. In the last twelve months, there have been massive funding cuts: one million pounds down from the previous year and another million targeted for the next financial year. Thatcher forced cultural institutions to look at how an organization actually works which is not a bad idea. The approach, though, has damaged the fabric of the museum, its people, and the building. The stress of finding savings in running costs resulted in a quite ironic source of revenue generation—running a lottery for special projects! I find it odd that the public says we will accept having to run lotteries for the museums running costs. If the government and the community saw the Victoria and Albert as a serious national concern then the running costs and capital costs should be met from government revenue.[11]

Economic turbulence forced directors into relationship management roles with benefactors and corporations—learning how to do "the ask" for bequests and sponsorship contracts.[12] For example, some directors and museum society presidents learned how to negotiate as members of task groups to shape legislative tax reform so that giving to cultural institutions became easier.[13] If we reflect back on the levels of complexity model in chapter 3, shaping policy is one of the functions of a Level 4 organization. Increasing role complexity shifted leaders from a focus on traditional museum budget management to directing capital campaigns, audience development, tax law reform, sophisticated marketing analysis, and entrepreneurial projects.

## MAKING MONEY BY MAKING A DIFFERENCE

What is entrepreneurism? Entrepreneurism has been defined as "seizing an opportunity, taking a risk, and making a go of it financially."[14] The term *entrepreneurism* evolved out of the study of economics, markets, and resource management.[15] Like all organizations, the museum manages resources in a market environment, although the drivers may be slightly different. One

cultural analyst indicated: "Sixty percent of an economy is market driven and forty percent has noneconomic drivers—the museum is in the forty percent group."[16] The Global Entrepreneurship Monitor (GEM) described the primary opportunity in any entrepreneurial effort as an unmet demand for goods and services.[17] Sensing, assessing, and satisfying unmet needs in a financially successful way defines entrepreneurship. The entrepreneurial museum director combines capital (human, economic, intellectual, social, cultural, environmental) with creativity and confidence as a change manager. The core of entrepreneurism is an ability to think beyond organizational boundaries, seeing new combinations for business that become sources of financial success.[18]

Entrepreneurism is relevant for any kind of organization. For example, Dr. John Yu, the founding director for the Westmead Children's Hospital in Australia, used an entrepreneurial approach to manage the change from an old established site in the middle of Sydney to a new site in the western suburbs. His passion for children, healing, and the arts attracted health staff, the board of trustees, the government, artists, an arts curator, and other vital stakeholders to participate in creating a hospital based on arts in health for kids and their families. On the business side, the Westmead Children's Hospital is the only public hospital in Sydney with its own board of trustees, independence, and autonomy. Like museums, hospitals are usually directed by experts in a domain of expertise (medical) who are not trained in business. One anonymous staff member shared the secret of Yu's success—a combination of extraordinary people skills (EQ), entrepreneurism, and skillfully building a team to do what needed to be done. As a matter of interest, Yu's career path bridges health (hospital director), education (vice chancellor for Australian universities), and the arts (trustee on the board for the Art Gallery of New South Wales).

Leaders in flow with the business side of the entrepreneurial museum feel passionate for a specific reason. Entrepreneurism provides them with a way to express creativity with a purpose. They actually enjoy creating a business in the business of creativity. They are aware of the tension between entrepreneurism, ethics, and the marketplace. The directors were not being seduced by the broader economic assumption that individuals and organizations are motivated solely by money. Increased competition for audience dollars and the push for entrepreneurism had not resulted in a decline in standards of corporate governance reported in other industry sectors.[19] In my research interviews,

leaders described how important it was to balance competing demands without losing themselves in the process. This ability, I believe, illustrates another aspect of emotional intelligence. There is a link between EQ competencies such as trust, trustworthiness, and integrity that distinguishes successful directors in the long run.[20] They never doubted their integrity despite accusations of commercialized museums, compromised aesthetic missions, and attacks on what some perceived to be the detrimental effects of globalized cultural products.

Globalized cultural products are a spinoff from broader economic changes that are not everyone's idea of success. This became apparent in Dr. Richard Steckel's keynote address on the theme *The Arts: Serious Business* at the biennial conference for the Australian Institute of Arts Management in 2002. As an international consultant, Steckel has assisted hundreds of arts and public organizations with inspiring changes in their giving and corporate social investment programs.[21] Despite this success and a very generous spirit, Steckel was criticized by the audience for the export of American culture. As an advocate for arts in business, Steckel responded to the criticism by describing arts in business as a mind-set, encouraging managers to accept that culture is not at odds with business. He coaches art institutions, museums, and other nonprofit organizations to learn how to enjoy being value-driven enterprises with an eye on long-term economic sustainability. Cultural sector leaders were encouraged to use their institutions to express major points about our common humanity to further world peace. As the past director of a children's museum in the United States, Steckel demonstrates a contagious passion for entrepreneurism—make money while making a difference.

Making money while making a difference has integrity. The intention is clear. This was illustrated by the director of the Please Touch Museum, who described an entrepreneur as someone who takes risks to do something they like to do in a way that makes money:

> We take on projects without money, like negotiating with the airport for space and money or the family court project. These are prudent risks but entrepreneurial nevertheless. Nonprofit organizations need to look at risk taking as a strategy for how best to invest the resources on hand to do what needs to be done. This can be doing things as diverse as work with the homeless to shelters for abused women to publishing to just doing different exhibitions. In regards to the definition of entrepreneurism, all generalities are false, as all museums are

different. We take museum resources that are object-based learning and put them into a variety of arenas. Some make money for us and others don't. This museum is a home base for objects, but they are not irreplaceable objects like an art or history museum. History museums are buried in stuff problems. Kids' museums are not limited in scope like science museums or fraught with the "do not touch" syndrome like art museums.[22]

Museums *are* all different. They attract passionate, creative staff with diverse intentions that may not include entrepreneurism. The director of the Museum of Contemporary Art in Sydney described challenges in coaching staff to use their creativity in an entrepreneurial way:

> Some staff are absolutely gifted but they don't know how to be entrepreneurial. To me, entrepreneurial means to know how to invest time and money in anticipation of a return greater than the investment. Curators don't see themselves as entrepreneurial but they should at least be able to solicit gifts, to attract donors, to liaise with artists to get exhibitions up and running. This is entrepreneurial.[23]

Although many changes have happened since the 1990s and curators have come a long way on the change journey toward entrepreneurism, it has not been an easy shift, according to the director of the Museum of Contemporary Art in Chicago:

> I have been disappointed by the lack of entrepreneurship in curators. For example, their wish not to share projects. I had to show them the financial reasons for sharing as a necessity—cutbacks in staffing and resources. But to do this, I have to go in with a club to beat them into starting to think beyond this museum with each exhibition. If we are going to get an exhibition from Europe, sharing the costs by contacting other museums so the exhibition travels is an obvious strategy. The curators just don't think that way, unfortunately.[24]

In my research, directors for small, medium, and large museums predicted that the decade ahead (1995–2005) would see increasing amounts of time spent on fund-raising, financial management, and the ongoing push to be *more* entrepreneurial. The prediction was based on patterns highlighted in chapter 3—many museums were in start-up and growth phases. Start-up and growth without government funding demands an entrepreneurial strategy to

survive. This creates tension because there are two kinds of entrepreneurs. Some voluntarily pursue attractive business opportunities while others engage in entrepreneurship out of necessity. Engaging in business because it is creative and financially rewarding is different from being pushed to become entrepreneurial to survive. Various factors, cultural and psychological, influence how readily leaders adapt to changes such as entrepreneurism. For example, in 2002 the Global Entrepreneurship Monitor outlined a statistically higher rate of entrepreneurism in former British Empire countries (such as Australia, Canada, New Zealand, and South Africa) and in the United States than in Europe, Asia, and South America.[25] Although the *external* culture may support an entrepreneurial approach, an organization's *internal* culture may not. An executive recruitment consultant reflected this tension and suggested that museums need to adapt to the increased focus on customer service delivery and fee for service:

> In the [art] museum world, there are a lot of curators who are very special but they are not attached nor focused on delivery to a customer. Their focus is more artistic. There is a big cultural change required in the [art] museum. It is a move from custodianship with the public admitted, to community property based on the tax payer as a stakeholder and a user pays situation which is partially subsidized. The director and the trustees need to shift it [the museum] toward a global systems view. This combines academia, knowledge about the product, and a sophistication that invites customers so the museum pays for itself.[26]

## MAKING A DIFFERENCE WITH SOCIAL CAPITAL

Although many think the museum's collection is its key product, the museum's real business and its most valuable asset is the social capital it creates around the collection. In my experience, successful museums use their collections to create sites for social interaction and community development. While the entrepreneurial museum is dedicated to managing cultural capital in a market economy, it succeeds economically with the hard to define and measure bottom line called social capital. Economists invented the term *social capital*. I use the term as a change agent, focusing on the use of EQ skills such as trust, interpersonal connections, and compassion to build sustainable relationships for organizational, community, and international development.[27] A simple way to define social capital is the value we place on the networks and relationships we build around our organizations and ourselves.[28]

Economists suggest that economic exchange occurs *after* trust or social capital has been built. People don't exchange money or lend economic support until they have an opportunity to test over time whether an individual or an organization behaves in an honest, ethical, and dependable way. People develop trust first, then they may make economic commitments. According to the economist Frances Fukuyama, social capital results from trust in society starting with the family as our first social group, leading into cultural groups, and then the nation.[29] Social capital is created and shared through cultural mechanisms like religion, tradition, and historical habit. It is harder to create than other kinds of capital because it is based on ethical habits, which are often hard to change. Ethical habits are value systems that define what is right and wrong, ideal codes of conduct, practice, and standards. The diversity of ethical habits in our world reflects the diversity of cultural groups we create (ethnic, national, professional, and organizational).

If we describe the museum's key asset as social capital, then the leader's role as an entrepreneur selling integrity becomes one of using interpersonal connection, creativity, and trust to sustain relationships in and around the museum that pay off financially. The shift in purpose and focus from cultural capital (collection) to social capital (relationships) can be uncomfortable for museum staff passionate about the collection. This does not mean devaluing collection management; it means revaluing the social relationships that are built around the collection. For example, a past manager for the young members group at the Museum of Contemporary Art in Sydney was amused by the reason many new members gave for joining the museum—meeting a potential (romantic) partner.[30] Ironically, an anonymous museum director shared a similar reason for feeling a deep affection for the Tate Gallery in London: "It was such a great place to pick up girls." The social experience is the most important part of the museum's business. In one early study, approximately 90 percent of visitors to art museums admitted they did not understand the visual language of art museums or use any of the tours, courses, or publications designed for public education.[31] They came for social reasons. The associate director for education at the Met said the museum's social role is far more important than material objects:

> Culture equals stories, loves, human excellence, human creativity, discovering
> who you are as a person and [the museum's job is] educating a person who has

curiosity about all this with the means to satisfy that curiosity. In the U.S., there are five main centers where institutions have deep cultural roots. These are Boston, Detroit, Philadelphia, New York, and Chicago. If we look at the roots, we see that the museum performs a broad public service. There was not really even a focus on the collection until recently. The social emphasis was and is far more important than the actual collection.[32]

Social engagement plays a significant role in our health and well-being. Based on current research, the solution to many health problems lies not in better health care but in broader *social* engagement that includes the arts.[33] Beautiful objects, brilliant color, and exposure to live music in a pleasurable setting strengthens the human immune system. Feeding the heart with art strengthens emotional resilience. This key point was made at an international conference on arts in health and design held in Sydney in early 2003. Numerous studies were presented outlining statistically significant improvements in health through exposure to the arts. One three-year research study presented by London's Chelsea and Westminster Hospital gave a compelling argument for art and health with an added bonus for museums. People who enjoyed the hospital's art and music program started attending museums and live performances in their local community. They discovered museums located in the city's civic center with excellent dining facilities and enjoyable social activities that nurtured the heart and the mind. This same discovery was described by the director for the Phillips Collection, who recalled how useful museums had been to his family when he was a child on grand tours or walk-abouts in Europe and the United Kingdom:

> The museums became our focal point because they were in the middle of the cities. They were safe, open to all, free, and offered cheap food. We organized all of our tours in each city around the museum.[34]

The Australian Bureau of Statistics described museums as the most popular cultural venue visited by Australians traveling overseas (51.6 percent), and more than a third of the visits are to art museums (35.5 percent).[35] Museums are obvious places for people to orient themselves culturally and socially when traveling overseas. For example, in my work with expatriates, executives and their families relocating internationally are encouraged to use museums as a resource to adapt and manage cross-cultural change. The museum is a

ready-made social network for accompanying partners. For example, clients who relocated to London and New York reported using museums for cultural orientation, social activities, meeting places, and aesthetic enjoyment. The National Museum of Bangkok reported that 80 percent of their 250 members were actually expatriate families who play valuable roles as guides, translators, and fund-raisers for the museum.[36] What was the most compelling reason for museum membership? The social connection, followed by the opportunity to use professional skills in a foreign country where work permit restrictions did not allow paid employment.

Social capital may be what museum consultant Elaine Gurian had in mind when she called the museum a "savings bank for the soul." Based in the United States, Gurian sees museums as places of memory that keep us collectively together with an etiquette or ethic that fosters trust in a safe, social, welcoming place for people to go to for unsafe ideas.[37] If we build on the savings bank metaphor, the entrepreneurial museum is a unique investment opportunity. Stakeholders who make an investment in the museum enjoy an immediate *social* return on their dollar—access to special events, lectures, education programs, films, and food. Investors may also reap another unexpected earning on the investment. Contributing to a museum's social capital plays a role in social learning, according to Falk and Dierking, who suggested that visitors pay attention to what other visitors do in museums and that social interaction influences behavior and learning.[38] The importance of this sociocultural behavior in museums is virtually unknown and opens up a whole new perspective for audience research.

For many people, investing in the museum's social capital is motivated by the need to feel part of a local community that makes a difference to the world community. My investment activity fits this profile. On a local level, when my membership is renewed annually with the AGNSW in Sydney, I review what I get for what I give. Like any investor, I assess whether putting my hard-earned economic capital into membership provides a worthwhile return. For me, the investment in a safe site for meaningful play pays off. I feel involved with an organization that has immediate personal value aesthetically, socially, professionally, and academically. My investment in the AGNSW is sustained because the director keeps the storytelling platform alive, which is an important criterion for leadership.[39] The director, staff, and volunteers create compelling reasons with an emotional appeal that invites an investor to experience pleasure—and membership is renewed.

Investment in the International Council of Museums (ICOM) fulfills a need to feel part of the global community. ICOM membership is an investment in an international network committed to long-term cultural heritage management that includes movable and immovable, tangible and intangible, natural and cultural heritage. The importance of protecting intangible cultural heritage for humanity is an increasing concern for ICOM, one that underscores the value of social capital.[40] For example, a professor of museum studies at Zagreb University described the role museums play in the re-creation of social capital in places affected by conflict:

> They [museum professionals] cannot continue with their work as if nothing has happened [after conflict]. They need to acknowledge the new structure of the local community in which they are working and note the changes that have taken place. They will start to gather new material that will bear witness to the changes in the natural, social and cultural environment. Exhibition openings are, among other things, *social* events in which people are happy to take part. They are also forms of social communication. An exhibition can encourage talk about the similarities and differences of people's former and new communities. The exhibition space can thus become a focal point for gatherings and for the creation of a new identity.[41]

According to Ian McAuley, who lectures in public administration at the University of Canberra in Australia, social capital is the museum's most important asset. He suggested that people go to art museums for a particular reason. They are one of the last vestiges of beauty, other than nature, that is publicly owned. McAuley said the argument is more than pure ownership: "It's about people struggling for some way of affirming they are still stakeholders in society and the [art] museum like Nature offers an affirmation of collective ownership of objects, if not the experience of, beauty.[42]

## ATTRACTING STAKEHOLDERS IN SOCIAL CAPITAL

Debate continues on how leaders can act as ethical entrepreneurs to attract investors in social capital. Opinions vary depending on whether one is positioned in the museum or viewing the museum from the outside.[43] In my research, social capital is built by directors talking up the museum as a safe site for meaningful play in a community context. The public is the first and most important stakeholder, according to the directors' survey results (appendix 2,

table 18). They ranked the public at the top of the list of stakeholders followed by trustees and staff, government funding agencies, schools, members or friends, and special interest groups such as artists, historians, and scientists.

It was not clear whether directors included volunteers in the public or members/friends category. However, I want to highlight again the critical role volunteer staff play in the development of the museum's social capital. Based on Australian statistics released in 2000, volunteers make up over 50 percent of the labor force providing audience services in museums. Research recorded 2,049 museums in Australia with 6,956 staff on the books and 29,963 volunteers acting as guides and front-of-house staff.[44] The president of ICOM urged museums to place themselves in the heart of society and celebrate volunteer staff for working together in a spirit of creativity and innovation.[45] Volunteers and some other staff, such as security guards, are undervalued but vital creators of social capital through audience services, according to the director of the Art Gallery of Ontario (AGO) in Canada:

> I am aware that I need to communicate messages to different stakeholders in ways that they can hear, which is going to be different for a security guard compared to our development department manager. For example, the new head of project services protects art and the public. It is a new role and requires a new attitude. Approximately 90 percent of people's experience in The Art Gallery of Ontario are with the protection officers. We need to ensure those experiences will be felt as welcoming, reassuring, and human. To the extent that we can, every task is being restructured as part of a larger vision to increase audience service.[46]

Investors in social capital are also attracted by the role the museum plays in a world with an increasingly fractured sense of community. This can be a double-edged sword, according to the director of the AGO, who described how the search for authenticity and meaningful social activity pressures museums to be safe sites for sociability:

> Art museums are a growth area because they are becoming more virtual. People are feeling increasingly disconnected from authenticity. Shopping malls are centers for social activity over churches. Art museums are becoming centers of authenticity where people come to seek out the real thing. The museum is a *social* experience and a context where people are permitted to look at and be in the

presence of original works of art, which have been affirmed as great. The art is actually owned by the public in that 50 percent of our funding comes from the government. The same holds for the American art museums although their funding base is different. The MoMA in New York is the most private institution with the biggest public presence. The Getty will soon overtake the MoMA in this arena. Galleries in the U.S. *do* receive public money through corporate support and membership. There is still a sense of public ownership, it is quite strong.[47]

How does the entrepreneurial museum attract investors in social capital? Give people a good reason to invest. People invest when it looks like the museum is making money *and* making a difference. Ethical entrepreneurs create meaningful reasons for people to give. Selling integrity takes creativity, especially when stakeholders like the corporate sector and community may not see the museum as a relevant contributor to the market economy. For example, the director of the Arthur M. Sackler and the Freer Gallery of Art described what happened when areas of the Asian collection needed funds and companies would only fund certain parts of the world:

> One strategy to deal with this is [to] engage the private community in a process of building for the future based on their own personal cultural roots, through support for their culture expressed in the museum context. In Asia, objects are used daily for personal, power, and religious reasons. In India, for example, you see the objects in temples as part of a process of worship. If the audience has seen or experienced the object in use, then that object in a museum can then be understood in its cultural context. If we can reach and teach on this level, we may find more private community support for the museum.[48]

Reaching, teaching, and attracting investor support for the museum is a competitive process. According to the Australia Council, only 5 percent of corporate public benefit funding in 1996 went to the arts (including museums), compared with 33 percent for sport and 39 percent for community welfare.[49] Again, use these figures as a baseline to track change over time. Based on that report, the Australia Council encouraged the cultural industry sector to compete, with an emphasis on marketing skills. The Council provided grants for marketing and management skill development programs with one explicit aim—create an entrepreneurial approach to business.[50]

Francois Colbert, chair in Arts Management at the Ecole des HEC in Canada, coached entrepreneurs to reflect on how "The cultural industry sector starts with the service and tries to find a market. In marketing, they find a market and then find a product."[51] Museums offer services that should be easy to market, but many people have no idea the services exist. Most people are familiar with museums as places to view collections. Many people are unfamiliar with the social activities, research libraries, gourmet restaurants, gift shops, and opportunities for pleasurable learning. Part of the problem revolves around the hours of operation. For example, people who work in Sydney and rarely visit the AGNSW established regular weekly visits when the museum's public programs department initiated the popular Art After Hours service. The night market came to hear the half-hour programs and were encouraged to linger on, enjoying the new bar and live music. They lingered in an economically significant way. The night market was completely different from the day market. The night market was employed and had money to spend on the services offered. The day market attracted more people without full-time jobs such as students, researchers, retirees, travelers, and volunteers. Compared to the night market, the day market had more time to invest in social capital but fewer resources for economic exchange.

Entrance fees are another factor museums consider when assessing ways to attract more stakeholders in social capital. Some museums charge an entrance fee and no fees for exhibitions once the visitor is in the museum. Others do not charge an entrance fee but charge fees for special exhibitions. Others ask the visitor to make a donation based on the visitor's felt level of satisfaction. Opinions vary, but the majority of museums seem drawn to the idea that free admission encourages visitors who would not normally come. For example, the entrance fee to the National Gallery of Victoria in Melbourne is approximately A$12.00—close to the price for a cinema ticket. Many people choose the cinema because marketing lets them know exactly what they are going to get for their money. At one time, there was an entrance fee to the Museum of Contemporary Art (MCA) in Sydney. The MCA is self-funded, and during a period of time marked by declining visitor numbers, the MCA took a big risk by dropping entrance fees. The risk paid off with immediate results—attendance figures went up 100 percent, visitor-related income went up, and costs went down through staff reductions in the admissions area.

Free admission does not mean museums are free of the need for support from the public purse. Directors in the survey (appendix 2, table 41) nominated the state and federal government as a vital source of income followed by user charges, bequests and special funds, and sponsorships. One observer suggested staff should also be listed as an income source—salaries are so low that staff feel like they subsidize museums. Tracking change over time revealed a serious decline in government funding. One Australian report issued in 1980 described 70 percent of museum funding as coming from government sources. By 1996, the figure was down to 38 percent with a continuing decline. It is ironic that the decline in government funding is a direct result of the museum's success in self-sufficiency, according to the director of the AGNSW:

> At the conclusion of the 1995–96 year, our magic financial pie-chart indicates that the total business of the Gallery in the year is no less than A$32 million and that government sources provided a mere 38 percent of that revenue. These figures powerfully demonstrate the significant levels of private support and patronage that have been achieved. Gifts of works of art to the collection far outnumber purchases; acquisitions funded by essentially private sources, such as the Society or the Foundation, have in recent years been among the most significant additions to the collection, as the recent Society-funded purchase of the Delacroix convincingly demonstrates. I think we all now realize that if we are to continue to develop and enrich the art collections of this Gallery, as we absolutely must do, then it will be the private sector, and above all the private individual, that will play a leading role. We are, after all, about the private experience, albeit in the public environment, and the individual work of art is the most durable and inspiring testimony to the individual, the private, the human experience and aspiration.[52]

Museum leaders looked back in the survey (appendix 2, table 12) and described three major changes that shaped economic strategies in the 1990s: master planning for building and site development, internal restructures, and increasing visitor-centered programs. For the decade ahead, directors predicted the same thing the director of the AGNSW described continued decreases in public funding and an increased need for entrepreneurism; implementation of master plans for building development; maintenance of financial stability; and increased activity in staffing, visitor-oriented programs, visitor growth, capital campaigns, competition or alliances with other museums, asset management, and strategic planning (appendix 2, table 13).

## ETHICAL ENTREPRENEURS AND CHANGE MANAGEMENT

If museums follow trends in other industry sectors, the 21st-century museum will experience flatter and less complex hierarchies with more pressure on leaders to do more with less.[53] Trends predicted over a decade ago now influence the way museums function: the information explosion fueled investment in information technology, increased economic turbulence fueled increased competition, and increasingly complex decision making fueled the emergence of a new set of values about quality of life and environment.[54] In the survey (appendix 2, table 16), directors predicted that museums would become change shapers in the community in three ways: increased social awareness and community presence, an educational or knowledge focus, and audience services with a customer orientation. Although the museum has been shaped by change, some critics doubt its role in actively shaping social change. One museologist said the museum's image of itself as a change shaper was a delusion because museums are traditionally slow to respond to change.[55] While this observation is partially true, there *are* museum leaders who are acting as ethical entrepreneurs, using the museum's social capital to shape successful economic changes. For example, the director of the Dennos Museum Center in Traverse City, Michigan, described using entrepreneurial flair to guide the museum as it changed roles from a repository for history made to a site for living history making:

The Dennos Center has living artists who have to be viewed at face value, as they have no art history. This challenges the viewer to figure out an attitude and determine how art relates by asking themselves—*How does this relate to me?* I want people to think about what they experience and why. I want the art audience to reflect on their own ideas or sense of things that seemed like great art to them at the time [because] art changes over time. This challenge means I will continue to build and offer [the museum as] a *taste center* where people come to learn *how to* taste, not what tasted good already or to be told what art should taste like. For example, the jazz series at the Center over the last five years has become the major form of music offered. People experience [the fact that] what you put in, you get out. Continued exposure and experience can lead to pleasure and stimulation! Five years ago, I myself didn't even like jazz! The audience audits indicated that jazz is the genre of interest and that feedback shaped the programs to date and will for the future. Over the last five years, my own taste has been shaped through continued exposure to excellent artists and jazz is now my passion too.[56]

The Dennos Museum Center is an example of ethical entrepreneurism—using social capital to shape successful economic outcomes. The museum co-operated and collaborated with the community's interest in jazz, building a highly successful subscription concert series over a five-year period. Collaborating with the audience was a significant factor influencing change as indicated in the survey, followed by specific museum initiatives, government policy, and social expectations (appendix 2, table 17). Social expectations included schools expecting museums to be a source of alternative education. The director of the Cleveland Museum of Art believes museums work best in collaboration with audiences, exposing them to excellence to shape demand:

> Traditionally, there are ignored communities in the museum world. Some museums have shaped themselves uncomfortably to meet the community need. It is better to look at the museum and the community to see points of intersection. In this way you can address the issue of community work done well versus the pundits who say museums are lowering their standards when they do this. The audience sees the museum as actually having standards, not lowering standards, when the museum chooses to present what the audience actually wants. In the 1980s, museums shaped programs that were not true to the nature of the institution. You have to understand the nature of your institution and what audience insight depends on. Audience insight depends on experience and that can be a problem.[57]

What is the key EQ skill used by ethical entrepreneurs? They use interpersonal connection skills for successful relationship management. Directors use this EQ skill to build long-term, financially supportive networks around the museum. The deputy director for the Guggenheim in New York suggested: "In the past, directors have been responsible for managing financial endowments. In the future, the focus will be on revenue generation based on attracting new audiences."[58] He described how the Guggenheim managed this change, crediting the director's relationship management skills with corporate investors as the key factor for success. The director for the Museum of Fine Arts in Houston also described using relationship management skills to tap energy and creativity in the business community—encouraging their desire to be involved with the museum, not just the need for corporate giving.[59] The director of the Art Institution of Chicago agreed that leaders need to

> Keep abreast of the broader culture through university contacts, newspapers, and contacts with business people. Find out what is happening out there! It is

changing very quickly. The Institution is a highly visible institution so we need to stay informed about changes in the broader world because it impacts on museum policy.[60]

At the ninety-first annual meeting of the American Association of Museums, a panel of museologists used an evolutionary model to make a prediction for the 21st-century museum. Museums would change into learning centers. The speakers represented zoological societies, children's museums, national trust properties, and art museums. They predicted zoos would be redefined as environmental resource centers. Children's museums would become learning centers with a focus on edutainment. Historic sites would become institutions of memory with objects presented in context.[61] Stephen Weil, respected scholar with the Smithsonian Institution, sounded a warning bell for the art museum. He said the art museum's mission as a scholarly center for the collection, preservation, and exhibition of art was redundant, and leaders must shape change accordingly:

> After the year 2000, the art museum will have evolved into a center for visual learning. In the past, art museums equaled cultural superiority. There is an evolution toward centers where people come to look at art as a product of human effort. In the United Kingdom and United States, communal and individual betterment is the true aim of the museum, not preserving the collection as an eternal task. The museum is becoming a center for learning, not a site for preservative functions.[62]

Directors in the survey predicted cultural diversity would be an important ethical issue as they managed change, followed by conflicts of interest, moral rights legislation, and cultural product treaties (appendix 2, table 19). Accommodating cultural diversity in social capital development prompted an important question from one anonymous Australian regional gallery director: "What should I do to represent one hundred twenty-one different ethnic/cultural groups in my region?" Cultural diversity and the museum's responsibility to internal stakeholders are complex issues, according to the director for the Met:

> We have a legal area now with four full time staff to deal with the increasing complexity of copyright, repatriation of material, accession laws, legislation for the visually impaired, and multicultural exhibitions. The whole area of work place diversity is a complex legal issue with 2,000 staff at the Met, including people over age fifty, Blacks, Hispanics, and Asians.[63]

Cultural diversity influences the way museums represent and interpret the collection, develop external audiences, build an organizational culture, and respond to legislation governing workplace diversity. For example, the director of the Sackler and the Freer Galleries revamped printed material, education programs, and installations to attract cultural groups represented in the collection:

> People from Asian cultures are comfortable with temples and mosques but [perhaps] not with a museum. The challenge is how to create an activity to increase their level of comfort through film, performances, and other activities to open the museum to them.[64]

Accommodating changes in cultural diversity is easier when we remember certain things about human nature, according to a research writer for the international organization Earthwatch:

> It seems that no matter how much economic globalization homogenizes the world's cultures, new ones will stubbornly break off from the bland, global mold. That's because humans want to belong to a community with which they can identify. If that community grows too large, we lose that identity and tend to form subcultures. In the end, although we seem to be heading for a rootless, homogenized society, human nature has shown us so far that the need to belong and to have a community identity, a cultural history, and a homeland have survived for millennia. If there isn't a defined culture, people will invent one.[65]

Can museums play a part in meeting an unmet longing for community, identity, and homeland? Remember, entrepreneurism is finding an unmet need and fulfilling it. How many ways can a museum fulfill the need to belong? How many ways can a museum fulfill the need for community identity? How many ways can a museum fulfill the need for cultural history?

## COACHING STAFF TO BE ENTREPRENEURS

Directors like the head of the National Gallery of Victoria in Melbourne said the leaders' job was to coach change by "applying some entrepreneurial business practices to make money out of the visitors because the museum is part of a mass market and seen as another leisure activity."[66] Although part of this statement is true, entrepreneurs need to have a purpose. Remember that

making money needs to make a difference. How can museum directors coach
staff to make the shift? Find an entry point into ethical entrepreneurism where
staff can appreciate how creative entrepreneurism can be. Provide a skill
framework that helps people understand what is involved with selling in-
tegrity. For example, one Australian-based entrepreneurial skills program in-
cludes topics such as understanding wealth, value-added products and
services, marketing, organizational culture, leadership, comprehensive think-
ing, systems, technology, community contribution, and life skills.[67]

Leaders can coach staff on ways to reinvent themselves as ethical
entrepreneurs—help them identify social causes, cultivate opportunities
around that cause, and turn them into profitable outcomes.[68] The director
of the Victoria and Albert coached change by encouraging staff to explore
value-added products:

> In decision making, my approach has been to establish new relationships be-
> tween previously unrelated material. As a director, one has to look at a whole
> new approach for commercial development. It has been particularly difficult for
> curators to see their "materials" being exploited commercially. For example, the
> V and A enterprise has a number of patents or licenses on various parts of the
> collection. Gallery Lafayette has taken up linens inspired by an Indian Mogul
> jacket to promote the sale of their new commercial product. We have to look at
> new sources of funding and partnerships that allow commercial and private fi-
> nancial initiatives.[69]

For the director of the Queensland Art Gallery in Brisbane, coaching change
for ethical entrepreneurism involved deconstructing traditional hierarchies in
the museum so staff could be more involved:

> When I arrived at the Queensland Art Gallery, there was a professional uncer-
> tainty and reluctance on the staff's part to do what's right if it was perceived to
> be different. First, the challenge was to get a basic management structure for a
> different ambiance in the gallery. I took a planned approach with a new struc-
> ture for the museum that challenged some of the old conventions. Disciplines
> like registration, education, and conservation have become more professional. I
> have to manage the interaction of these professional groups. I do this by look-
> ing at a project-specific approach with a greater level of horizontal communi-
> cation and decision making that involves all of the people.[70]

The director for the Cleveland Museum of Art described similar experiences, highlighting less formal relationships so staff could relate better in their work.[71] The director for New York's MoMA said the shift toward entrepreneurism was different for each institution because each has its own complexion.[72] There are different ways to put the organizational pieces together and different ways to share team leadership, according to the director of the Saint Louis Art Museum:

> As an organization, we tend to work in groups and teams to get things done. Some of this is formal and the rest is informal. My role as director means bringing people and tasks to bear on issues. A lot of us do that, not just me. I have six people doing this. They represent different operational aspects of the museum—education, public relations, community outreach, curators, development, and fund-raising. The director works with and through a group. We have actually spent quite a lot of time deconstructing the hierarchy.[73]

Resistance to change is normal in any organization. In this case study, curatorial staff have slowly adapted, although directors described how curatorial staff were prone to creating demarcation lines with competition over scarce resources.[74] The director for the J. Paul Getty Museum in Los Angeles noted a similar response to change:

> This may sound a bit grand but my job is to perceive relations that are complimentary and supportive. The institution wants to fragment constantly in the curatorial area through turf battles and specialization issues. The curators [can be] narrow in their questioning and they want to outperform each other. They actually have very few incentives to do things together, which is my wish . . . for them to do things together.[75]

The director for the Minneapolis Institution of Arts described how restructures for a more entrepreneurial approach created opportunities to look at all aspects of the museum's function. He coached staff on changes to publishing, support systems, marketing, exhibition design, and education:

> Education and curators are finally working in a team where the idea of chief curator is scrapped in favor of an academic model of a rotating chair held for two years. This way there is shared responsibility and increased organizational learning.[76]

The director of the Art Gallery of Ontario in Toronto described coaching change as a process of *knitting* together a new media center with curators, registrars, education, and marketing to create more opportunities for shared leadership.[77]

## STORIES ABOUT SELLING INTEGRITY

There are many stories about museums adapting entrepreneurial strategies to cope with changes in the economy. A report tabled by the National Endowment for the Arts in the United States presented compelling figures illustrating the contribution arts institutions make nationwide.[78] Each museum creates its own unique form of entrepreneurism based on perceived markets, place, stakeholders, and position in the community. For example, the MoCA in Los Angeles used the director and a development team of twelve to attract investors from the local, national, and international community. In one project, the MoCA secured commitment from a corporate stakeholder to fully fund one department for one year to allow the museum to bank all ticket income for the year. In a different project, the MoCA developed a program that built bridges between a sculptor, a foundry, and a local gang whose members had few employable skills. The result? A limited edition of bronze-cast sculptures auctioned through the museum for a handsome profit. Part of the profits funded an ongoing foundry skill project that allowed gang members to develop a new role in the community. The director coached change with the development team, focusing attention on understanding the *nature* of different organizational cultures and designing financial proposals to accommodate specific needs. The goal was a win/win proposition for the museums and their corporate partners. Out of a team of twelve, three members were dedicated to designing financial proposals, and the museum's circle of influence expanded:

> As a result of this [approach to development], 60 percent of our finances are actually raised *outside* of LA. We transcended the task of getting press coverage and increasing development activities by moving beyond the task. For example, we arranged for MoCA to have shows in Mexico, Japan, New Delhi, and Berlin. And we raise money for the exhibition in that country with a different approach. We take 20 percent of what is raised for administration fees to feed MoCA, and the country that has the show gets the other 80 percent of the revenue generated. This is good for them and good for us.[79]

Another treasured story focuses on diversity fund-raising. At the Japanese American National Museum in the United States, diversity fund-raising means attracting corporate support by targeting particular ethnic groups rather than corporations or foundations for funds.[80] A one-to-one donor relationship is developed with a primary aim—educating the target community on philanthropy. Using a similar strategy, a particular New York–based museum successfully targeted U.S. corporations that also had operations in countries with large ethnic groups in the New York community.[81]

One of the most inspiring stories came from the National Museum of the American Indian (NMAI). In 1996, the development director described how they grew membership from zero to 70,000 in five years.[82] The successful campaign was built on the way the museum represented its story. They invited all stakeholders to join the museum as a museum for everyone, not just Native Americans. The message tapped a social need—the desire to be in partnership with a museum with a social conscience. The membership campaign attracted membership and donations as diverse as pony blankets with family stories attached and anonymous donations of large sums of money.[83] On the other hand, while the NMAI strategy was successful, the director of the Art Institute of Chicago suggested social conscience might be in transition:

> A small group of fifty donors essentially cover the costs of the Institute. I can't depend on just one source, though. Corporate finance is fickle funding and the government has cut back arts and cultural funding. Foundation funding comes from private individuals and oddly enough, [it] is still the most dependable source. The top 10 percent of America is richer now than they were ten years ago but their interest in giving and in the arts is under question. The tradition of tithing and philanthropy as social responsibility appears to be a dying form.[84]

The associate director for education at the Met described how important it is to track economic changes and the contribution museums make to the economy, describing a five-year economic impact study tracking visitor spending patterns.[85] The Portland Art Museum (PAM) in Oregon started developing economic impact studies with their Imperial Tombs of China exhibition. PAM's study showed that 40 percent of the visitors were from out of town, and the museum's business had generated U.S.$12 million for local business. The Portland City Council was so impressed that it contributed

$1 million to the museum.[86] This was unexpected because the council had been historically thrifty with museum funding.

The Art Institute of Chicago used a Monet exhibition to develop an economic impact study, with surprising results. According to the executive vice president for development and public affairs at the AIC, the integrated marketing strategy was sponsored by a corporation interested in tracking the relationship between visitor services, visibility, and hotel linkages.[87] Thirty-five hotels agreed to offer package deals with premium tickets for the exhibition. The strategy paid off, with a staggering increase in income generated just through membership and admissions—thousands of new members joined during the Monet exhibition.

The Art Gallery of Ontario's story tracked links between blockbuster exhibitions, entrepreneurism, and contributions to the local economy with the Barnes exhibition in 1994. The exhibition attracted 7,500 new members and generated C$2.6 million in net revenue for the Gallery, positioning the museum as the number one tourist attraction in Toronto that year. The results reported by the president for the board of trustees were astonishing:

> An independent study commissioned by the Government of Ontario ascertained that the Barnes Exhibit stimulated the production of $317 million in goods and services across Ontario, generating more than 2,000 jobs and $42 million in federal, provincial and municipal taxes. Overall, these results reinforce the critical role that the cultural tourism industry can play in revitalizing the economic health of the province.[88]

Collaborations between museums mean shared costs for economic impact studies. When three major museums in New York tracked the influence of four major exhibitions held in the early 1990s, the mayor of New York applauded the results:

> No city in America has a richer cultural life than New York and no city gives more to the arts than we do—both from local government and the private sector. In return, the arts repay this investment generously. According to this report, these four exhibitions alone contributed more than US$600 million, including US$60 million in state and city taxes. This is no isolated phenomenon. The MMA, MoMA, Guggenheim and scores of other museums, theaters, and nonprofit organizations contribute to our economy every day in jobs, taxes

and creative stimulation. We must value our cultural institutions and the many artists who work in New York for their economic benefit as well as their contribution to our happiness and well being.[89]

Although these stories focus primarily on museums in major capital cities, visits to regional museums produced equally impressive success stories. While in England, a visit to the Tate Gallery, St. Ives, in Cornwall revealed a small museum that opened in 1993 as a regional division for the Tate in London. When the museum and the local tourist board studied the museum's contribution to social and economic development, they found a surprising result. Cornwall is one of the top five counties for tourism expenditure in the United Kingdom. The study reported Sterling$16 million, or 2 percent of the total $831 million spent each year by visitors to Cornwall, was attributed to the Tate Gallery, St. Ives.[90]

## INTEGRATING CHANGE AND THE ENTREPRENEURIAL ROLE

Museum leaders in this chapter described the impact of extensive economic changes in the 1990s on their role as fund-raisers. Increased complexity meant new skills were developed to sell the museum's integrity—making money while making a difference. The change was most successful when leaders worked out ways to coach and focus staff creativity on ethical entrepreneurism. In the process, several directors discovered that it is the museum's *social* experience rather than the collection that actually attracts visitors and investors to the museum.

Attracting investors in social capital is not an easy task, but museums are managing the transition from collecting institutions to learning centers and sites for meaningful play. The change has created tension and will continue to do so. The United Nations Educational, Scientific, and Cultural Organization (UNESCO) released a report in 1996 from the World Commission on Culture and Development acknowledging the tension cultural industries may feel as they assume more economic importance in the 21st century. UNESCO predicted that globalization would continue to shape the role governments play in financing and supporting cultural development nationally and internationally. The government's role would become that of a facilitator to balance the expectations of a market economy with investments in human development and social capital.[91]

A guest mentor illustrated this role for a session on ethical entrepreneurism in the *Leading with Passion* course in Australia. The mentor was a CEO with extensive experience leading a state-based government organization responsible for assessing and providing venture capital for complex commercial projects on a state, national, and Asian Pacific regional basis. He presented several case studies on ethical entrepreneurs, and key factors for success were summarized at the end of the session. The first and most important factor for ethical entrepreneurs to remember was the importance of EQ skills such as intention and self-awareness:

- Be clear about personal values. Leaders are drawn to organizations [like museums] because of shared values. Acknowledge the desire to do something toward a broader universal good and act on it.
- Entrepreneurship is about being a bold leader, looking for opportunities that can become successful and profitable. Be willing, enthusiastic, and creative.
- Firmly believe that what the leader has done is right and honest. Leaders have to be passionate and confident that what they do is right. It is a form of self-protection because explicit ethics may be fuzzy guidelines.
- All successful entrepreneurs use well-developed financial models and net benefit budgets to assess every single business plan. A rigorous criterion for assessment must be developed for every entrepreneurial proposal. It is the only way to justify the judgments made.

Although we know museums can do qualitative and quantitative audience analysis for exhibition planning, we need to develop the next link.[92] We need to integrate audience analysis techniques into a more sophisticated analysis of the links between the museum's cultural capital, social capital, and economic outcomes. Is there a way for museums to plan each fund-raising initiative as an entrepreneurial change management project? Can we use data in this chapter along with other economic indicators to benchmark the contribution the museum's social capital makes to local and national economic well-being?

## NOTES

1. Singer 2002.

2. Gittons 2002.

3. Mulcahy 2002 (C).

4. Steckel 2002 (C).

5. Moffett 1996 (I).

6. d'Harnoncourt 1996 (I).

7. Capon 1995 (I).

8. Demetrian 1996 (I).

9. Powell 1996 (I).

10. National Center for Culture and Recreation Statistics 1999.

11. Borg 1996 (I).

12. Suchy 1993.

13. Sykes 2002: 12.

14. Ottley 1995 (I).

15. Drucker 1985.

16. Johnston 1996 (C).

17. Reynolds, Bygrave, Autio, Cox, & Hay 2002: 14.

18. Bricklin 2001: 53–59; Sutton 2002: 96–103.

19. Gittins 2002: 35.

20. Fox 2002: 64.

21. Steckel 2002 (C).

22. Kolb 1996 (I).

23. Paroissein 1995 (I).

24. Consey 1995 (I).

25. Reynolds et al. 2002: 6.

26. Spence 1995 (I).

27. Australian Association of Social Workers 1999: 5, 15, 31.

28. *Business and Professional Women Newsletter* 2002.

29. Fukuyama 1995: 26–27.

30. Capps 1995 (I).

31. Dobbs & Eisner 1990: 217–35.

32. Lydecker 1996 (I).

33. Morgan 2003: 28.

34. Moffett 1996 (I).

35. Australian Bureau of Statistics 1995: 6.

36. Buhrman 2003 (I).

37. Gurian 1996 (C).

38. Falk & Dierking 2000: 106.

39. Gardner 1995a: 289.

40. Galla 2003: 10.

41. Maroevic 1997: 13.

42. McAuley 1995 (I).

43. National Gallery of Australia 2002 (C).

44. National Center for Culture and Recreation Statistics 1999.

45. International Committee for the Training of Personnel 2003.

46. Anderson 1996 (I).

47. Anderson 1996 (I).

48. Beech 1996 (I).

49. Cochrane 1997: 15.

50. Suchy 1999b.

51. Colbert 2002 (C).

52. Capon 1996b: 13.

53. Leeuwen van 1996: 18.

54. Sadler 1991: 152–53.

55. Weil 1996 (I).

56. Jenneman 1996 (I).

67. Bergman 1996 (I).

58. Levenson 1996 (I).

59. Marzio 1996 (I).

60. Wood 1996 (I).

61. Wilcoxon 1996 (C); Spock 1996 (C).

62. Weil 1996a (C), 1996b, 1995.

63. de Montebello 1996 (I).

64. Beech 1996 (I).

65. Bloch 2001: 15.

66. Potts 1995 (I).

67. Excellerated Research Inc. 1997.

68. Aburdene & Naisbitt 1994: 31–34, 319–39.

69. Borg 1996 (I).

70. Hall 1995 (I).

71. Bergman 1996 (I).

72. Lowry 1996.

73. Burke 1996 (I).

74. Capon 1993 (I).

75. Walsh 1995 (I).

76. Maurer 1996 (I).

77. Anderson 1996 (I).

78. Kellogg 1996: 39.

79. Koshalek 1996 (I).

80. Sung 1996 (C).

81. Siege 1996 (C).

82. Colonghi 1996 (C).

83. Colonghi 2000 (C).

84. Wood 1996 (I).

85. Lydecker 1996 (I).

86. Gragg 1996: 2.

87. Molen 1996 (I).

88. Art Gallery of Ontario 1995: 4.

89. Arts Research Center of the Alliance for the Arts 1993: i.

90. Tate Gallery, St. Ives 1996: 10–12.

91. World Commission on Culture and Development 1996: 41.

92. Soren 2002: 58–66.

# 5

# Trust
## *The Director–Trustee Interface*

Nurturing relationships of trust with and between stakeholders is the fourth part of the fourfold leadership role. As we appreciated in chapter 4, the public, staff, government, sponsors, and trustees are important stakeholders in the museum's cultural and social capital. Out of this group of stakeholders, the director–trustee interface is one of the most important because it involves shared leadership. An interface is a boundary between two bodies, a point where two systems or disciplines interact, communicate, and exchange ideas. A past director for the Brooklyn Children's Museum linked the director–trustee interface with the success of the museum's presence: "Institutions reflect who is in charge and we link their reputations with the directors and boards who run them."[1]

Chapter 5 focuses specifically on the director–trustee interface, describing predictable role confusions in three key areas: governance, policy development, and succession planning. These areas are explored primarily from the director's point of view, not that of trustees. The directors' views have been balanced with views from other professionals responsible for trustee appointments or for facilitating retreats to strengthen the director–trustee interface. The main aim is teasing out role clarity so that directors and trustees can strengthen the trust radius around the director–trustee interface. The focus is on roles and relationships rather than on the sometimes intricate legal differences between boards of trustees in Australia, the United States, England, and Canada. And many differences arise between and even within parts of a single country regarding director–trustee appointment processes, the size of the

board, whether trustees pay or are paid to be on the board, and how roles are defined. Yet with all the differences, they have one thing in common. Museum directors and the president or chairman for the board of trustees share a passion for the museum. A board member for the Getty Trust in the United States described shared passion as "loving the organization more than anyone else does."[2]

## NURTURING RELATIONSHIPS OF TRUST

For better or worse, it's passion that fuels battles between directors and trustees over long-range planning, governance, and the director's operational role. The director of the MoMA in New York said *trust* was the key to resolving ongoing battles:

> The organization structure for a museum has to achieve change over the next ten years. We need to ask what to create for tomorrow? We need to use our minds and act as think tanks to think abstractly. The trustees, though, tend to blur church and the state. They fund the museum so they feel they have a vested interest. This relationship is complicated. As director, I have the discretion to screw up. Museum trustees are powerful. To manage the relationship effectively requires *trust*. It is the critical component in defining and redefining the role. This is a publicly funded institution so the trustees have the policy role and the director the operational. And it all depends on trust.[3]

One of the external examiners for my doctoral research thesis wrote a poignant comment on my description of the director–trustee interface. As a museum director, the examiner said a director's success is directly dependent on having the trust and support of the trustees. Getting support while maintaining one's independent authority is tricky, the failure of which has been the downfall of some directors. He commented on my analysis of the role of trustees and directors with reference to the differences or lack of perceived difference between setting policy for the museum and managing the implementation of that policy. This can be especially difficult after the tenure of a director with uneven performance or the extended absence of a permanent director (as opposed to having an acting director).

One consultant on board development suggested that trust was the most important contribution trustees could contribute to the 21st-century

museum: trust museum staff (i.e., directors) to get on with the business of the entrepreneurial museum.[4] This needs to be balanced with enough courage and humility to know how to allow directors to quickly unpack the odd bad decision. According to the director for the Yale Center for British Art in New Haven: "Trust in the director's judgment is then retained and you can just get on with it."[5]

Trust radius is an EQ competency measured by the degree to which people expect other people to be trustworthy—trusting until there is a specific reason not to. EQ researchers correlate strength in trust radius with a leader's ability to use trust in a transforming way by suspending narrow judgment, establishing stronger relationships, enlisting support, and harnessing the energy of those around them.[6] Increasing trust radius allows us to move away from old values of power, politics, and personality. A director for a Maryland historical society in 1996 described new values for future directors and suggested trustees needed to change the way they recognized, rewarded, and retained directors with what we now call nontraditional skill sets.[7]

In Australia, the government may appoint trustees without consulting the museum. This has a major impact on trust levels between museum directors, government ministers, and trustees whose motivation may be under scrutiny and then tested by the museum. According to the director for the Art Gallery of Western Australia: "Some state governments appoint trustees as political paybacks without any regard for the museum's actual needs."[8] The government's role in board appointments was discussed with an experienced board appointment consultant and another perspective emerged. The consultant understood that creative organizations like museums might function differently than other types of organizations but the expectations for governance were the same. He described the ideal trustee as someone with political awareness and financial experience, and he stressed the importance of trust:

> The government expects directors to be good people, with skills in management, sales, marketing, innovation, and to be good politicians. The same holds true for trustees. First off, a trustee has to have political sense. This means mates, a network, and they have to be aware that politicians tend to appoint people of their own kind. Second, they have to be seen as plausible. In other words, there has to be evidence of other board and management experience. Experience with a balance sheet is evidence of financial acumen. This is critical. Along with this,

some experience and ability in fund-raising. They have to be aware of the government's push for microeconomic reform. It started in the late 1980s in Australia and continues. The government's agenda will be achieved through government organizations whether they like it or not. Therefore, reforms like Enterprise Bargaining [a workplace agreement rather than union negotiated contracts] and commercialization of organizations means greater competitiveness will be reflected in the types of decisions boards must grapple with. Finally, there has to be evidence that the trustee has linkages to the various constituencies. This will be good for the political business.[9]

Based on this consultant's assessment, the interface between the director and the board of trustees requires role clarity. There needs to be a clear appreciation of the boundaries between shared responsibility for financial management, fund-raising, political networks, and relationships with key stakeholders and constituencies. A successful director–trustee interface actively nurtures trust relationships with the business community *and* the government. Nurturing relationships of trust has a direct benefit for the director–trustee interface—judgment is trusted and outside interference is reduced. The director of the Yale Center for British Art suggested ways to create trust with new board members:

> There is a nominating committee process in the U.S. for trustees on [art] museum boards. The selection of a new trustee is brutal. They have to consider gender, race, and their line of wealth, community profile, and upward mobility. The museum has to be guaranteed continuity, and the trustees are the only way this is going to happen. The director vetoes board appointments, which is a responsibility shared with other trustees. In Australia, Acts of Parliament limit the number of trustees, which means the trustee's personal profile needs to be broader. Once a board is appointed, the director needs to use good group process skills with style. This means arranging for the board to meet at the gallery, serve wine, and make the meeting interesting. In this sense, *interesting* means to entertain the board at this point rather than educate them. You have to see the trustees as an asset and put them in a situation where they feel good about themselves, the museum, and each other.[10]

The Australian-based consulting firm ProNed offered a critical perspective on the director–trustee interface. ProNed specializes in locating and appointing chairmen and independent nonexecutive directors, analyzing board

composition, and evaluating board performance for the government and corporate sector. Although many readers may feel affronted with the following negative assessment, we need to consider whether it contains kernels of truth we can learn from. The consultant offered a scathing assessment:

> The [arts] institutions you are interested in are similar to welfare institutions. They are full of such a lot of nonsense that men just won't put up with them in the long run. Creative, uncommercial sorts of people gravitate to the boards of arts organizations, and it seems that these people seek those roles for social kudos alone. Being on a board is a thankless task in Australia. In the U.K. and Europe, people are paid to go on boards but not here. Art galleries should be there for general education as they are built with the taxpayers' dollars. They, unfortunately, have quite a lot of financial resources nowadays, with people on boards who don't have any sense of the commercial or cash value basis of the resources nor any measure of success for entrepreneurial activity.[11]

According to Company Directors, another Australia-based firm, there needs to be a balance between core skills like reading a set of accounts and particular skills like assessing the financial performance for an organization so those in the director–trustee interface learn to trust each other's judgment.[12] Expanding the EQ trust radius starts by trusting until there are reasons not to. This can be difficult when observers continually point out the mixed agenda trustees often bring to the role. One anonymous critic said, "The problem with the ideal view of trustees is that the agenda for most trustees in cultural institutions is one of cultural influence, not business management. The agenda between museum trustees and the actual needs of the museum are not well matched." The director of the Isabella Stewart Gardner Museum shared this view. She said the best trustees were people who actually had some experience running a business: "The other three groups who we often draw on as trustees are artists, writers, and lawyers. Again, we have problems because of their lack of understanding of what it takes to run a business."[13] The director of the National Gallery of Canada resolved part of this dilemma by astutely matching the museum's needs with the trustees' skills:

> Establishing new relationships between currently unrelated things is what board management is all about. The government appoints the boards of museums in Canada. When the government changes, so do the board appointments, which

can produce a mixed bag of trustees! As director, I have to mold the board to understand the mandate of this gallery. To do this, I have to look at the market, press, party politics, broadening the museum to include film and dance festivals, financial dimensions of the balance sheet, and all of the areas of fund management under the Financial Administration Act.[14]

## CHANGE AND ROLE CONFUSION

According to a past president of the U.S.-based Andrew W. Mellon Foundation, trustees must understand the importance of governance and their role as governors for the museum:

> In many cases, the board of trustees actually owns a museum's [art] collection. This may help explain why museums are bringing a new energy to the search for trustees, trying to spot three qualities that one museum director identified as the mark of an ideal board member: talent, treasure and time. Trustees are more likely than before to fire directors. Some museums have even hired corporate headhunters to single out the best prospects for board positions [that] one used to hear about only on the squash court. Many institutions also now set a cash minimum for membership on a board: US$50,000 a year and far more in the more distinguished museums. Board jumping occurs frequently, with trustees *trading up* to join institutions perceived to carry greater prestige. People have come to understand that governance at the board level really matters. For many years it was taken for granted. New museum trustees now include businessmen who may be inclined to think strategically, to expect their organization to have a plan and to help to develop it and monitor the development. This suggests a new discipline in nonprofit management could evolve.[15]

We have moved beyond the suggestion that a new discipline in museum management *could* evolve. It *has* evolved and with increased complexity for the director–trustee interface. Although talent, treasure, and time are valuable resources, a past member of the board of trustees for the Minneapolis Institute of Art said that change in every area of cultural heritage management means trustees must be willing to share leadership more, contributing more to goals, policy, fund-raising, and reviews.[16] This view prompted heated debates among delegates at an American Association of Museums conference. One delegate said museums needed strong directors *and* strong presidents or chairs for the board of trustees. If the director did not get along with the head of the board, then the director should move somewhere else because trustees

were the true center of power. Another delegate suggested that museum trustees had to learn to focus on results, not the process of getting in and getting there or who gets along with whom. One critic concluded that conflicts happened with the director–trustee interface in museums because more than any other kind of organization, museums live *in themselves.*

While this perception may be partly true, museums are *not* different from other types of organizations. Change management consultants working with museums and other nonprofit organizations describe important similarities in board management issues across a range of organizational types. One consultant in board member development described uniform board functions for all nonprofit organizations in Australia, the United States, Canada, and England:

> The board is a group of volunteers who, for the most part, actually want to make a difference, to feel needed and to feel their skills are actually appreciated. Despite the old U.S. board dictum of *Give, get, or get off,* the statistics in the U.S. show that 50 percent of adults volunteer at least two hours of their time per week helping religious groups or working with kids for self-esteem reasons. It makes *them* feel good about *themselves.* Given that the basic intention is giving service in some way, the board's main responsibility is one of ensuring the organization is adequately resourced. Resourcing may not actually mean fundraising. For example, the Museum of Contemporary Art in Sydney is a self-funded institution but the board has nothing to do with fund-raising. The director's role with the board could be described as a combination of political skills, relationship management, developing and maintaining trust, and keeping the board informed. It requires ongoing role clarification.[17]

The director of the Please Touch Museum reinforced the view that the essentially volunteer nature of trusteeship needs to be respected by directors: "Know what it means to volunteer! Director–board problems are usually with directors who are trying to direct their board. The director has to understand what volunteerism is all about."[18] Several directors recommended that all aspiring directors should have some experience as trustees on a board to foster a deeper understanding and valuing of what it means to be a trustee. The director of the AGNSW understands this issue and has dealt with it by creating quite specific ways for trustees to make a contribution to the museum:

> They [trustees] are in powerful resource roles because they have experience in corporate relations, law, advertising, product development, financial management.

They have a feel for the place. They represent the users of the Gallery. Basically, the trustees want to be used and want to help. My job is to see that happen.[19]

## CLARIFYING GOVERNANCE AND STEWARDSHIP

From the director's point of view, the trustees' primary responsibility is museum governance and stewardship. These terms need to be defined. Governance, stewardship, and trusteeship are not management, according to the Center for Nonprofit Boards in the United States.[20] Governance recognizes responsibility carried by trustees to protect the long-term future of the museum and to ensure that it fulfills its obligations to stakeholders, however they are defined.[21] In very broad terms, stewardship and governance are social and legal obligations. Stewardship is best described as the museum's right to manage its business balanced with an obligation to the public.[22] In *principle*, stewardship and governance are shared between the director and the board of trustees. In *practice*, stewardship and governance are the board's primary responsibility. Practices differ but the principle remains the same. The director for the Yale Center for British Art described the differences between principles, practices, and roles:

> Trustees are on boards for governance, not the management of the museum. The director is the prime minister, as such, because the director knows the museum. In fund-raising though, the trustees must have a role. They need to be at all the fund-raising lunches and given leads in the conversation. Donors feel the institution asks through the symbolism of the trustees and the director, which is very, very important. Governance to some extent is about stewardship, which is a symbolic responsibility.[23]

Directors lead and manage the organization with the board's support. Directors lead trustees by creating a context for them to fulfill their responsibilities. Directors enable governance by providing information, reports, and proposals on the museum's performance. Trustees are there to support, encourage, challenge, stimulate, and help the directors they have selected to lead the organization. If we review the levels of complexity model, trustees need to ensure that the concept, vision, and genius that created the organization is protected for the future. They do not create, they protect. Putting the principles of governance into practice is the director's job. Vision, policy

development, and decision making are governance in action, according to the director of the Queensland Art Gallery in Brisbane:

> I got the director's job due to my vision. I have been given the discretion to shape that vision by the board of trustees and the government's Ministry for the Arts. As a member of the board, which is more of a corporate model than usual, I can represent the institution and the staff, arguing from both sides for good governance.[24]

According to the director of the National Gallery of Canada, governance is a big issue because trustees may be political appointees or seeking social kudos rather than roles to provide governance:

> They are [often] totally untrained in governance, with generic ideas of governance and how it is applied to a national museum. This results in a range of issues both political and moral because of financial pay-off. The director has to continually draw the lines with policy and boards so they do not micromanage the museum.[25]

The director for the Museum of Fine Arts in Houston managed the lines with trustees and staff by using a *chalk and talk* strategy, ensuring everyone in the museum participated in the museum's development. He created a contract between eighty trustees and the museum staff based on commitment to a radical idea: "We are *all* part of governance for the museum."[26]

Based on the feedback from directors (appendix 2, table 33), stewardship is an important part of governance, but the focus varies for directors and can include compliance with heritage legislation, a responsibility to conserve objects in the collection, ensuring public access to the collection, designing programs to interpret the collection, and legal responsibility for publications based on the collection. In principle, governance and stewardship revolve around legal obligations to assist and sustain the museum's development over the long term. Governance and stewardship is supported by clearly articulated strategic plans aligning the museum's vision and mission with policies, resources, and staff. Trustee governance and resource management may not include control of all expenditures, but trustees enable governance by ensuring that budget structures and financial regulations are developed for the museum as a whole. According to the director of the Art

Museum of Western Australia in Perth, trustees may not be well prepared for this level of governance:

> The boards are in sad shape. Boards often don't know why they are there, what to do, and don't want to do really hard visionary work. They want to either rubber stamp or meddle in the work of the museum. It is often very difficult for them to keep their own private interests separate from the museum's priorities. The bad habits set up in a board are too often passed down from one generation to the next.[27]

A director for the Asian Art Museum in San Francisco shared a similar story. Governance through the director–trustee interface was fraught with tension because trustees were not prepared for vision development, long-term planning, and change management:

> The trustees and staff were absolutely not prepared for the idea of a new museum! The curatorial staff just wanted a small, quiet academic organization with shows. They had not been pushed to publish or to achieve any national attention before. The exhibition staff had not been pushed. The education staff have stuck to the same program for the last ten years. The last eighteen months have been a challenge trying to initiate and manage change toward a new museum. What with unions and staff needing to see me as the authority figure and trustees having trouble seeing what I was doing and not being willing to give me any credit at all, it has been tough. Out of the sixty trustees, only one supported me. I was lured all the way from Texas to San Francisco to do this job. The trustees knew that the situation required firm leadership but only one trustee really offered the support needed. Only one person saw what needed to be done.[28]

Directors interpret governance in different ways. They use a variety of techniques to manage governance through the director–trustee interface. For some, governance is easier when the director is a voting member of the board, according to the director of the Please Touch Museum, "Being a voting member of the board helps with any problems to do with governance and stewardship. Boards often think in terms of *them* and *us*. I told the board we are all *them*."[29]

Being on the board creates equality for the director, like a corporate model. Another technique is to ensure the director's position description defines

governance as duty of care for the board of trustees by keeping trustees informed. Keeping trustees informed can cause problems because there is often either too much or too little information to meet the trustees' needs. One solution to the problem is to make sure all trustees have orientation programs and committee work aligned with their area of expertise. Directors enable trustees to govern through involvement. The director of the Art Institute of Chicago described this as a process of creating power through respect:

It's about pragmatics, how much compromise is tolerable for the Institute plus the absolute ideal. For example, the relationship with the board is one of managing up and having an impact through subtle, diplomatic action for the growth of the board and the museum. It is about setting horizons that are realistic. An art museum is not just the *bottom line*. Directors and boards have to generate power through respect. There are members on the board who are collectors and experts in art themselves. As a director, I have to allow them to have their authority but not succumb to it.[31]

Allowing authority and not succumbing to it is an art, not a science. According to the director of the Phillips Collection, directors perfect the art by learning to transcend the task:

I discovered this in my relationship with the board of trustees, which is different than I thought and hoped it would be. In business, you can't please everyone but you can aim for the 50 percent plus one. Adversarial relationships are awful. *Star Wars* comes to mind. Some people insist on living on the dark side of the Force. Many trustees are not well motivated. They are driven by ego and power control issues. Decision making needs to be viewed like pieces of a jigsaw puzzle. It is all a picture, not linear. Problems with the board and curators are there because people want it as an either/or and *x* equals *y* but it is always more than one thing—it depends on the context.[32]

Teasing out personal motivation and the impact on governance is a concern in the corporate world too. In the corporate sector, governance includes financial control with serious responsibility and liability for trustees as well as shareholders. Some critics contend that governance in the nonprofit sector differs because it is based on social and political agendas rather than on business management. Another critic, an Australian government consultant, said

motivation driven by the need for power and control is misplaced in the museum context:

> In nonprofit and government organizations like art galleries, boards and the directors actually have no control over the budget, staff numbers, or appointment of successors. Anyone attracted to the prospect of being on a board for a cultural institution would more than likely be there to satisfy a constituency. The museum's lack of perceived business influence is reflected in the fact that there has never been a Minister for the Arts alone. The minister [usually] carries a mixed portfolio. This is why board reform and refinements to the appointment process for cultural institutions have never taken place. They are not seen as organizations that are important enough to affect the politician's sense of safety.[33]

As issues on governance and the director–trustee interface were assessed, I wondered what would happen if those in the interface used EQ competencies like intentionality to clarify purpose? Would this increase flow? Remember flow and creativity are released when personal desires and wants (passion) are aligned with clear purpose. Intentionality is the ability to act on purpose, making decisions consistent with personal and professional goals and values. It has three components: managing distractions and remaining focused on objectives; being aware of deeply felt motivations during interactions; and making a consistent effort to bring about desired outcomes.[34] Intentionality shapes ideas about governance and influences the quality of the director–trustee interface. Mixed intentions create mixed purposes, which interfere with governance.

## POLICY DEVELOPMENT AND FINANCIAL AND LEGAL RESPONSIBILITY

Policy and financial management is another source of misunderstanding for the director–trustee interface. It may help to know that policy and financial management requires constant role clarification. The fact that roles differ from one museum to another reflects different constitutions, legal requirements, and the way the director and trustees negotiate and agree on who does what. According to one professional practice manual on museum management, trustees carry full responsibility for financial management, investment policies, and budget approval.[35] In addition, trustees are ultimately responsible for any fund-raising necessary to meet budget requirements and special expenses. While the textbook says trustees carry financial responsibility, directors enable trustees to carry out the job by informing the board on a regular basis about actual and anticipated changes in income and expenditures.

During the decade of change in the 1990s, museum theorists pointed to a major change in roles and expectations in financial issues and the director–trustee interface—the need for expanded financial management skills.[36] While all directors take responsibility for financial management, many directors do not see themselves playing an active role in actual fund-raising. Remember, the director for the AGNSW in Sydney who said: "My job is about selling the integrity of this museum, not fund-raising."[37] Despite the value of the directors' role in social capital development, bottom line financial management is a joint responsibility in the director–trustee interface. Roles have changed, according to the director of the J. Paul Getty Museum:

> In the past, directors were expected to articulate and symbolize the [art] institution. In the future, directors will have to be someone who can manage a complex organization and raise the finances to sustain it.[38]

The director of the Hirshhorn Museum and Sculpture Garden described similar changes saying, "Directors *have* to do fund-raising today; the trustees used to take on the role of providing finance and resources for staff to do their job but that has changed."[39] Although financial management and the director–trustee interface in Canada is less pressured because of government commitment to cultural development, the director of the Art Gallery of Ontario said role expectations still have to be managed:

> In Canada we have a 50/50 [financial] model that combines a European and American perspective. It is a mind-set that works better for boards of trustees. Here we have a board with an open mind. In LA or Boston, trustees prefer a business-type director with a vision of the institution based on a business model with a hands-on board. I didn't want that. The Toronto board is there to enable the director. My role then is to make the board aware of the museum's needs, solicit advice, and advice only.[40]

While a mix of government support and entrepreneurism provides some financial foundation, the director for the NGV in Melbourne questioned how solid the foundation was given continual microeconomic reforms and the lack of a deep philanthropic base in Australia:

> What is the most appropriate level of government funding? Should the State provide 100 percent? There needs to be a mix of funding from the community,

benefactors, and entry prices. There is no one right way but an equitable one needs to be sought. There are so few private benefactors here in Australia, unlike the United States. We have to have government support as a consequence, so we need to look at things people will willingly buy. How can we encourage people to willingly put their discretionary spending into art gallery products and services?[41]

Who makes decisions about these issues in the director–trustee interface? Based on the survey (appendix 2, table 20), directors vary in who they think is responsible for making decisions about policy and governance. The majority of directors thought trustees were responsible for making decisions about policy and governance only. Others thought trustees were the ultimate authority for all decisions, while some believed trustees were responsible for decisions on financial issues only. A few felt trustees were there to act as guides or advisors only because the director retained ultimate authority for all decisions. Other directors indicated trustees were responsible for decisions about strategic development and long-term planning for the museum. When we looked at responsibility for policy development (appendix 2, table 22), the majority of directors thought trustees were responsible for all areas of policy development. Others thought trustees were responsible only for policies around fund-raising and financial development. Few directors thought trustees were responsible for strategy and mission development.

The most effective *best practice* outcomes happen when directors and staff formulate and administer all major policies. The board is then responsible for policy approval. In *theory*, according to one handbook on museum management, policy development combines decisions and actions taken by the board as they realize and implement the museum's mission.[42] They expect the director and staff to develop policy proposals, which the board approves. Directors who think trustees are ultimately responsible for all policy development and decision making need a word of caution. According to one board development consultant, directors with uneven leadership skills tend to protect or hide undeveloped leadership by delegating major responsibilities to trustees.[43] When this happens, trustees may be far too willing to take over financial management and policy development. It gives trustees an opportunity to exercise control that undermines trust relationships and creates legendary struggles over power, politics, and personality.

It is important to nurture and protect the director–trustee interface to share leadership for complex issues predicted for the decade ahead (appendix

2, table 32): legal obligations for copyright, access and equity issues, financial accountability and tax status, and cultural product treaties with indigenous people. The Internet and other forms of electronic information exchange mean copyright and intellectual property protection will become increasingly difficult to police.[44] Access and equity issues reflect changing demographics for migrant, ethnic, and indigenous populations. Tax legislation reform and government demands for financial accountability indicate changes to the entrepreneurial museum's claim as a nonprofit organization. Cultural treaties with indigenous people reflect new ways to manage culturally sensitive collections, recognizing the primary rights of creators to define the meanings and interpretation of work in the museum environment.[45]

Directors used the survey (appendix 2, table 34) to rank order their responsibilities, which may create greater clarity for trustees. Directors indicated their most important responsibility was the legal structure of the museum based on statutory obligations, followed by an advisory role to the board (including managing any conflicts of interest), employment practices, security and maintenance for collection management, health/safety, and acquisition policy. With the creation of the entrepreneurial museum, they also felt increasingly responsible for fund-raising. According to the director of the Isabella Stewart Gardner Museum, managing these responsibilities along with the director–trustee interface is not an easy job:

> I had to learn how to ask for money! The trustees are also expected to do fundraising. It is a real wrestle because fund-raising can so often be seen as predatory. The real issue is about charity but not in the current definition and sense of the word. The word charity comes from the Hebrew word for *justice* through giving or philanthropy. In the Jewish tradition, you don't know you give and the person receiving does not see it. It must be done in this way. We need to reteach the art of charity and philanthropy as the art of unintentional but intended giving. Trustees can enable a museum. In my role, I have fourteen to twenty-five trustees who are constantly being juggled. It is critical to manage these relationships well for a range of reasons, including gift giving. This relationship management can sometimes be quite impossible when you are dealing with impossible, idiosyncratic, and egotistical trustees. The trustees [are] capable of arresting action through the demise of public and foundation funding.[46]

When the interface and financial development is not managed well, the greatest risk is fracturing the museum's external presence. For example, back

in the mid-1990s when the NGV in Melbourne won a substantial financial commitment from the state government, the media attributed the success to the president of the board of trustees. The media also noted the director's absence in the museum's new alliance between business and the arts, commerce and government.[47] Research revealed the real picture—it was the director who had shaped and created the successful financial coup.

The director for the NGV had fought for the abolition of admission fees. This was a step toward increasing museum revenue through increased visitor numbers over a five-year period. Improved and larger facilities were part of a strategy targeting a 50 percent increase in commercial revenue through increased visitor numbers. Trustees resisted abolishing admission fees but when they were dropped, attendance figures multiplied threefold over the subsequent four-month period. One source described how the director persuaded nine trustees, including those with business backgrounds who were skeptical about removing the charges, and then won over the treasury.[48] The director actually did more than that. He had won with a deliberate strategy over a one-year period designed to attract private sector support to meet shortfalls in government funding. The director, not the president of the board, went into twenty different corporate boardrooms, winning financial support with one in three visits. Government funding was based on corporate support. The director for the NGV said part of corporate boardroom success relied on entrepreneurial skills:

> Senior arts administrators today are no longer curators who have come up through the ranks. They need a whole range of skills: management, financial, entrepreneurial, and marketing. The days when a curator gets promoted to director of a major art gallery are over, at least in the current cycle where there is declining public funding and an increasing need for private sector support. Look, ten years from now many more people will have these sorts of skills; I don't know anyone at present that has quite my combination of academic credentials, curatorial experience, and hands-on financial, business and marketing skills. But there will be many more in another decade.[49]

## SUCCESSION PLANNING ISSUES

A prediction for the decade ahead introduces the issue of succession planning in the director–trustee interface. Succession planning is the third area of

shared responsibility between directors and trustees. In theory, trustees are responsible for the search process to locate and select new museum directors. Their success depends on a number of factors: right assessment of the museum's leadership needs, right selection criterion, right timing, and right leadership candidates. Directors support this process in several ways: right representation of the museum's needs, right assessment of the director's job for an accurate position description, and right responsibility for *growing* potential leadership candidates. In my view, every director is responsible for *growing up* at least six people to take their place when the time comes. In the survey, directors indicated they would nominate a director from another museum or a curator to replace them in the leadership role (appendix 2, table 27). This approach to succession planning works if the curatorial candidates have developed experience and skills to shift from indirect leaders for an expert domain to direct leadership for the museum overall.

Succession planning involves teamwork between directors, trustees, and executive recruitment consultants. Teamwork relies on trust in each other's judgment. Important questions must be asked to ensure museums inherit the leaders they deserve. Has selection criteria been updated to reflect requirements for a museum in the 21st century? One guidebook used by boards instructed trustees to look for directors with a combination of expert domain training, museum experience, administration skills, and demonstrated ability.[50] Is this an accurate reflection of the job? Who analyzes the museum's needs and designs director–trustee position descriptions to match? Are EQ competencies and entrepreneurial skills included as leadership requirements? Is there a succession planning process actually in place? Does this include actively creating leadership opportunities for future possible candidates? Does the board or the director participate in or collaborate with any international human resource management forums to explore ways to develop the pool of potential global leadership candidates?

The alarm bell rang in 2000 at the first international conference on museum leadership hosted by the Canadian Museum Association and the International Council of Museums. During the conference, statistics were presented that underscored what my research had already pointed to—a leadership succession planning crisis for the museum sector. In Canada alone, over 50 percent of current museum and heritage directors will retire between 2000 and 2005. This means trustees in over 50 percent of Canada's museums

are conducting executive searches for replacement directors at a time when the talent pool is underdeveloped. Museums may try to avoid the problem by retaining current directors for as long as possible. All directors will eventually retire, so a different strategy is necessary.

I worked with executive development and succession planning processes with a multinational insurance company and an Australian bank with international offices over a five-year period. This experience exposed me to issues that make succession planning a challenge for any organization. I shared some of this experience in a workshop on succession planning after the 2000 leadership conference in Ottawa.[51] The workshop provided an opportunity for participants from Canada, Spain, France, and Australia to explore principles, practices, and problems around succession planning. Workshop participants included current museum directors, human resource managers, and individuals seeking help with their own career path planning. I designed the workshop to include the following core ideas: create a pool of potential talent, pull new leaders up behind you, and integrate organizational and individual development to ensure the museum's long-term survival.

Although enthusiastic about career path planning, many of the participants were less enthusiastic about succession planning for a range of reasons. For example, participants from Europe said the government appointed museum directors, and they had little influence on what seemed to be a political process. To broaden perspective, participants were encouraged to think about succession planning from a personal point of view, naming two people who could do their job if they left the organization today. They were asked to outline the five most important outcomes for their position and whether the two people they thought could do their job could achieve these outcomes. If not, what kind of professional development would they need to grow into the job? We then worked on naming four more people who would be ready for the job in ten years' time. Participants were asked to make predictions about where they thought their organization would be in ten years. We compared the prediction to the four names to see if they intuitively felt these candidates had potential and what kind of professional development they would need to grow into leadership roles over the next ten years. This is the beginning of succession planning.

When the workshop finished, the participants recommended that an international task force be created to address the following points on succession planning as an urgent international museum management issue:

- Reorder financial priorities to ensure the museum has a budget line for professional development by giving up three exhibitions per annum. This releases funds to invest in the museum's most important asset—its people.
- Understand that succession planning for leadership roles is about the museum's survival. Reflect on the levels of complexity model, and assess what level of complexity the museum appears to be working within. For example, many major state and national museums appear to be functioning as Level 4 or Level 5 organizations. Look for people aligned with the museum's level of complexity so leaders will feel in flow with the challenges and perform accordingly.
- Plan leadership searches five to eight years in advance.
- Develop objective standards to measure performance of directors and trustees alike. Conduct annual reviews and offer opportunities for ongoing professional development.
- Create organizational cultures that value human resources and human resource management—find ways to become a learning organization.
- Focus on competency development, not positions in a hierarchy. This shifts perspective from hierarchical advancement to lateral development in an industry with a flat career structure. A focus on competency development for lateral growth rather than vertical advancement provides more opportunity to develop critical EQ competencies that are all too often sacrificed in a climb to the top.
- Collaborate with universities and professional associations, and encourage staff to attend courses on succession planning, change management, and leadership. Attend courses *outside* the cultural heritage sector to expand perspective on entrepreneurism.
- Align enterprise agreements and industrial relations legislation with the principles of succession planning. Although practice may be hampered by some industrial relations agreements, the principles of succession planning remain—pull new leaders up.
- Conduct regular job reviews, keep position descriptions up to date, and use the levels of complexity model to create a leadership matrix for on-the-job leadership experience.
- Most important, develop local talent for a global pool of potential. Grow talent within national borders to keep morale up and allow parochial border protection to drop away in favor of global career paths.

There is a range of published material, practical and cautionary, on succession planning.[52] Human resource professionals have been grappling with the issue of succession planning for decades. Some of their cautionary tales should be read so that anecdotes like the one shared by the director for the Please Touch Museum becomes part of history rather than contemporary practice:

> The boards are just now getting it! There were a couple of science museums that were hiring astronauts as directors! What does an astronaut know about museum management? What do these people know about running a business? Museums are big business and very complicated. The director needs to have people skills and not just be object focused. Trustees need to know [more] about business management.[53]

While conducting research in the United States, I noticed a pattern with boutique (unique or small) and regional museums that larger museums can learn from. Trustees for smaller museums are responding to change more quickly and adapting succession planning strategies. They start looking early on for candidates capable of seeing the entrepreneurial potential in the museum, along with practical ideas on how to develop cultural, economic, *and* social capital. According to the director of the Dennos Museum Center, trustees select directors for smaller museums who are not particularly scholarly but who have leadership experience and backgrounds in business and marketing:

> Boards are now more apt to hire business managers to look at how to position a museum in the community in an active sense. That is a major move from the traditional passive role of museums as a repository of collections. Boards are also aware that the community today no longer has big pockets for funding. Giving is almost a lost art, even in communities where there may be substantial disposable incomes such as Traverse City. As a consequence, directors have to be sensitive to collectors in the area. This more commercial marketing-sensitive orientation challenges museum directors who may have come from the scholarly curatorial path and who are often very narrow in their perspective. A purely curatorial focus tends to neglect the connection to the public. That is not a realistic thing to do any more for directors or trustees.[54]

Connection to the public depends on EQ skills, such as interpersonal connection, to nurture trust relationships with stakeholders around the museum. Intuitively, trustees look for these skills, but the way they do it can be a curious

process. One director described his appointment as a three-part selection process: dinner with twenty-four trustees, lunch with a few more, and a two-hour interview. The interview focused on experience running an art museum, administrating a budget, and hiring/firing staff. The candidate had *no* experience running a museum or managing staff, or working with a large budget. His academic career path included several well-known universities in the United States. After his appointment, the director of the Cleveland Museum of Art discovered that the trustees were looking for EQ competencies such as enthusiasm to be with people, ability to build bridges, and a passion to convey art to people:

> The trustees said that if I could do that, they were confident I would figure out the rest of the plot! The trustees took a big act of faith! I was thirty-six years old at the time. I knew nothing about museums, but the thirty-four-year-old president of the board of trustees became a key to my success through his humor, fund-raising skills, and knowledge about the museum. I directed that gallery for twelve years. We had enormous success and achieved great things.[55]

Succession planning includes making an effort to understand influences on leadership behavior such as differences between various intrinsic motivators, the role passion plays, a willingness to experiment with participative leadership, resilience or energy, and a willingness to learn.[56] Insights into how to approach succession planning can be found in the levels of complexity model. Not everyone will feel in flow with increasing levels of complexity. Pacing challenge with growth in capability over time results in more effective decision making. For example, the director for the Cleveland Museum of Art described an ability to create the *big picture* as the foundation for all leadership decisions and planning processes:

> I am the only one who can create an overall picture of the problem for the staff and the board. Staff and trustees have mastered a strand of the problem but they have not seen the overall picture. I am the one who is uniquely capable of creating that picture and then projecting it back through something like the final strategic plan.[57]

The director of the Saint Louis Art Museum commented on how rare these characteristics were in the director–trustee interface:

> The reason there has been a big turnover of directors in the last five years in the U.S. and Canada is that there are many directors who just cannot see the whole

picture. Directors who can are at the National Gallery in Canada and in Houston. These directors have the big picture concept and can deal with the complexity without getting flustered. That is what is required for a director of a major [art] museum. And you need trustees who are capable of seeing that in [candidates] they might think of hiring.[58]

## INTEGRATING CHANGE AND THE NURTURING TRUST ROLE

The Sydney-based governance advisory group Boardroom Partners offered the final set of insights on the director–trustee interface.[59] The board's role is governance rather than running the organization. Governance involves five main functions: sitting in the pilot seat, recruiting and mentoring the director, succession planning, ensuring resources, and monitoring that all is well organizationally. More professional and career-minded trustees are starting to come onto boards. Trends in Australia include a move toward more independent directors, whereas in the United States there are more nonindependent directors. The CEO and the president of the board may be the same person, which means defining roles very clearly. Other trends described by Boardroom Partners include the following:

- Smaller boards are becoming more common, with a shift from more than fifteen members down to ten or fewer.
- More diversity is needed because women still make up only 5 percent of the board members in Australia.
- There is an increased focus on sustainability and triple bottom lines, which includes social capital.
- Best practice is being redefined to include autonomy, availability, assistance, advertising, and accountability, along with advocacy for the CEO.
- A more disciplined approach to performance management is under way, with codes of conduct and an expectation that trustees are on boards to make contributions, including wisdom and trustworthy advice for CEOs.
- Legal and commercial acumen will be required because government boards are becoming more commercial with laws similar to corporations.
- While entrepreneurism and risk taking are government policies in Australia, legislation has to evolve to rein in "free spirits" who have not acted as ethical entrepreneurs.
- The need for astute succession planning is growing across all sectors, acknowledging the fact that the government will retain control of any government appointments.

- Boards need to ensure all organizations have business plans so the trustees can support the CEOs who are trying to keep their organizations on track.

In most cases, trustees are on museum boards because they want to be useful to the community. They have sought the role to make better use of their skills and experience on behalf of an organization they believe makes a difference in the world. Although many critical comments and observations appeared in this chapter, it is important that issues be aired. The director–trustee interface functions best when it is built on trust. Although directors and trustees seem to agree on the role of governance, trust gets wobbly when it comes to who does what for policy development, approval, and implementation. Trust also gets wobbly around financial management and fund-raising. As for succession planning, this particular interface needs critical attention.

Succession planning depends on how able the members of the director–trustee interface are at seeing, assessing, and judging leadership potential in *advance of need*. This assessment depends on how well they track and respond to changing mandates for the museum, guided by professional human resource management strategies. The director of the Isabella Stewart Gardner Museum suggested that a win/win approach includes professional board development training for trustees and more sophisticated use of human resource management tools: "There is a move to have annual evaluations done on trustees regarding their role and performance and an increasing awareness that directors have to engage in training members of the board for their roles in business management."[60]

The director of the Minneapolis Institute of Art said it took eight years for "mutual training to occur, a two-way process between myself as the CEO and the board of trustees, before we could really say we were functioning effectively."[61] Although it would seem self-evident that once trustee appointments are made, board training should take place, one board development consultant indicated that only 20 percent of organizations actively engage in trustee training.[62] The directors of the Museum of Contemporary Art in Sydney and the Art Gallery of Western Australia reinforced this observation. They commented that their trustees all had informal rather than formal orientation to their roles, the organization, and its overall functions.[63] Both directors reflected that with hindsight they should and would be doing more formal trustee orientations in the future.

Finding people passionate, able, and willing to step into the director–trustee interface may be easier when some of the traditional constraints are removed. How can museums open the way for nontraditional candidates to serve? Some astute observers think the pool of potential leadership candidates can be renewed when museums open a way for women and men from universities, research and professional organizations, government, and the corporate sector to serve.[64] The administrative director at the Walker Art Center said they had "hired more *outside* people in the last five years than ever before to bridge the gap between necessary performance and past behavior."[65] Although museum experience is desirable for those involved in the director–trustee interface, success relies on people passionate about the museum who can use their EQ skills to communicate with people, negotiate conflicts, and manage change.

Two extracts on nurturing relationships of trust are shared from the *Leading with Passion* course to illustrate ways to integrate change.[66] Two different guest speakers told the stories on one Sydney program. Both urged their audience to share their commitment to the need to forge constructive alliances at any cost. The first story was told by a director general for a state government department who encouraged leaders to "Be fair dinkum [Australian colloquialism for truthful] in how you relate to others. This can be hard but leaders need to be up front, listen, and show some empathy. *Passion* is the driver for things you want to achieve. It's what makes it all worthwhile. Create annual goals with meaningful outcomes that make a difference."

The past director of the volunteers committee for the 2000 Olympics told the second story. His story illustrates what happens when leaders nurture relationships of trust and alliances that, in his case, included thousands of volunteers, staff, government officials, trustees, corporations, athletes, and the public:

It's better to have problems with alliances than no alliances at all—better to be in the tent than outside the tent. One leadership size does not fit all—there are different styles and industries. It's an art, not a science. There are quiet ones and outgoing leaders with no self-doubt. Leadership is about the power of contagious enthusiasm. There are different styles for different stages. It's an art of push/pull. Don't be put in a box. Play your natural game. Use your natural strengths and be thoughtful because practice does help. Have a touchstone or explicit idea of leadership. These are the guide ropes to pull forward on. They are the conceptual

frameworks. Know the goals for the organization and why you are persuading [stakeholders] toward that goal. Learn how to use management capability [around you] because leadership and management intersect, they are not separate. Get clear on the *What* [intention]. Use the power of the picture, that vision thing, and create a goal staff [trustees and stakeholders] can picture. Create a picture of the desired outcome and it becomes the power of prediction. Hold people together with the power of the picture. This is what we did for the world and Australia. We created the picture of the Olympic Torch [and its international journey to Sydney]. Remember why you want a particular goal and that an organization's most precious asset is motivated staff. Our goal [the Sydney Olympic Games] was a highly energizing goal. People wanted to get the Games done. We called on their professionalism, passion, and pragmatism. *All* of the volunteers at the Olympic Games had a *passion* to help others.

## NOTES

1. Duitz 1995: 30.

2. Dayton 1987: 13.

3. Lowry 1996 (I).

4. Barbeito 1995 (I).

5. McCaughy 1996 (I).

6. Orioli 1996: 16.

7. Fiori 1996 (C).

8. Latos-Valier 1996 (I).

9. Howard 1995 (I).

10. McCaughy 1996 (I).

11. Beech 1995 (I).

12. Potts 1997: 67.

13. Hawley 1996 (I).

14. Thomson 1996 (I).

15. Bowen, quoted by D'Arcy 1996: 27.

16. Butler 1996 (C).

17. Barbeito 1995 (I).

18. Kolb 1996 (I).

19. Capon 1995 (I).

20. Slazenger 1996 (I).

21. Dayton 1987: 10–14.

22. Simpson 1989, 1994 (I).

23. McCaughy 1996 (I).

24. Hall 1995 (I).

25. Thomson 1996 (I).

26. Marzio 1996 (I).

27. Latos-Valier 1996 (I).

28. Sano 1995 (I).

29. Kolb 1996 (I).

30. Barbeito 1995 (I).

31. Wood 1996 (I).

32. Moffett 1996 (I).

33. Howard 1995 (I).

34. Orioli 1996: 8.

35. American Association of Art Museum Directors 1992: 10–11.

36. Moore 1994: 1.

37. Capon 1995 (I).

38. Walsh 1995 (I).

39. Demetrian 1996 (I).

40. Anderson 1996 (I).

41. Potts 1995 (I).

42. American Association of Art Museum Directors 1992: 6.

43. Dayton 1987: 2.

44. Simpson 1994 (I).

45. Winkworth 1994: 6.

46. Hawley 1996 (I).

47. Maslen 1996: 22.

48. Suffield 1996: 14.

49. Potts, quoted by Maslen 1996: 21–27.

50. American Association of Art Museum Directors 1992: 14.

51. Suchy 2000c.

52. Burdett 1990: 4–5; Chung 1987: 3; Hirsch 1990; Karpin 1995: 10–14; Kets de Vries 1988: 56–60; Leys 2000: 6; Lorsch & Khurana 1999: 96–105; Russ 2000: 37; Vines 2000: 12–18; Mair 2000: 26–31.

53. Kolb 1996 (I).

54. Jenneman 1996 (I).

55. Bergman 1996 (I).

56. Silcock 2000: 32–33.

57. Bergman 1996 (I).

58. Burke 1996 (I).

59. Bridge 2002 (C).

60. Hawley1996 (I).

61. Maurer 1996 (I).

62. Barbeito 1995 (I).

63. Latos-Valier 1996 (I); Paroissein 1995 (I).

64. Boyd 1995: 183.

65. Galligan 1996 (C).

66. Suchy 2001d.

# 6

# Realigning
## *Past and Present Leadership Requirements*

Up to this point, we have examined changing expectations and practices in museum leadership for the 21st century. We have used a fourfold leadership model as a framework to describe how leaders

- represent the organization internally and externally, guided by passion
- create a context to encourage flow so others can give their best
- act as ethical entrepreneurs to sell the integrity of the organization
- nurture relationships of trust with key stakeholders, as in the director–trustee interface

In this chapter, we explore how these changes began to be reflected in position descriptions and approaches to professional leadership development. In theory, changes in leadership requirements create a need to realign position descriptions and career path planning. In practice, this means creating appropriate position descriptions, career paths, and leadership development programs to narrow the gap between past and present leadership requirements.

Shifting patterns in position descriptions were already evident in the 1990s—from museum management to business leadership. There was also evidence of changing patterns in approach to and participation in professional development programs. Although most directors favor on-the-job training and mentors, many have learned to appreciate the values and benefits found in professional development programs. Once again, the information presented in this chapter should be used as a benchmark to track past and present practices. Readers are

encouraged to use the information to audit position descriptions and profes-
sional development to realign past practices with contemporary requirements.

## REALIGNING POSITION DESCRIPTIONS

The director's position description for the NGV in Melbourne provided a
valuable insight into the way trustees and recruitment specialists began re-
aligning expectations for leadership roles. In 1995, the media described the
new director's appointment using the phrase *new breed*, creating an expecta-
tion that the successful candidate would be leading the museum into the 21st
century. During research interviews, the newly appointed director explored
what new-breed director actually meant, whether this was reflected in the se-
lection process, and how his career path enabled him to develop skills to meet
changes in leadership requirements. He said new-breed directors were more
entrepreneurial, capable of balancing a belief in the institution with the real-
ity of marketing:

> The director is the nerve center for the gallery and needs to direct or coordinate
> what should be done, why, and across broad sectors for the organization and
> constituencies like the government, corporations, visitors, and the art commu-
> nity. In the process, our job is to apply some entrepreneurial business practices
> to make money out of the visitors. We also need to be dealing with outreach
> publications both in print and electronic media. We need to look at the way we
> promote ourselves [in relation to] the competition with other audience attrac-
> tants. Art museums are part of a mass market and seen as another leisure activ-
> ity. The curators have to come to terms with this. We need to balance a belief in
> the institution with the reality of marketing. We are not reluctant to enter com-
> mercial activity but we cannot wear the museum's mission to promote and un-
> derstand the visual arts on our sleeve. We are not exactly about entertainment
> and access but about creating greater understanding for people so they will want
> to know more.[1]

Were these new job competencies reflected in the director's position de-
scription, selection criteria, and the executive search process? In theory, a di-
rector's position description reflects the organization's needs. If we consider
information explored in the previous chapter, trustees create position de-
scriptions and selection processes based on their assessment of the museum's
current and future needs. How is this assessment done? What does the

organization use to conduct a leadership needs analysis? Who does it? What tools are used to assess the health of the museum as an organization? How are position descriptions designed so they reflect current and future needs? How do trustees and executive search committees realign past practices for contemporary requirements?

Once a needs analysis is done, leadership requirements must be woven into position descriptions and the executive search process is initiated. The director's position description at the NGV in Australia contained eleven key requirements.[2] Brackets are used and the word *art* is highlighted because the position description applies to other kinds of museums and cultural heritage organizations. The trustees and the state government expected the director to

- provide information to the council of trustees on various matters
- develop strategies for growth and delivery of services
- lead the management group in the development of a business plan
- maintain the development of professional standards
- develop relationships with the state and regional gallery network
- demonstrate extensive experience in policy development [preferably in an *art* museum environment]
- direct acquisitions policy and exhibition programs
- demonstrate leadership and innovation at a senior level in a major organization
- provide evidence of scholarship and professional standing [in the *visual arts*]
- demonstrate extensive experience in leading fund-raising
- provide evidence of an effective network of [*art*] museum professionals

Using the position description as a framework, the trustees highlighted seven characteristics for the recruitment consultants to use as selection criteria. According to the executive search consultant working on the appointment, the *ideal* director would be someone who could support business development while developing a climate for the business of creativity:

> The first criterion was *internal management* of the gallery, defined as a leadership style that was ruthless yet inspired people. This was followed by *external management* of constituencies that meant defining the identity of the gallery in

the public and government's mind. Scholarship [was required] for internal and external credibility—the director had to know about art. *Personality* was defined as able to communicate with people ranging from security staff to the media. Personal connections were essential. The director would need an ability to create a vision of what the art museum could be in the year 2000 in terms of attendance, articles written about it, how readily other galleries would lend to it, what the building would look like. What is it going to take to direct this type of business? A director *different* than what we see today. The arts industry tends to see themselves as precious in some ways but there are parallels with other creative industries such as software, advertising, research, and development. They also have to find a balance between fiscal responsibility and development and sustaining a climate for creative staff in the business of creativity.[3]

A pattern emerged when past practices were realigned with the NGV position description. A director for the 21st-century museum is expected to

- define and represent the museum's identity or story
- establish credibility based on relevant experience and scholarship
- communicate successfully with a wide range and level of stakeholders
- create an organizational culture that encourages staff creativity
- establish and maintain personal connections [social capital]
- create a vision based on a realistic assessment of current and predicted requirements
- develop a business plan and manage financial affairs including revenue development

The realigned position description created a benchmark to track past and present practice. It is worthwhile reviewing press reports on museum director appointments from the mid-1980s to the turn of the century because they revealed major shifts in expectations about leadership, with conflicts and controversies in succession planning and the selection process.

## TRACKING CHANGE THROUGH POSITION DESCRIPTIONS

Looking back to the director's appointment in 1986 at the National Gallery in London revealed an executive search process fraught with issues. One of the main issues was nationality. The first successful candidate recommended by

the chairman of the board of trustees was from the United States. As a member of the selection committee, the chairman recommended the international candidate and made negative references about the British candidates. This alienated the selection committee, who ended up not supporting the recommended candidate. Although well qualified, the candidate tactfully withdrew from what turned into a nationality debate.

The search process for the National Gallery in London continued and another candidate was eventually appointed. The ever-critical media described the new leader as an academic with no museum experience.[4] Although it wasn't explicitly in the position description or selection criteria, the candidate did meet one very critical need—the right nationality. Nationality was an implicit yet important criterion. The director had to be in charge of the museum. The director also had to be an advisor to the government for sensitive decisions on export of paintings and inheritance tax. According to one report, trustees ignored candidates with more ability and public presence in favor of a local candidate who they thought would be more culturally sensitive to the museum–government interface:

> The incoming director has nothing to do with all this [controversy about nationality and director appointments]. He had to face a considerable challenge, all the more so as his credentials for this most important post are relatively modest, and he has no experience working in a gallery, let alone running one. He will need patience and resourcefulness as he battles over the new extension and copes with export problems and acquisitions, as well as the supervision of conversions. And he will have to fight his corner against a powerful Chairman who has gone on record to say that the role of the new recruit is to be that of a coordinator.[5]

Despite media criticism about lack of museum credentials, the director appointed to the NGA in London in 1986 was still holding the leadership role in 1996. Selecting a director with coordination skills paid off for trustees, the museum, and the director. A similar shift in focus happened with a director's appointment for the Corcoran Gallery in the United States around the same time. Similar conflicts were also reported. The director appointed in 1988 resigned one year later over conflicts about censorship and management issues.[6] Media reports on the resignation described the outgoing director's credentials

in art history and experience as an academic. There were also hints that trustees had realigned the position description to better reflect the museum's needs. When a new director was appointed one year later, the media described the candidate as an art historian, educator, *and* administrator—a combination of qualities supported by trustees.[7]

Leadership requirements in the 1990s shifted to include a new focus on coordination and administration skills. The change was reflected in a range of search and selection stories. When the longstanding director for the National Gallery of Art in the United States resigned in 1992, the media described the outgoing director as the epitome of the new-breed museum director—comfortable with a budget and a Botticelli.[8] When the next director for the NGA was appointed, the media highlighted appropriate credentials and experience with reference to a degree in art history, curatorial experience, previous experience as a director for another major museum, experience with royalty and heads of state, a commitment to education, not just blockbuster exhibitions, experience defending budgets with the government, experience building corporate and private support, experience mediating controversies over corporate sponsors, and experience with audience outreach.[9]

Evolving organizational complexity has led to position descriptions designed to attract candidates with experience in a domain of expertise, financial and business management, diplomacy, curatorial practice, public education, collection management, and resilience. Executive search consultants said leaders were expected to cope with an ever increasing workload of budgets, endowments, and audience numbers. Business acumen gained in value. Although scholarly credentials are important (art, science, history), an appreciation and respect for curatorial expertise rather than being an expert curator was one of the major changes. When the longtime director for the National Gallery of Australia retired in the mid-1990s, new criteria used by the international executive search process included leadership, entrepreneurism, marketing, and a new-century vision:

> The successful applicant will be an experienced, innovative leader able to guide this important cultural institution into the future. The successful applicant will need to demonstrate [visual arts] scholarship of international standing and have outstanding management and entrepreneurial skills to develop sponsorship, marketing, and other commercial activities relating to the

Gallery's functions. He/she will also require an appreciation of current communications issues and is well positioned to exploit the opportunities new technology will bring to collecting institutions in terms of access, education, and scholarship. The director may be appointed for a period up to seven years.[10]

The changes created conflicts. Once again, readers are encouraged to use the EQ skill constructive discontent to remain open and receptive to new and different ideas.[11] New ideas about leadership requirements were hotly debated at one American Association of Museums conference in a session on *Credentials for the New Century: Museum Leadership and Management.* A guest speaker from the United States opened the debate by describing differences between leadership and management—leaders grow and move the museum forward, working with managers who settle the process of change and prepare for the next stage of growth.[12] The speaker went on to describe two abilities that needed to be included in position descriptions for the 21st century. The first was being able to assess a situation, synthesize complex information, and motivate others around issues using what looked like EQ competencies (interpersonal connection, trust, and constructive discontent). The second requirement was change management skills. Leaders must be able to adapt, seize opportunities, and move outside territorial boundaries by taking risks, making tough decisions, and admitting mistakes. The session concluded with delegates agreeing that directors' position descriptions were evolving into increasingly complex jobs—far from the original domain of curatorial expertise. Directors for the 21st century need to know how to set boundaries for the museum, define its role in the community, and advocate wisely on its behalf. Delegates acknowledged that directors don't do this on their own. They must have team-building skills—hiring, leading, and developing teams passionate about the role museums play in our communities.

## REALIGNING REMUNERATION WITH JOB COMPLEXITY

Tracking change in the director's position description compared to the real complexity of the job raised questions around remuneration. If directors were expected to play a complex fourfold leadership role, were they being paid for the increased complexity? Remuneration is a complex area of human resource management that requires skills in job sizing and job analysis. Remuneration specialists compare jobs of similar size, responsibility, and scope both within

and between industry sectors. In theory, appropriate remuneration reflects an accurate appreciation of job complexity, responsibility, and expected level of performance. In practice, there are questions we need to ask. How much *should* an entrepreneurial museum director's position be worth? How is job worth measured? How is a candidate's experience measured? How is passion valued? How much is passion worth? If a candidate does not have domain-specific credentials but has a passion for the industry and experience making money while making a difference, does this count? How is willingness to serve valued? Is the level of organizational complexity included in the remuneration review along with the size of the budget and number of staff? How much are skills in social, environmental, and cultural capital development worth? How are EQ skills valued? Are EQ skills equal in value to financial acumen? How do we measure the value of truthfully representing the organization? How do we measure the value of creating a context for staff to give their best? How do we measure the value of ethical entrepreneurism? How do we measure the value of nurturing trust relationships, knowing that trust forms social capital, which is the foundation for economic exchange? What is the bottom line perform-ance expectation and is this rewarded fairly?

In the survey (appendix 2, tables 9–10), just over half of the directors de-scribed salary increases in the mid-1990s to reflect increased job responsibili-ties due primarily to changes in government funding. Decreased government funding meant directors experienced increased responsibility for marketing and budgeting followed by financial management and fund-raising, new tar-gets established in the corporate plan, and staff responsibility. Regular remu-neration reviews are recommended to track what is called *felt fair pay.* Although most remuneration reviews result in increased salary packages, this is not always the case. In some industry sectors (finance), boards have had to come to grips with executive remuneration packages that are completely out of alignment (i.e., overpriced) with the position description and perform-ance.[13] The museum sector can learn from this experience.

When the American Association of Art Museum Directors (AAAMD) con-ducted a remuneration review in 1996 across 168 museums, they recom-mended salary bands based on a museum's operational budget and metropolitan area of population. We need to ask if this kind of banding accu-rately reflects the complexity of the job. Are there other factors we need to in-clude in remuneration reviews? The AAAMD described the mean salary for a

director in the United States as U.S.$114,744 with responsibility for an oper-
ational budget between U.S.$2,500,000 and $4,999,999 in a population center
of 2,000,000 people.[14] The highest salary reported in the survey was
U.S.$303,493 with an operational budget over $10,000,000 positioned in the
Midwest with a population between 2,000,000 and 4,999,999.

When museum sector remuneration was discussed with executive recruit-
ment consultants in Australia and the United States, they highlighted discrepan-
cies between countries. The discrepancies influence successful international
executive selection practices. For example, the total remuneration package for the
leader of the National Gallery of Australia back in 1995 was around A$130,000.
As a public museum, the salary was in line with government remuneration tri-
bunal guidelines. It was distressingly low in comparison with similar executive
level roles with the same complexity in other industries.[15] One anonymous
source pointed out that the prime minister of Australia was paid a base salary
around A$150,000 for the nation's most important leadership role. Another re-
cruitment consultant said remuneration packages in the 1990s were *too low* be-
cause they did not reflect job complexity and did not include risk management.
With the addition of risk management, the recommended basic salary package
for the NGA and NGV leadership role should have been around A$200,000.[16]

Risk management was introduced as a criterion in the United States when
trustees realized the amount of expertise required to make decisions about ac-
quisitions, deaccessions, collection appraisals, and benefactor donations. In
the survey (appendix 2, table 35), a high percentage of directors said collec-
tion management was based primarily on their own sense of connoisseurship.
To manage the risk, directors use valuation tools like the auction market, a
professional valuer, professional dealers, and curator expertise (appendix 2,
table 36). Very few directors said they held *total* responsibility for decisions
like acquisitions or valuing collections. They rely on curators, art auction
house valuers, and commercial gallery valuers to assist risk management (ap-
pendix 2, table 38). Although directors have discretionary decision-making
power, they share the risk with curators and trustees, who play an important
role in risk management (appendix 2, table 39).

## TRACKING CHANGE WITH PROFESSIONAL DEVELOPMENT
Up to 1993, based on the survey, it appears that potential and existing museum
directors were not actively engaged in leadership development programs. From

1993 onward, the survey (appendix 2, table 6) indicated that changes in museum management requirements prompted directors and aspiring directors to take a more active interest in professional development with courses on team building, strategic planning, marketing, organization development, and executive negotiation. By the mid-1990s, changes in museum management were so apparent that the Museum Management Institute (MMI) in the United States conducted an applicant development needs analysis.[17] Outcomes contributed to the curriculum review described in chapter 1, and evidence for the change has been mapped in subsequent chapters:

- Change has been endemic in the museum field in the United States, as well as in the countries represented by the participants. One of the most challenging aspects of the change is reconciling dichotomies. Participants reported being torn between being advocates for their particular domain of expertise (art, science, and history), scholars, and visionaries on the one hand and cost-efficient managers on the other. They also reported that the skills that had served them well as curators such as independence, scholarship, and orientation to detail were at odds with the strategic vision required of museum directors.
- Museum professionals have been confronted with questions about the museum's relevance to society. As a result, they must think creatively about their museum's value and communicate it to their publics.
- There were a constellation of issues relating to decreased public funding, including the desire to attract and retain new and diverse audiences, the need to identify additional sources of funding, and a demand for better financial management strategies. Museums have felt the impact of retrenchment—staff have been asked to do more with less, often resulting in job burnout and dissatisfaction.
- As a result of the shift away from museum management, participants need new skills for more direct leadership, such as team building, conflict resolution, and managing board relations.

Consultation with museum management program coordinators in Australia revealed additional issues. Initiated by the Australian Council of Museum Directors in the early 1990s, Australia's annual museum management course began as a two-week residential program that focused on managerial

functions, personal development, and generic leadership skills for organization effectiveness. The program was suspended after 1995 because of market saturation and financial constraints for museums in the Austral–Asia Pacific region. When the original Australian museum management program was reviewed, some unusual patterns were noted. The majority of participants were not directors, and art museums rarely participated. The Australian program coordinator attributed this to a combination of factors, such as lack of commitment to training and development, lack of training funds, and lack of available staff because of cutbacks:

> We didn't have anyone from cultural organizations like art museums. The participants came from natural history, history, science, zoological, and maritime museums. The group was totally focused on issues to do with traveling exhibitions. There was some interest in marketing, balancing science and research, and change management. They were also interested in how to manage politicians, the government who have particular agendas in regards to museums, and how to deal with the populist view.[18]

When I discussed the background of the program with a past president of the Council of Museum Directors, she described a split between art and science as an ongoing issue for museums, professional development, and society in general:

> It took ten years to bring art galleries and museums together. In Australia, there is a split between science and art, museum educators and curators. The essence of museums is all the same. They are collection-based institutions with a service to the public but there are these splits within and in the public eye. What does it take to be an effective director? It starts with being innovative, a leader, and having essential survival skills as the pressures are very high![19]

The perceived split between science and the arts became apparent when reporting outcomes from the research on change management and leadership challenges. Science and natural history museums were reluctant to consider the relevance of the research to their organizations because the case study organization had been art museums. On an ironic note, when the *Leading with Passion* course was launched, participants came from a range of organizational types (no museums). They found the case study on art museums relevant for their business—all they had to do was substitute the word *museum*

with the name of their organization and the change challenges and leadership issues were exactly the same.

After a period of turbulence, Museums Australia (the national industry association) launched a new museum leadership program in 1999. The Museum Leadership Program or MLP has new sponsorship and a different university auspice. The eight-day program is coordinated by the Melbourne Business School at the University of Melbourne, has two foundation sponsors, reports to an advisory panel, conducts a careful participant selection process, and combines teaching faculty from the MMI in the United States with staff at the Melbourne Business School. When the current program director reflected on past and present leadership development practices, it was apparent that the MLP does what it can to bridge the gap between past practices and contemporary requirements.[20] At the same time, some past patterns still influence present practice:

- Two MLP programs have been offered since 1999, attracting eighty participants. The majority came from art museums/galleries and a high proportion from the regional sector.[21] The remaining participants (in order of frequency) came from national or history museums, science (which includes botanical), zoo, marine, war memorials, industry-based professional associations, special interest museums (which includes religious), university, maritime, children, and city councils. Industry sector representation is skewed toward art museums. On the upside, increased art museum participation corrects past lack of participation in professional leadership development. Also on the upside, program participants represent most of Australia's major public museums (art, history, war, science, and natural history). On the downside, there is a lack of balance in national participation. Australia's vast geographic distances mean participants are drawn mainly from the east coast. Travel expenses are a problem in a traditionally cash-strapped sector.
- Sponsorship and funding to keep museum leadership programs running is an ongoing concern. The fee income for the Australian MLP is only 50 percent of program cost. Given that the principal sponsors are visual arts oriented, there is some concern that the sponsorship influences the museum sector's perception of the program. Hence, the turnaround in museum representation with a higher proportion of arts and arts related participants.

Equal external sponsorship from the science sector would help heal what appears to be an ongoing split between the arts and science. In this instance, natural history museums are included in science.

- The participant profile in the MLP has changed from the 1990s, with more participants described as directors rather than curators.[22] Applications are processed through an allocation matrix with specific selection criteria. Program participants are drawn from similar organizational levels to create the perception of equality so participants will be more willing to work together and share experiences. The number of directors (40 percent) participating in the MLP has increased since the 1990s, and they represent regional and special interest museums and industry associations. Other participants include deputy directors, the executive team or heads of functions (corporate services, education or access, collection management, finance, business development, and registration), curators, and project managers.
- Australia's MLP program design is based on outcomes from a needs analysis symposium conducted in 1997 with selected industry representatives. The symposium was facilitated by a representative from the U.S.-based MMI curriculum review team. The curriculum for the MLP is updated prior to each program based on feedback from members of various industry associations and trends detected by MMI advisors. The basic framework for the program is balanced three ways: strategy design (direction and vision), implementing strategy *externally* (marketing, branding, and positioning), and implementing strategy *internally* (making strategy happen through team development and organizational buy-in).

Directors for large capital city–based institutions do not attend the MLP for several reasons. The invitation strategy is designed to encourage broad industry representation. The strategy includes encouraging institutions to send two or three participants at one time. This means participants become peer support to increase successful transfer of theory into practice when they return to their organizations. Because the curriculum for the MLP is designed to facilitate the transition from functional responsibility to general management, existing museum directors do not fit the selection criteria. Existing directors are *already* in general management roles; it was not clear what professional development strategies are available for continuing professional development.

Part of this problem was tracked in the 1990s. Although Arts Training Australia, a government-funded body, developed a category for museums and galleries in their National Vocational Education and Training Plan for the Arts and Cultural Industries, the occupational classification that came nearest to a museum director was *specialist manager not elsewhere classified*. They agreed that the classification did not reflect the evolving complexity of the role. As a consequence, ongoing professional development for executive-level staff fell short of the real requirements:

> Increasing corporatization and commercialization of the museums and galleries industry means there is a need for managers to have highly developed skills in human, physical, and financial management as well as strategic planning and reporting. Similarly, revenue generation is becoming increasingly important, and many museum workers require marketing, sponsorship, lobbying, fundraising, and promotional skills.[23]

It takes substantial financial resources to maintain specially designed museum leadership programs like the MMI in the United States and the MLP in Australia. Some critics suggest that program resources could be better invested in other strategies, given that few existing museum directors cite museum leadership programs as a major influence on their career path. Perhaps this view reflects a past practice of anti-managerialism that will change as we move further into the 21st century. For example, the director for the Phillips Collection initially resisted the idea of management development training because it felt at odds with a curator's career path: "Once I got there [MMI], a case study on Motown Productions hooked me—for the first time I saw management as a creative act and I knew then I wanted to be a museum director."[24] In this case, the leader had an astute mentor who recognized potential and provided encouragement to explore avenues *outside* the curators' domain of expertise. Other directors shared similar conversion stories. One English museum director's self-confessed anti-American British arrogance was completely turned around by the MMI: "It was a remarkable, extraordinary experience of enormous value and to describe it in a less than serious way would be to demean it."[25] Someone else who came into the museum sector from mainstream business was surprised by the industry's attitude of anti-managerialism. This is ironic given that several management consultants, myself included, use museums as models to illustrate leadership skills with other industry sectors. Mu-

seums are excellent role models to teach concepts like creativity, cross-functional teamwork, social capital development, elegance, membership, and commitment.

Some parts of the cultural industry sector have been critical of university-based courses that seem to have little to do with real life; this may be slowly changing.[26] Readers are encouraged to look around their own organizations and industry groups. Are past professional development practices realigned with present requirements? Is anti-managerialism starting to shift toward an appreciation of the *business* of creativity? Changes will continue to challenge assumptions about leadership, according to an executive recruitment consultant:

> Leadership inspires, takes risks, lives outside the nine dots and management is a more orderly process. You can't learn what you can't learn. Leadership is a self-select process. We all have to ask ourselves if we are going to be natural curators, natural managers, or natural leaders.[27]

While the idea of natural leaders is frequently raised, evidence discussed in chapter 7 will shed a different light on career path choices and shifts into leadership roles. Over the last twenty years, I have witnessed hundreds of people in professional development programs learn how to develop positive ways of energizing and influencing others toward a shared vision. This is the essence of leadership. Structured professional development programs provide opportunities to learn leadership skills that may feel unnatural at first but pave the way for successful cultural enterprise development.[28] Professional development needs to happen *before* a predictable fork in the career path—the choice between functional or general management. The director of the J. Paul Getty Museum in Los Angeles said museum management courses like the MMI should provide opportunities to explore leadership capability prior to assuming museum director roles. Professional development helps prepare people for leadership roles so they need not repeat the old trial and error approach. People in leadership roles without the benefit of prior professional development often inadvertently end up damaging themselves and the organization. The director of the J. Paul Getty Museum suggested director development options needed to range from international institutes to in-company workshops focused on specific skills:

> These courses need to be led by people with human resource management experience and finance backgrounds who are capable of teaching people with curatorial

backgrounds how to equip themselves for management roles. We have to have peo-
ple [leading museums] who can understand the essence of [art] museums, not
professional artists or art historians, as such.[29]

The preceding analysis of professional development programs examined
patterns in the United States, Australia, and Canada. Professional develop-
ment programs in England in the 1990s were also reviewed. According to one
report, management and leadership skills had not been included in museum
training programs because of the perception that museums were the antithe-
sis to theme parks and living history displays, which needed management
skills.[30] The report described conflicts around rigid position prescriptions,
conventions in the museum industry, and definitions of curatorship that fo-
cused on documentation, care, and assessment of objects rather than museum
management. The report also picked up conflicts in the way museum sector
staff see museums and their roles in museums. In their experience, museums
are *not in business*; therefore, museum staff do not need management skills.

Readers are encouraged to conduct audits on professional development pro-
grams in their local industry sector. The international situation continues to
change, according to key members of the International Committee for Training
of Personnel (ICOM).[31] We must continue to look carefully at how curriculum
changes align with leadership requirements reflected in changing position de-
scriptions. For example, since my research was completed, countries like New
Zealand have launched culture-specific leadership development programs that
cater to bicultural and bilingual requirements.[32] The United States has more
programs and development options than other countries because of the sheer
size of the market. This has advantages and disadvantages. The director for the
Art Gallery of Ontario indicated that many Canadians go to the United States
for concentrated development, often overlooking excellent Canadian-based de-
velopment options.[33] In addition, many museum professionals may never at-
tend professional development programs, no matter where they are offered. The
director for the Cultural Resource Management Program at the University of
Victoria in British Columbia tracked factors that motivate or deter participation
in professional education and found problems with time, time frames, and
making commitments to programs four months ahead of time:

The general lack of institutional planning and support for continuing profes-
sional education [in the cultural industry sector] emerged as *the* biggest issue

for individuals. While most [participants] don't encounter active resistance to professional education requests, there are few financial resources devoted to professional development, although conferences get support. There is little formal planning around competency development or career development and little back-up support for staff who wish to take time away from demanding jobs. In this neutral to slightly hostile atmosphere, it seems to be up to individual staff to initiate, justify, and locate resources to support professional development activities. I know that these are generalizations but they emerged in a pretty powerful way and represent a significant challenge for this community. It is an interesting dynamic to study because most museum directors would confirm that they support professional development wholeheartedly.[34]

In my experience, museums often give financial support for conferences but shy away from financial support for professional development programs. In many cases, conferences cost more than professional development programs. The problem with funding conferences over development programs is obvious. There is plenty of opportunity at conferences for networking and information exchange, but there is little scope to test, expand, or build new leadership skills. Conferences are a safe but inadequate form of professional development.

## ON-THE-JOB DEVELOPMENT IS THE FAVORITE OPTION

Many directors continue to use on-the-job leadership development to prepare for their roles. The director of the Museum of Fine Arts in Houston described a mixture of development options but hinted that on-the-job training was much more effective than museum-specific training courses. He also suggested that potential directors need physical fitness, experience in the hospitality industry, and exposure to hard business. In his experience, these options are more beneficial than *soft approaches* offered through museum training programs:

First, be prepared for the social activities associated with a museum. There is a dinner every night! I never thought I, of all people, would own four tuxedos. Aspiring directors need to be prepared for a seven-day week and twelve-hour days. It is hard work. Second, go to Cornell School of Hotel Management and learn the politics of hospitality as so much of the director's time is spent in this role. I am a hermit by instinct but the director has to be an extrovert and socialize. Third, know about art [domain of expertise]. I have written and published five

books. It helps to know your field. Fourth, continue the education process. I did my doctorate on the popularity of fine art in the American 19th century. I did a double major at the University of Chicago in history and art history. With art museums, pure art history is still required but this must be matched with hard-core business skills. In the future, knowledge of [art] and how to deal with American businessmen will make the success of an [art] museum. My advice to any aspiring director is *not* to do a museum studies course or even the MMI, as these are much too soft. Mix with and learn about business functions through business relationships or do an MBA.[35]

On-the-job development is excellent when there is a clear ten-year plan and a career path that includes *real* leadership opportunities on the job. It also works when individuals are self-aware enough to feel when they are out of flow and deliberately seek new job challenges to cultivate new skills. For example, the director of the NGV in Melbourne created a career path bridging arts and business because he felt or *sensed* changes in himself and the industry:

> With a background in academia, I sensed that business and lateral thinking skills were going to be absolutely necessary. I moved into investment banking and corporate finance as the director of media and telecommunications with a major company in the United Kingdom. Working in finance was the opposite end of the spectrum from academia. The commercial world offered insights and experience into sponsors, financial stewardship, and how to handle money as investments. I could see connections, horizons, and new ways of doing things. You have to be temperamentally suited to move from academia and curating to the finance world. Curatorial positions in museums attract only one sort of person, and those people are not commercially oriented. I moved from the finance world to deputy director of international art at the National Gallery of Victoria in 1994. I won the director's position in 1995.[36]

The director of the Museum of Contemporary Art in Chicago also sensed changes in himself and the need for more complex challenges to stay in flow. He created a mixture of academic, industry, and on-the-job development on a career path leading to directorship. He described how EQ skills such as resilience are essential to leadership and stressed that potential directors need to develop a sense of robustness and toughness. He learned resilience through the school of hard knocks, which taught him how to appreciate failure as an

opportunity. He described setbacks as a source of energy, encouraging direc-
tors to return to battles rather than retreat:

> I had done business education for arts managers at Columbia University, which
> fueled the move to Texas. My wife had also gone from retail to banking. We were
> both reading in areas of common interest and saw that managing arts or cul-
> tural organizations had things in common with banking. There is a scientific
> and analytical process to running an organization. The manager of an oil com-
> pany has things in common with the director of an art museum, like setting
> goals and achieving objectives that require a nuts and bolts process of thought
> and diligent execution to be effective. I blended my curatorial, scholarly, history
> background with the nuts and bolts of business. I am more practical and terse
> now with creative decisions. I work with an organic whole, not two separate fil-
> ters. The nuts and bolts approach can be used in the profit and nonprofit world
> with the right qualifications. I have been lucky with my career path as I had suc-
> cess with director appointments at a very early age. The question now is, what's
> next? I have twenty-five more productive years ahead and it won't be in this
> field. I need more emotional satisfaction with the intellectual stimulation.[37]

Although on-the-job leadership development works for some directors, it
is fraught with difficulties for others. Several directors described problems
with narrow career paths and stymied advancement in an industry where
many people hold the same position for over ten years. This pattern, com-
bined with low pay and professional silos or ghettos, may result in limited op-
portunity for on-the-job leadership experience. Creating more opportunities
means breaking down what the director of the National Museum of African
Art in the United States called the cult of the museum:

> A director has to have a passion for objects. This is appropriate, as [art] muse-
> ums are object oriented. It is rare, though, to find curators who combine object
> orientation, scholarship, and the gift of management. The Museum of African
> Art has staff with very strong turf consciousness. There continues to be compe-
> tition for the director's favors. The board does not create difficulties, talented
> staff do this. They could do more if they were less competitive. The situation is
> based on the cult of the museum, which is curator centered. The previous di-
> rector was a curator who looked for curators and awarded leadership [opportu-
> nities] in the museum only to curators. This set up terrific resentment with
> other professional groups on staff.[38]

As we have seen in previous chapters, there is a kernel of truth in this director's experience. In the survey (appendix 2, table 26), directors described curators as their first point of contact for input into decision making, followed by the board of trustees, corporate managers, deputy directors, and financial managers. Other staff members were consulted, but less often—exhibition planners, public program managers, marketing managers, and business development managers. While there is an understandable bias toward curators this is not an unusual pattern. There are similar patterns in other kinds of organizations.

The financial services sector calls it the cult of the accountant or actuary. Capable individuals with obvious leadership potential who are not members of the dominant professional group must learn how to manage the bias, obstacles, and barriers to career development. Functional silos develop in most organizations. For example, some of my client organizations include essential service industries like telecommunications and electricity. In these industries the cult of the engineer is very strong. Feathers were ruffled when two different state public utilities in Australia appointed executive directors with commerce rather than engineering backgrounds. The candidates were very capable leaders who had *grown up* in the organizations but they were not engineers. Their appointments initially met strong internal resistance, but capability won in the long run. In the health sector, the cult of the doctor dominates leadership roles. While nursing professionals carry equal responsibility for ward management, do their career paths lead into general management roles for the hospital as a whole?

## ALTERNATIVE CAREER PATHS FOR DEVELOPMENT

While curatorial dominance is a significant influence over on-the-job leadership development in museums, there are ways around and through the pattern. Several directors enjoyed career paths in administration, architecture, journalism, and science. For example, the first job after graduation for the director of the Fine Arts Museums of San Francisco was acting as the director's assistant at the Met in New York.[39] The next move on this future director's career path was on-the-job leadership training in public programs and education. From there, a position opened as head of the education department, which he accepted when he was only twenty-seven years old. The move into public programs and museum education was a deliberate choice. He saw the need for leadership skills in a traditionally neglected division in many

museums. On-the-job leadership training led to a vice-director position for education, which paved the way for the director's role at the Dallas Museum of Art. After thirteen years in Dallas, the director accepted an offer to lead the Fine Arts Museums of San Francisco.

This was not the only director whose career path bypassed curatorial roles. The director of the Maryhill Museum gained valuable on-the-job training through marriage, raising a family, international moves, and diverse work experience:

> Marketing and legal work are pertinent to any leadership role. Marketing helps [leaders] know how to deal with demographic data and audience analysis. It helps to understand the extension of data and how to analyze, quantify, and interpret it. Statistical data is very useful to a CEO, as are accounting skills. How many art museum directors are comfortable with these skills? The legal work hones and disciplines thought, plus you have to meet deadlines, be quick witted, switch gears quickly, and know how to write contracts.[40]

The director of the National Gallery of Art in the United States described on-the-job experience as an officer in the Navy as "worth its weight in gold," providing valuable administrative and operations experience.[41] The director of the Art Gallery of Western Australia described how coordinating national and international touring projects developed leadership skills on the job:

> The Biennale of Sydney brought me in touch with major centers around the world. Big exhibitions like a Biennale are different in that they require a coordinator to deliver a product to big museums like the Art Gallery of New South Wales. This involves a large number of people, international forums, catalogue production, sponsorship, and freight deals. I was head-hunted for the director's job in Western Australia after my Biennale experience.[42]

Originally trained as an architect, the director for the MoCA in Los Angeles enjoyed on-the-job training designing installations for the Walker Art Center in Minneapolis: "I had no interest in museums but one exhibition with light artists [which] the Hell's Angels came to see opened my eyes about potential audiences."[43] This revelation led to a role directing Public Art for the National Endowment for the Arts in Washington, D.C. As a national foundation, the position offered opportunities to lead national projects that required

skills in policy development, budgets, project assessment, and grant alloca-
tion. These skills led to a series of museum directorships on a career path
through Texas, up the east coast, and out to California to start up the MoCA.
He warned that the success of on-the-job training depended on having a very
clear inner sense of personal timing to stay in flow.

The innate desire to stay in flow prompts some aspiring directors to make
radical moves between museums, coasts, and countries. Moves are easier in
countries like the United States where there are more choices in the museum
market. I tracked what appears to be a career path pattern in the United States.
Many potential directors start on the east coast, move to Texas, on to Califor-
nia, up to Chicago, and back to the east coast. Although traditional career
paths favor large museums in capital city centers like New York, Boston, Lon-
don, Melbourne, and Sydney, smaller cities actually offer *more* on-the-job
leadership opportunities. According to the director of the Saint Louis Art Mu-
seum, smaller cities offer better lifestyle options and more leadership oppor-
tunities in an industry sector with career path challenges:

> There's a new director in Dallas who had an unusual career path. He worked for
> five other museums prior to Dallas. That is unusual, as most people stay with
> their museum for over ten years. There is, historically, very little movement in
> the field. The director in Houston has been there sixteen years. What doesn't
> show in any career path study are those directors who are *impossible* to move.
> They are paid so well that other museums can't lure them with money to an-
> other city. They are wearing golden handcuffs. Search firms won't take people
> out of deferred contracts as they think it would cost too much money so they
> often don't even approach people who might be appropriate candidates. Take
> MoMA for example, they would not pay the difference in living expenses for
> one particular candidate to move interstate to New York. We have an ex-MoMA
> curator who moved from New York to St. Louis for lifestyle reasons. She is very
> athletic and said it used to take three weeks to find a tennis court for a game in
> New York. When we recruited her, we found out she was 30 percent undercom-
> pensated in New York. There is someone from a museum in Boston who moved
> to Seattle to be a chief curator and it was for salary and lifestyle. It's not just
> lifestyle but broader opportunities that are fueling the move for senior staff to
> leave the big cities and big museums for nicer places to live. The national pic-
> ture is loosening up in the U.S. In St. Louis, we do our own recruitment and hire
> people off other large organizations. We make it quite clear what we have to

offer, opportunity and freedom. We have a history of aggressive recruitment and see it as creating new opportunities for people. When they come to St. Louis, they find they have increased responsibilities. We are all in it together, creating new and interesting ideas to bring people to the Saint Louis Art Museum. We offer more rewards through major projects.[44]

Smaller cities and regional centers may not offer the kudos but they do offer leadership experience and life enrichment, according to the director of the Dennos Museum Center:

This is a big city job in a small town with all of the amenities of a larger community. The salary is livable and I have no desire to be the next Thomas Hoving. I viewed Traverse City as a center for potential cultural development and despite the lack of strength in countywide planning to combat over- and inappropriate development, I am optimistic about Traverse's ability to develop and sustain a viable community in an extremely beautiful part of Michigan.[45]

Directors described career paths with on-the-job training as "a series of happy accidents," and four factors come into play—self-awareness, opportunity, timing, and clear intentions. Leaders with self-awareness use EQ skills like intuition, paying attention to *inner* prompts that signal a need for new challenges. To stay in flow, leaders need to pay attention to their intuition. For example, the director for the Tate Gallery said he had *no choice* when he took on the Tate Gallery.[46] The opportunity presented the best collection of British art and offered ways to shape not only the collection but also the museum's presence nationally and internationally. The director for the Yale Center for British Art had two rules for on-the-job leadership training. First, stay in a job for the length of time it takes to see outcomes for major decisions. Second, look for a new position within museums experiencing problems and in need of immediate leadership:

Five years is the minimum at any museum. Seven to eight years is the optimum and ten years the maximum. When I took on the role at the National Gallery of Victoria [in Australia], they had had a succession of weak directors. This had created a situation where staff were at each other's throats, but they had a great collection. I decided to take on the job because people wanted something to happen. I learned a great deal about the director's role with the National Gallery

of Victoria. I learned about the Public Service Board, difficult curators, how to improve the atmosphere of an institution. This was not easy. It meant taking the role of internal exile. We had to create new positions for staff to resolve difficulties. One particular trustee's advice was invaluable, take the easiest people first and then the difficult cases. To be a director, you have to be prepared to do the difficult. You just can not be weak! And while you are doing this, you have to look like you are enjoying yourself![47]

The director for the Queensland Art Gallery in Brisbane used a similar on-the-job training strategy. The career path included experience leading two regional galleries and a stint on the board of the Australian Gallery Directors Council to develop confidence as a leader. This particular director was only thirty-three years old when he successfully won the director's role for a major state museum: "I thought I could do it, and the best time to leave a job is when you don't need one! As you can see, there's no problem with self-esteem here."[48] The director for the Art Institute of Chicago also described the benefits of regional development opportunities. Although he started with an internship at the Metropolitan Museum of Art, it was experience in smaller regional museums that led to directorship of the Saint Louis Museum of Art and then the Art Institute of Chicago. The AIC director also described other important influences on leadership development such as early childhood experiences, personal values and interests, and personality:

You can't teach these things to a museum director but we hope to draw people with those characteristics to this profession. I want to offer the idea that directors need [art] history, experience with people management, and exposure to other types of discourse such as management, law, and economics.[49]

## THE IMPORTANCE OF MENTORS

Mentors are the last, and for some directors the most important, professional development strategy to realign past and present leadership requirements. Mentoring is defined as a relationship that increases self-awareness through shared reflections, collaboration, a sense of challenge, and activities that foster personal and professional change. Mentoring is designed into the Effective People Management program taught in the Graduate School of Management at the University of Technology Sydney, in Australia.[50] Mentoring has two

main aims. First, it provides people with a source of support and a resource for personal development. Second, involvement in mentoring relationships provides people with an opportunity to practice the art of mentoring, which is an important leadership skill. Mentoring uses EQ skills to create rapport (warmth and trust), interpersonal connection, empathy, and shared experience rather than advice giving, and allows the mentor to be with another person in a compassionate way, help the person explore preferred options for actions, and trust that if both parties listen well, much can be accomplished.[51]

The director of the Art Gallery of Ontario described a mentor's influence during a summer internship at the MoMA in New York as a turning point for his career path. The mentor encouraged him to consider experience *outside* the museum's traditional domain of expertise:

> As a consequence, I left to teach at the University of Rome for one semester to decide whether academia was going to be for me or not. It was not. But the travel was good. From that experience, I moved to Atlanta to take up the directorship of the Atlanta Museum of Art for eight years.[52]

The director for the Dennos Museum Center described a similar mentoring influence but one that was a bit closer to home.[53] Trained as a physicist/astronomer, the director came into the art museum world through the world of planetariums and was mentored by his wife. His wife's degree in art and her experience in the Montessori education system influenced the director's educational approach to content and audience development at the Dennos Museum Center.

Mentors are critical for building leadership confidence, according to the directors of the Tate Gallery in London, the Isabella Stewart Gardner Museum in Boston, and the Whitney Museum of American Art in New York. Their extended quotes below illustrate the importance of mentoring as a process of personal development for managers and leaders.[54] Leadership in senior roles can be a very lonely job. Appropriate and trusted mentors are essential for personal survival, according to the director of the Tate Gallery:

> There were two to three people through which I learned about critical aspects of the director's role. One was a museum director in Holland through whom I learned how important it is to stay close to artists even when you are aged sixty.

One was the director of the Pompidou Center who had a real feel for works of art and acquisitions. And finally, someone associated with the Tate who is aged seventy and makes me think about problems from a different direction. Mentors are very important. I often realize how very alone I am in this job. It is frightening that there are only one or two people around the world one can share one's ideas and thoughts with.[55]

The director for the Isabella Stewart Gardner Museum described two key influences on her evolution as a leader—development programs and mentors:

> I have been fortunate to have unique experience in leadership development. To begin with, I participated in a program launched by the Ford Foundation called Leadership in a Public Arena held in Washington, D.C., with characters similar to cabinet ministers. From this first experience, I learned how to lead based on an innate *take charge ability*. Secondly, I was apprentice to Donald Mitchell and Michael Spock. Spock was a pure pioneer in the development of children's museums in the U.S. These two men changed my life because they had such a commitment to museums as hands-on [organizations], participative, and based on a vision from the soul. They made a big impact—blending science and children's museums. Finally, I worked with Michael Dukakis when he was governor of Massachusetts. As governor, he supported the arts when I was director of the Arts Council [and] I was pushed to think in policy ways.[56]

The career path for the director of the Whitney Museum of American Art was very unusual and was influenced by significant mentors *outside* the museum sector:

> I was still an undergraduate student when I took on the role as assistant to the director for this particular museum in New York. It was controversial because a site was being leveled in a black ghetto for this museum. Here I was this smart . . . kid! The director was a real maverick, an ex-director of the Corcoran. He'd quit his previous job over principles. He taught me about museums. When I moved to take up the role of deputy director for the Long Beach Museum in California, I was only twenty-four years old and saw this as a chance to work with I. M. Pei [architect] to create a model for the new museum. Frank Geary [architect] was one of my mentors in that process. I learned about the complexity of museum planning from Pei. I learned all I know about museology from a man who had been directing the Wadsworth Atheneum. He loved and

trusted artists. He took a risk putting [me] in the deputy director role for the University of California, Berkeley, Art Museum.[57]

The director of the Minneapolis Institute of Arts suggested that entrepreneurial museum directors for the 21st century need to think more about succession planning and the role that mentors can play:

Seek good experience through internships and work in smaller organizations. Develop a mentor system at the same level of work. Use the ability to get involved to learn through the advice of others. Understand the history of relationships between the command hierarchy and how this compares to your own style. Finally, see if you can get people as trustees on the board who can bridge the gaps between your style and what is necessary to direct the new museum. Start to see succession planning, at least at department level, as an innovation, along with the introduction of depreciation accounting for a new approach to smart business. This, in addition to good planning processes overall, will insure the museum's capacity to deliver on its mission.[58]

## INTEGRATING CHANGE AND LEADERSHIP REQUIREMENTS
In this chapter, we reviewed increasingly complex position descriptions to track potential gaps between past and present leadership development strategies. We used a museum director's appointment in Australia as a case study, highlighting the relationship between position descriptions, selection criteria, the appointment process, and professional development. The case study illustrated changes in job requirements over the last decade—from functional leadership to general management roles. Interviews with directors revealed a wide range of influences on their ability to sense, shape, shift, and adapt to change. For some, the shift was enabled by participation in professional development programs. For the majority, on-the-job training and mentoring was the preferred approach. As a benchmark, readers are encouraged to use the case study to conduct ongoing audits. Track changing leadership requirements and realign position descriptions, career path guidance, and professional development strategies.

The preference for on-the-job training and mentoring sounds good in theory but there are a few problems in practice. Although there are excellent directors in the field, flat and slow career paths can mean few on-the-job

training opportunities for aspiring leaders without a deliberate human resource management strategy. Biases in the museum sector between art and science continue, as does a bias toward the collection rather than the human resources who manage the collection. In the past, the museum sector has traditionally placed a higher priority on collection funding than on professional development, according to a recent report on training for the museum profession.[59] The report highlighted a collection bias and lack of commitment to human resource development. The report recommended changes to present practices, encouraging institutional accreditation based on clear evidence of commitment to human resource development and allocation of funds to professional development training to raise professional standards.

The preference for on-the-job training and mentoring is repeated in other industry sectors. Are museums similar to universities and hospitals in this regard? People who work in these organizations have a strong intrinsic motivation—they want to make a difference. They are already very well educated, passionate about their specific domain of expertise, and loyal to something other than themselves and the institution. An anonymous hospital doctor said leadership development in hospitals had a similar feel to issues in museums—doctors feel they are already qualified to be leaders so why do leadership training? They prefer on-the-job training and use mentors to bridge the gap between operational and general management roles. This hospital doctor described why he felt professional development was critically important. Although doctors are leaders in their own field, they are not experts in leadership. Doctors, like museum directors, benefit from learning about team building, finance and budget management, risk assessment, strategy planning, market awareness, and organizational behavior.

How do we sense and then narrow the gap between organizational needs, position descriptions, and professional development strategies? Issues discussed in this chapter describe leadership candidates *within* the museum sector; what happens when potential candidates *outside* the museum's traditional boundaries are considered? Is there a way to realign past and present practices to accommodate nontraditional domains of expertise so the leadership talent pool can be expanded? For example, the selection criteria for the MMI requires five years experience *in* museums. Can this be modified for candidates with an empathy and passion for museums and extensive experience in other fields? How viable are museum management programs like the MMI in the

United States or the MLP in Australia as orientation programs for new directors coming in from the *outside*? Is there scope for a crash course on the technical aspects of museums? Is it possible to develop a pool of entrepreneurial leaders with high EQ for the 21st century? The next chapter explores what's possible when principles are put into practice.

## NOTES

1. Potts 1995 (I).

2. National Gallery of Victoria 1994.

3. Spence 1995 (I).

4. Barker 1986: 50.

5. Sutton 1986: 230.

6. Hochfield 1989: 62.

7. Cembalest 1991: 50.

8. Editor 1992: 29.

9. Cembalest 1992: 36, 38.

10. National Gallery of Australia 1995: 8.

11. Orioli 1996: 12.

12. Fiori 1996 (C).

13. Hewett 2003: 49.

14. American Association of Art Museum Directors 1996: 16.

15. Goh 1996 (I).

16. Spence 1995 (I).

17. Rolla 1996 (I).

18. Leigh 1995 (I).

19. Coaldrake 1995 (I).

20. Speed 2003 (I).

21. Makris 2003.

22. Makris 2003.

23. Doyle 1994 (I).

24. Moffett 1996 (I).

25. Day 1993: ii.

26. Tramposch 1994: 61–65; Roodhouse 1994: 28–31; Sola 1994: 61–65.

27. MacKay 1996.

28. Miller 1999: 24.

29. Walsh 1995 (I).

30. Murdoch 1992: 18–19.

31. Birtley & Boylan 1998–2002 (I)

32. Museum of New Zealand Te Papa Tongarewa 1999: 2.

33. Anderson 1996 (I).

34. Davis 2000 (I).

35. Marzio 1996 (I).

36. Potts 1995 (I).

37. Consey 1995 (I).

38. Fiske 1996 (I).

39. Parker 1995 (I).

40. de Falla 1996 (I).

41. Powell 1996 (I).

42. Latos-Valier 1996 (I).

43. Koshalek 1996 (I).

44. Burke 1996 (I).

45. Jenneman 1996 (I).

46. Serota 1996 (I).

47. McCaughy 1996 (I).

48. Hall 1995 (I).

49. Wood 1996 (I).

50. Caldwell & Carter 1993: 55.

51. Connor 2003: 14.

52. Anderson 1996 (I).

53. Jenneman 1996 (I).

54. Patching & Chatham 1998: 316–37.

55. Serota 1996 (I).

56. Hawley 1996 (I).

57. Ross 1996 (I).

58. Maurer 1996 (I).

59. McShane 2002: 3.

# 7

# Action
## Principles into Practice

In this final chapter, change management insights discussed previously are pulled together to describe principles in practice *and* ideas for succession planning. Research with ninety professionals in the museum sector, over three hundred executives in other industry sectors, and allied human resource development professionals creates a rich mix of insights. For example, many of the ideas described by directors in previous chapters have now been tested in the EQ leadership program *Leading with Passion*. Some surprising insights from that program will be shared here to create a context for action. And we will look at the influence of personality preferences on career choices, organizations in society, and implications for succession planning. The approach taken with succession planning in this last chapter is a simple one. In principle, *every* existing leader shares responsibility for creating a pool of potential leadership talent. In practice this means, over the course of a career, mentoring at least six people passionate about and potentially capable of moving into a director's role in due time. The chapter concludes with six initiatives designed to translate this principle into succession planning practice.

Working with this translation process created a new vocabulary. According to one astute observer, we have entered a new era of leadership in action using *co* words—cooperation, coach, collaboration, coordination, consultation, cohesion, communication, conservation, community, competitors, consensus, connection, and commitment. Potential and existing directors, trustees, university-based educators, centers for continuing education, consultants, and human resource managers are encouraged to undertake active

succession planning using this *co* word vocabulary to create a pool of passionate potential leaders in flow with the creative challenges ahead.

## TESTING PRINCIPLES IN PRACTICE

Succession planning, like leadership development, needs a time horizon. It takes at least ten years to develop competence in an indirect leadership role in a specific domain of expertise before shifting to direct leadership for an organization as a whole.[1] Over that ten-year period, as we saw in previous chapters, on-the-job training is the preferred option. In principle, this is fine as long as on-the-job training provides enough opportunity to develop the range of skills required for a direct leadership role. We use the principle of on-the-job training with projects in the EQ leadership program *Leading with Passion*. We also use insights passed on by museum directors to focus the program on EQ skills, intuitive decision making, and change management. Over a three-month period, participants are offered opportunities to create passion in action, develop targeted EQ leadership skills, explore ways to create conditions for flow, enact the fourfold leadership role, and enjoy the art of change management. Two years after *Leading with Passion* was launched, a colleague pointed out that the MBA program at Harvard University was highlighting three important skills for leaders in the 21st century—EQ skills, change management, and intuitive decision making. If there is safety in numbers, then we are on the right track.

The importance of passion as demonstrated by museum directors is a fundamental part of the *Leading with Passion* program. To withstand the waves of change, participants are encouraged to discover, rediscover, and then connect with that part of the leadership job that has heart. The levels of complexity model is introduced to provide a way to understand the connection between flow, organizational challenges, and change. Change means new leadership stories must evolve to represent the organization internally and externally. Participants are challenged to interpret and shape stories about change for their own organizations using the fourfold leadership model to answer a series of questions: *How do I represent the organization? How do I create a context for others to give their best? How do I act as an ethical entrepreneur? And, how do I nurture trust relationships around the organization?*

The answers to those questions form the basis for leadership stories that come from the heart, with contagious enthusiasm. To support the process, we

introduce the power of language as a tool to shape organizational life, coaching creative ways to express what political scientists call rhetorical leadership or engaging others through a persuasive and credible story.[2] The arts and cultural industry sector is a constant source of inspiration. Art and music are like a good leadership story. To be successful, both have to engage the mind *and* emotions. To be truly believable, a leader's story must engage the hearts and minds of others. We refer to four factors Gardner described that attract followers—a tie to the community, a certain rhythm of life, embodying the story, and leadership through choice.[3] Participants reflect on these factors, shaping stories meaningful to them to represent their organizations in a way that creates meaning and identity for others.

This is not an easy process. Participants come from different industry sectors and bring diverse experiences, values, and interpretations about leadership roles. There are often strong beliefs about profit and nonprofit orientation for an organization. For example, a long-term volunteer with the St. James Ethics Center (nonprofit) in Australia suggested that leaders with passion are only found in nonprofit organizations. In this person's experience, there were few, if any, leaders working from the heart and for the love of the organization in the for-profit sector. This perception, whether accurate or not, exposes deeply held values about social capital (interpersonal connection, compassion, and trust) in a market-driven economy. When public and private sector participants refine insights, they discover similarities rather than differences. We share concerns about accountability, stakeholder trust, ethical entrepreneurism, and creating contexts for high-performance teams. The process inevitably uses the *co* word vocabulary—cooperation, collaboration, and consultation.

Testing principles in practice in the course *Leading with Passion* includes creating conditions for flow. We hope participants experience a context where they feel they can give their best. We role model flow in practice so participants can adapt to change, absorb input more readily, and develop deeper trust relationships to achieve program goals.[4] Modeling conditions for flow means that participants, we hope, learn how to create a context for others to give their best in their own organizations. We start the process by collaborating on clear, achievable goals designed to shift performance on *one* EQ leadership scale through *one* of the four leadership roles over a period of three months with on-the-job projects.[5] Over the three-month period, participants

engage in deep dialogue forums, mentoring, peer coaching, action learning projects, and mapping change. When the program concludes, we review the original reason the participant joined the program, track individual and organizational change, and assess implications for position descriptions. Rich insights always emerge when participants reflect on what they did to put the principles of fourfold leadership into practice. The insights inevitably change the way participants see themselves as leaders. This influences career path planning, self-selection for leadership roles, and succession planning. It leads to a deeper commitment to *pull up* at least six potential leaders behind them so that succession planning evolves naturally. Succession planning becomes a leadership responsibility that combines mentoring, insightful on-the-job training, and targeted professional development.

## PERSONALITY TYPE, SELF-SELECTION, AND SUCCESSION PLANNING

In addition to an EQ map, we use the Myers-Briggs Type Indicator (MBTI) in *Leading with Passion*. As introduced in chapter 3, the MBTI is useful for four reasons—appreciating psychological diversity, encouraging better-balanced team development, coaching intuition, and exploring the influence of personality preferences on leadership style. The MBTI is one of the most popular psychological tools used internationally. It was originally designed to appreciate innate differences in the way people focus their energy, take in information, and make decisions.[6] The differences influence tasks such as decision making, motivating others, problem solving, communication, stress management, and that *vision thing*. The MBTI evolved out of research initiated by Swiss psychiatrist Carl Jung in the 1920s and was developed further by Isabel Myers and Katharine Briggs.[7] Researchers observed predictable patterns in what initially looked like chaotic human behavior. People actually behave in predictable ways—we have innate or natural preferences in the way we take in information from the outside world and organize it to come to conclusions. Although people are capable of working with all of the preferences described in the MBTI, some preferences feel more natural. Like writing with a preferred hand, people feel more in flow when they can work with their natural preference. There are sixteen personality types based on four scales that describe how we energize ourselves, attend to information, make decisions, and like to live our lives:

## Energizing

*Extroversion (E)* is a preference for drawing energy from the external world of people, activities, and things based on external action and a do-think-do style.

*Introversion (I)* is a preference for drawing energy from the internal world of ideas, emotions, and impressions through deep inner reflection and a think-do-think style.

## Attending

*Sensing (S)* is a preference for taking in information through the five senses, noticing what is actual and practical in a step-by-step way.

*Intuition (N)* is a preference for taking in information through a *sixth* sense, noticing patterns and what might be or could be, and creating theoretical future possibilities with novel insights.

## Deciding

*Thinking (T)* is a preference for organizing and structuring information to make decisions in a logical, objective way, using reason for firm but fair decisions.

*Feeling (F)* is a preference for organizing and structuring information to decide in a personal, values-oriented, subjective way using empathy and compassion.

## Living

*Judging (J)* is a preference for living a planned, organized, regulated life, gathering information, setting goals, and bringing closure to decisions in an organized way.

*Perceiving (P)* is a preference for living a spontaneous, adaptable, flexible life, gathering information and leaving decisions open.

Although the MBTI has been used extensively in other industry sectors, it has not been used to the same degree in museums and cultural organizations.[8] There is an opportunity window open with the MBTI to build on cultural industry sector studies such as museum education and art participation; type preferences and influence on the museum's organizational culture; and artists' personality types and approaches to management.[9]

As an MBTI practitioner, my ear is attuned to language differences associated with different personality type preferences. Although the MBTI was not used in my museum research interviews, evidence in previous chapters aroused my curiosity. Directors described using *intuition* for complex decisions, working with the *big picture*, and focusing on *people-centered* values. This language is associated with particular type preferences. This prompted a review of data collected over the last two decades by MBTI researchers on type preferences and occupational groups. I started looking for insights that might help explain the patterns and ended up finding something that may actually influence succession planning in the cultural industry sector.[10] These insights are included in this last chapter so readers can reflect back on previous chapters using MBTI insights to see how preferences may influence career paths, leadership style, succession planning, and quite possibly the museum's role in society.

The museum may be a particular type of organization that attracts directors with a strong preference for what the MBTI calls intuition (N) and feeling (F). Individuals with an NF preference in their overall personality type profile describes leadership with reference to what *could be*, future possibilities, ideals worth striving for, empowerment, growth for self and others, a facilitative leadership style, and a desire for their teams to give encouragement to others, internally and externally.[11] Individuals with an intuition (N) preference in the general population are less common. Estimated type frequencies in North America describe 65 to 70 percent of the population with a sensing (S) preference and only 30 to 35 percent with a preference for intuition (N).[12] Some research suggests that individuals in leadership roles with an intuition (N) preference may have a strategic advantage. Managing increasingly complex leadership decisions in *any* industry sector relies on intuition (N) to provide direction in ambiguous, changing, and unpredictable times. Khaleelee and Woolf described leadership as an ability to *conceptualize vision*, having the authority, energy, and clarity to communicate the vision, and the resilience to sustain the work program necessary to creatively bring the vision into reality.[13] Researchers such as Myers and McCaulley pointed out that creativity involves intuition (N) and an expanded awareness that results in entirely new developments:

> Type theory assumes that *all types* have unique and valuable gifts. By definition, however, *creativity* means the creation of something new, which has not existed

before. Perception of the new is in the domain of intuition. All intuition is not creative; intuition can also include the merest hunches or unfounded suspicions. True *creativity* requires a highly differentiated awareness of many observations of the senses, from which intuition develops new patterns.[14]

Other research suggests that intuition (N) is directly related to organizational effectiveness in that leaders who use intuition (N) are better at engaging in risk taking to shape and adapt to change.[15] The connection between intuition, the MBTI feeling (F) scale, and emotional intelligence is also being explored with positive indicators.[16] Leaders who make decisions exercising feeling (F) to gauge the impact of decisions on people are described as having emotional intelligence skills.[17] Hirsh and Kummerow described different leadership styles associated with MBTI type preferences. When intuition (N) is dominant, strengths include recognizing new possibilities, supplying ingenuity to problems, seeing how to prepare for the future, watching for essentials, and tackling new problems with zest.[18]

MBTI researchers suggest that *any type* can perform *any leadership role* but each type has its own distinct leadership style. When people are forced to use a style over a long period of time that does not allow for, or call upon, their preferences then inefficiency and burnout result. Although leaders can adopt a different type style when needed, individuals contribute most when a context is created that allows them to use their type preference. The basic message is—*go with the leader's strengths.* Remember that the best teams are composed of people who have *some* personality differences but who are not total opposites.[19] Differences encourage team growth; similarities encourage understanding and communication. Understanding complete opposites with psychological type theory helps clarify misunderstandings and the need for individual and organizational integration.

MBTI statistics on type preference, career paths, and occupations contain data from many different industry sectors. There is a clear pattern in the data—individuals with a strong thinking (T), sensing (S), and judging (J) preference are referred to as the *classic managerial type.* Individuals with a preference for intuition (N) who use feeling (F) to assess the impact of decisions on people are drawn to occupations like education, psychology, and the arts. When I analyzed the MBTI data, I grouped occupations such as manager, artist, and curator/archivist with first, second, and third most frequent type

preference occurrence.[20] The first most frequent type preference for managers is ESTJ and for curators is ISFJ. The second most frequent type preference for both managers and curators is ISTJ. The similarity between the second most frequent type preference for managers and curators may account for 10 to 20 percent of curators who feel in flow with the transition into general management roles for the entrepreneurial museum.

**Roles and Type Preference Frequency**

|  | First | Second | Third |
|---|---|---|---|
| Managers | ESTJ | ISTJ | |
| Artists (painters/writers) | ENFP | INFP | ENFJ |
| Curators/Archivists/Librarians | ISFJ | ISTJ | INFP |

People with ESTJ type preferences like to organize projects, operations, procedures, and people, and then act to get things done.[21] They live by a set of clear standards and beliefs, and they value competency, efficiency, and results. ESTJs generally enjoy interacting with other people, and others rely on them to take charge and get things done. As leaders, they seek leadership directly and take charge quickly, applying and adapting past experiences to solve problems. ESTJs get to the core of the situation quickly, deciding and implementing quickly. They tend to act as traditional leaders who respect the hierarchy, achieving within the system.[22]

People with ISFJ preferences such as curators are dependable, considerate, committed to the people and groups they are associated with, and faithful in carrying out their responsibilities.[23] They work with steady energy to complete jobs fully and on time. ISFJs focus on what people need and want, and they establish procedures to bring these about. They take roles and responsibilities seriously. As leaders, ISFJs may be reluctant to accept leadership at first but will step in when needed.[24] They expect themselves and others to comply with organizational needs and structures, use personal influence behind the scenes, follow traditions, and use an eye for detail to reach practical results.

What happens to succession planning when entrepreneurial museums seek new-breed directors from the curatorial domain of expertise? Instinctively, many curators may sense a lack of alignment between type preference and what organizations expect general managers to do. Curators may self-select *out* of direct leadership career paths. An extended description of ISFJ type may help directors and human resource managers appreciate the influence

type preference has on change management and career paths, with implications for succession planning:

ISFJs have a realistic and practical respect for facts. ISFJs use Feeling to make decisions based on personal values and concern for others. They respect established procedures and authority, believing that these have persisted because they function well. ISFJs *will support change only when* new data shows it will be of practical benefit to people. They are uncomfortable with confrontation and will go a long way to accommodate others, though their respect for traditions and people's feelings can lead them to challenge others. Others usually see ISFJs as quiet, serious, and conscientious, considerate, good caretakers, honoring commitments, and preserving traditions. If ISFJs do not find a place where they can use their gifts and be appreciated for their contributions, they may feel frustrated and may become rigid in supporting hierarchy, authority, and procedures; feel unappreciated, resentful, complain; and can be overly focused on immediate impacts of decisions on people. Under great stress, ISFJs can get caught up in catastrophizing or imagining a host of negative possibilities.[25]

Does this description sound familiar? This may help explain difficulties described by museum directors in previous chapters as they shape change for the entrepreneurial museum.[26] A major ISFJ strength is *preserving tradition,* and preserving tradition is how many museums define their role in society. What happens when the external environment creates changes that challenge traditions? One executive recruitment consultant described succession planning in the museum sector, highlighting a particular concern: "In the [art] museum world, there are a lot of curators around who are very special but they are not attached nor focused on delivery to a customer, their focus is more artistic."[27] This fits the pattern described by a coordinator for the Museum Management Institute, who indicated applicants have been confused by changes in skill sets that served them well as curators (independence, scholarship, and orientation to detail) and by the strategic vision required of directors.[28] Another executive recruitment consultant in the United States specializing in museums stressed the importance of honoring self-selection for succession planning in the museum sector:

Credentials are less important than before. What counts now is evaluation of performance. You can't learn what you can't learn. The Museum Management

Institute tries to teach curators management skills but we have to stop and ask whether this is right or not. Self-selection is required. There are natural managers or leaders and natural curators. This needs to be accepted. The CEO role for a museum is undergoing a shift from scholar to entrepreneur. It is important to know yourself. If you are a good curator or historian and aspire to a management role when it may not be suited, then you need to look at yourself. You need to *not* be too hierarchical about job value and self worth.[29]

## TYPE AND ORGANIZATIONS IN SOCIETY

In an ideal world, career paths lead people to organizations where they can use their personality type preferences to enjoy feeling in flow with fulfilling work. People with the same or similar type preference may actually be attracted to the same kinds of organizations. When this happens, type preferences naturally influence the way organizations develop. Ron Cacioppe, an Australian academic, expanded this insight in an early study on type and the function of organizations in society.[30] Organizations with strong sensing and thinking type preferences are described as *production and regulation* organizations and include mining, manufacture, business, enforcement agencies (police, military), trade unions, transport, and distribution. Organizations with a strong preference for intuition and thinking are described as *planning and resource management* organizations, such as economic and resource management groups, law and government, scientific research, and strategic planning. Organizations with strong sensing and feeling preferences are described as *human service* organizations and include health, medical, recreation, entertainment, social welfare, and community social services. Organizations with strong intuition and feeling preferences are described as *quality of life* organizations, such as religious, art, music, literature, cultural, environmental, and social harmony organizations.

Cacioppe's study constructed interrelationships on a social scale that encouraged equal value for *all* organizational types. This was a deliberate attempt to counterbalance the economic and social value given to production and regulation organizations (ST) over quality of life (NF) and human service (SF) organizations. The imbalance was described in a previous chapter with reference to healing perceived splits between arts and science. With further research, I think we can better appreciate whether museums are naturally aligned as human service (SF) or quality of life organizations (NF) in society.

Museums and cultural organizations may like to *see themselves* as quality of life organizations (NF), while society and governments *expect* them to be human service organizations (SF). This conflict is reflected in initiatives such as the push for renewed engagement between museums and communities that one writer said adds social services to an already overburdened institutional workload.[31] Given changes in the economic landscape, society and governments also expect museums to perform more like production and regulation organizations (ST), with a focus on financial facts, logical systems, and corporate plans so they can regulate and control what, for some museums, is a million-dollar business. Despite tensions in this three-way pull, the cultural industry sector has a strategic advantage in the 21st century.

An NF organization, such as a museum, can orient itself to use and express strengths in creativity, intuition, people-focused values, ideals, and social vision. It can represent itself as a catalyst for change, persuading people about timeless human values, inspiring and focusing on personal meaning-making, and creating congruence for people in a personalized, imaginative way. It can represent itself as a site for the generation of social capital, offering opportunities for meaning-making through meaningful play. Remember the flow personality as described by Mihaly Csikszentmihalyi. People who succeed in making sense of chaotic life experience do so by using well-ordered information found in music, art, poetry, drama, philosophy, and religion.[32] On an organizational level, the challenge for the NF museum lies in positioning and representing the organization as a site where people experience a renewal of flow or pleasure in life.

Entrepreneurial museums are blending quality of life (NF) with human services (SF), as well as meeting society's expectation to perform like a production and regulation organization (ST). The leader's change management challenge is keeping the heart in the organization while balancing the shift with a tougher analytical approach to cultural enterprise management. In previous chapters, we have seen innovative and creative leaders shaping change, building teams of people with new strengths in new roles. This was evident in the increasing number of people in roles such as administration, accounting, and information technology. A change in team type profiles has implications for career path planning and succession. Many new people in the museum may have STJ type preferences with a natural attraction to careers like accounting, information technology, and the data management side of human resource development.

Some museum sources shared feelings of resentment and resistance about increasing numbers of administrative staff in museums. Rather than valuing the diversity of type preferences supporting a successful entrepreneurial museum, they sense a devaluation of curators, exhibition planners, and education staff.

Balancing this tension and creating a context to appreciate type diversity is a leadership challenge in *any* organization. Successful museums need staff with STJ preferences to translate their visionary, idealistic, classically romantic NF type values into practice. Based on MBTI research, many managers have an STJ type preference.[33] Some curators share the STJ preference. Yet, change management requires use of nondominant intuition (N) and imagination to shape leadership vision and decision making in increasingly complex business environments.[34] Therefore, leaders are coached to manage change by guiding their teams through a four-phase process: sensing and gathering information (S), creating possibilities (N), testing the possibilities using rational analysis (T), and assessing the impact choices will have on people (F). In the *Leading with Passion* program, we use techniques designed to explore and appreciate type preferences. We create conditions so participants can explore and experiment with MBTI preferences such as intuition (N) and feeling (F) using EQ skills to shape meaningful vision making. The coaching incorporates a variety of techniques, some inspired by the director of the Maine Photographic Workshops who suggested: "The intuitive mind is best trained through experience and that means making mistakes."[35]

The connection between EQ and the MBTI needs more research for deeper insights into the relationship between type preferences and succession planning.[36] Although all types are equal, leaders with an NF preference may have an edge in the 21st century. A preference for feeling (F) may enable easier development of EQ competencies. A preference for intuition (N) may enable easier development of strategic plans that predict patterns of social development. Individuals with an NF preference may be more attuned to deeper *meanings* rather than the particular aspects of a situation.[37] This is why they need the balance and backup of a team with STJ preferences who provide the objective, logical, fact-based action plans to translate visionary principles into practice.[38]

## PREPARING FOR LEADERSHIP TRANSITIONS

In addition to the influence of type preferences on succession planning, let's consider insights from the levels of complexity model described in chapter 3.

As described earlier, we use the levels of complexity model in the *Leading with Passion* program to introduce a matrix of working relationships between different levels of organizational complexity. We highlight the differences between operational leadership (Level 3) and general management leadership (Levels 4 and 5). In succession planning, shifts from operational roles into general management redefine work objectives, responsibility, collaboration, creativity, and vulnerabilities.[39] Based on changes described by directors in the museum sector, some of the major state museums have been mapped as Level 4 organizations, where the time horizon for the most complex task is five years and the theme of work is development—designing new systems and practices to meet changes in mission. A few of the major national museums have been mapped as Level 5 organizations, where the time horizon for the most complex task is ten years and the theme of work is defining the viability of the organization in the long term—representing the organization to the external environment nationally and internationally though a board of trustees. Smaller, less complex regional museums function very effectively as Level 3 organizations, where the time horizon for the most complex task is two years and the theme of work is good practice—keeping established systems for service and products ticking over in the medium term.

With practice and skill, the levels of complexity model can provide a coherent way of understanding organizations and preparing leaders for transitions between different levels of complexity.[40] Directors of large, major national organizations need to have at least a ten-year perspective-setting strategic outreach if the museum is expected to thrive in the long term. It is important to note that seven to eight years is the longest forward time horizon within which most human beings seem to be able to plan and carry out specifically budgeted projects. Larger scale projects must be broken down into seven-year or shorter subprojects and phases.

The relationship between passion, flow, change management, EQ skills, and succession planning becomes more relevant when we use the levels of complexity model. Staying passionate and in flow with the work challenges depends on five conditions: clarity around goals, resources to achieve the goals, discretionary control over decision making, a trust environment to fully engage in the tasks at hand, and new challenges over time for personal growth and development. A basic tenet in succession planning is to consider best practices for assessing and pacing individual capability with organizational

challenges so individuals stay in flow. This may mean accepting the fact that some people will feel more in flow with increasing levels of complexity and others will not.

Once leaders move across the two-year time boundary between Level 3 operational roles into Level 4 general management roles, the level of abstraction becomes acute. The balance between a leader's technical skills and emotional intelligence starts to tip in favor of EQ skills to manage increasing levels of abstraction. For example, exercising good judgment over tasks with long time horizons relies on the use of intuition, which many of the directors described in chapter 3. Jaques and Clement described the transition between Level 3 operational leadership and Level 4 and 5 general management as a shift in perspective from a *concrete* focus on balance sheets, expenditure, revenue, assets, and liabilities to *conceptual tasks* such as balance sheet value systems, political and economic circumstances in specific countries, and treasury (or cultural) policies.[41] People need to be prepared for this transition.

In my original research, a draft position description was designed for the director's role in a major museum with state or national responsibilities. However, a generic position description is not useful because individuals and museums come in so many different shapes and sizes! It is much more useful to work instead with the principles found in the levels of complexity model. The model offers trained human resource professionals insights into how to pace capability and challenges for succession planning. Large state and national museums are at one end of the complexity scale, and smaller regional organizations are at the other end. The cultural industry sector needs to consider ways of designing position descriptions based on an accurate assessment of job complexity.

For example, directors in Level 4 and 5 general management roles are responsible for acting as an energetic source of the organization's story, redefining it as needed to position the museum for long-term survival financially, socially, and culturally. They work to realize the strategic intent of the museum by guiding it through various conflicts caused by its impact on the environment. They work with the board to modify the museum to accommodate changes in the environment. For larger museums, this may mean maintaining a national position in an international cultural network. The director represents the museum in the broader socioeconomic context, setting the overall direction for business targets and objectives. Resource management

includes the control of all expenditures, both capital and revenue, ensuring realistic budgets and financial regulations are developed for the museum as a whole. Creativity involves sustaining the external and internal well-being of the museum in the face of rapid social, economic, and technological changes. Anticipated political and demographic changes likely to affect staff and recruitment are managed by preparing departments, introducing appropriate systems, and nurturing changes in attitude and organizational climate. Gaps in understanding are used as a source of innovation and a base for creating new knowledge beyond the currently defined field, with outcomes that may not be realized for up to ten years. The director's approach needs to be one of constantly weaving, shaping, and reshaping interconnections within the museum and between it and the environment, in the light of anticipated as well as actual change.[42]

Preparing potential leaders for a transition into this level of leadership complexity starts as a conscious process *prior* to the appointment. The director of the Harvard University Art Museum suggested that candidates thinking about the transition should focus on a ten-year plan. Starting with professional development in a specific domain of expertise, they should make a commitment to the pleasure of the object (in the museum sector), study and understand human personality, and develop skills (such as EQ) to manage competing constituencies to build consensus.[43] EQ skills are critical for managing and building consensus. Unfortunately, many operational level leadership roles focus almost exclusively on task achievement, not relationship management skills. In some industry sectors, by the time leaders become directors they are accustomed to climbing over what one coaching educator called *dead bodies*: "Task-focused skills that served them well in competitive operational leadership roles are no longer useful—directors need to use EQ and relationship skills to lead effectively."[44] Interested candidates can prepare by exploring how others perceive EQ competencies, using a series of EQ-related questions advocated by Bennis and O'Toole for CEO selection.[45] Immediate contacts around a potential leadership candidate are asked the following:

- Does the candidate lead consistently in a way that inspires trust?
- Does the candidate hold people accountable for their performance and promises?
- Is the candidate comfortable delegating important tasks to others?

- How much time does the candidate spend developing other leaders?
- How much time does the candidate spend communicating the organization's vision, purpose, and values? Can people down the line apply this vision to their day-to-day work?
- How comfortable is the candidate sharing information, resources, praise, credit?
- Does the candidate energize others?
- Does the candidate consistently demonstrate respect for followers?
- Does the candidate really listen?

A similar approach is used with structured 360-degree questionnaires in the *Leading with Passion* program and management development programs taught at the University of Technology Sydney, in Australia. Preparing indirect leaders for direct leadership roles starts by focusing on the first and most important EQ skill—self-awareness.[46] Seeking and responding to feedback from others creates a baseline for targeted performance development.[47] We use coaching to assess current and ideal performance, conduct a gap analysis, set performance development goals, design action plans, and review goal achievement over time. We encourage participants to use the same process in their own organizations as they start to take responsibility for leadership development and succession planning.

Preparing for transitions in the entrepreneurial museum means designing career paths that bridge expert knowledge bases (science, history, art, natural history, marine biology, zoology) and new domains of expertise such as sociology, psychology, and management. Bridge building and the importance of soft skills like EQ are not confined to the cultural industry sector.[48] In Australia, the Karpin Task Force on Leadership and Management Skills commissioned by the federal government established international baselines for the development of enterprise culture organizations and described changes in approach to professional development to be achieved by 2010:

> In the next ten to fifteen years, a whole new management paradigm will have emerged. Already, increasing globalization, widespread technological innovation and pressure on business to customize products and services has created a business environment that would be unrecognizable to the typical manager of fifteen years ago. Increasingly, we will focus more on behavioral and interper-

sonal aspects of leading and managing. Small to medium size businesses, with their flexibility, speed, innovation and creativity will play a pivotal role. We are failing to manage the transition from specialist to manager and are not linking management development to strategic business direction.[49]

The prediction that small- to medium-sized organizations will do well is good news for most museums. Many cultural industry organizations are small- to medium-sized businesses already working with creativity and innovation. The last point quoted from the Karpin report highlights the need for organizations to make transitions less difficult, and it's a dilemma shared by all organizations, not just museums. The report closed with a prediction—the speed of change is only going to increase, so career paths must include change management skills, comfort with ongoing learning, opportunities to develop skills in human resource management, interpersonal connection, and customer service.

As a final benchmark study, consider a project with similar insights reported by the past director of the Australian Museum in Sydney and past national director for the professional association Museums Australia. Des Griffin conducted an international survey on best practice principles over a two-year period with thirty museums in four countries and concluded that change and cohesion were major issues that needed to be provided for through professional development. He described a range of change management issues, including the relationship between the board of trustees and the director. Boards were encouraged to become more committed to the museum, take a stronger financial focus, and help with the longer-term vision. Curators were encouraged to see their roles more broadly and to become more involved with the organization as a whole. Ongoing funding difficulties need to receive ongoing financial management. Griffin listed thirteen characteristics observed in best practice museums and highlighted six factors for success—quality of communication associated with the leadership role, a clear understanding of the museum's goals, a strong sense of team spirit, flexible goal setting, commitment, and long-term board vision:

> The lessons learned from the best practice museums were fourfold. There must be clear and shared core values for any success to happen. Trust [an EQ competency] and support were features of the organizational culture. There was a

good balance between short- and long-term vision. They had a clear understanding of industry trends and the responses of competitors in the field to those trends. The leadership was focused on cohesion and communication [again, EQ competencies], getting the internal social processes [social capital] right through conversations across boundaries or domains within and external to the museums. These conversations helped learning, clarification of important values, and focused on issues facing humanity. Management structure, as such, was irrelevant with a focus on supportive project teams and coaching. They worked together to increase a sense of integrity and each other's ability to make a difference.[50]

Professional development for the transition into leadership roles for best practice entrepreneurial museums is under way, based on evidence provided through the MMI and MLP. Changes to program curriculum now focus attention first on leadership then on management. The challenge ahead is to resolve problems alumni still face—blocked career paths on return to home base and career paths that do not equip them with necessary *new* skills to convey the museum's relevance to the world.[51]

### INITIATIVES FOR COST-EFFECTIVE SUCCESSION PLANNING

Easing the succession planning crisis depends on a major shift in thinking and an investment in human resource development. Repeating the facts, succession planning needs a ten-year time horizon. We need to look for more cost-effective ways to develop people capable of leading entrepreneurial museums. Based on insights shared by directors in my research, we have clarity on the principles of the fourfold leadership role and the preference for on-the-job training. Putting the principles and preferences into practice starts with a review of options used in other industry sectors, which can be modified and used in the cultural industry sector. For example, a joint publication under the International University Consortium for Executive Education and the Pennsylvania State Institute for the Study of Organizational Effectiveness in 1995 provided an overview on executive education and leadership development based on views of executives, consultants, and university leaders throughout the world.[52] I used this report as a base to shape six initiatives for succession planning combined with on-the-job development. While some of the proposed initiatives may already be in use, it is worthwhile to review them.

The first initiative focuses on the benefit of using customized in-company development programs rather than public or open enrollment courses. In-company programs offer distinct advantages for directors and staff to engage in on-the-job development with real tasks in real teams working together. This gives everyone an opportunity to observe and work with leaders in different domains of expertise. This can broaden perspectives on potential talent for succession planning. The programs can be designed with an intimate understanding of the museum's unique organizational culture and role in society. Customized in-house programs also create a *context for change* rather than changing individuals and returning them to unchanged organizations. Over 90 percent of MMI alumni felt they had grown and developed through MMI programs, but only 72 percent were able to create any change when they returned to their museum environment.[53]

The second initiative focuses on the benefit of shorter, focused, large-scale programs that cascade or flow through all levels in the organization. Most programs focus on horizontal training and development initiatives that cut communication and teamwork, described in the levels of complexity model. Cascaded programs based on vertical slices mean each level of work in the complexity model has an opportunity to appreciate how levels support one another. Vertical slice initiatives eliminate reference to *those up there* and *those below*. Vertical slice cascaded programs mean organizations pressured to do more with less can reduce the cost of having directors and other key staff away from the organization, thus overcoming the most common obstacle to participation in professional development programs—feeling unable to leave the organization. This would alleviate the problem described by another consultant of finding ways for directors and board members to participate.[54] Programs must be designed so that participants can see their own results without having to wait excessively long periods of time. Results-based vertical slice programs also provide concrete evidence of performance useful for succession planning.

A word of caution: Cascaded vertical slice programs often include adventure learning. Adventure learning involves intense three- to five-day outdoor programs focused on team building and strategic planning with physical challenges. There are many criticisms about adventure learning. The most common criticism is the absence of an appointed team leader during outdoor programs. There are also built-in barriers to participation when programs include physical challenges. Many people, for various reasons, do not want to

compete and may not like participating in physical challenge activities. The main criticism of what some call *mountain climbing courses* is that adventure groups do not stay together as work groups back in the business. Team bonding while rappelling down a cliff face is wasted back in the boardroom. Participants complain about difficulties transferring outback wilderness skills into the real world workplace.

The third initiative for succession planning describes the benefit of in-house learning projects with measurable results. The acid test for any human resource development investment is whether there are observable, measurable, and significant changes in individual or organizational development. Targeted on-the-job learning projects generate a higher rate of return on the human resource development investment dollar than do generalized programs. The trend toward learning projects suggests that facilitated project groups in the museum provide better opportunities for leadership development. To be successful, learning projects require that participants be actively involved in the diagnosis, discussion, development, and resolution of real challenges in the museum. A learning project approach means museum directors and potential leaders spend more time with skilled facilitators, coaches, and mentors creating a context in which others can give their best.

The fourth initiative focuses on the benefit of sabbaticals for succession planning. Leadership sabbaticals can be creatively shared between museums and museums or between museums and the corporate world. For example, most multinational companies have developed in-house executive development programs that would benefit from cross-industry exchange with visionary, creative museum directors leading quality of life (NF) organizations. Exchange sabbaticals provide potential leaders with an opportunity to share unique museum insights with other types of organizations and vice versa. Leadership sabbaticals support what Gardner called the *familiarization strategy*—an opportunity to explore leadership prior to committing to a leadership role.[55] Some museum directors use sabbaticals as a cost-effective way to renew personal energy and update leadership strategies based on insights discovered in other industry sectors. For example, the director of the MoCA in Los Angeles described a three-month stint with a sports team in San Francisco exploring succession planning and game strategy:

I learned about game plans, personalities and how professional football tracks people from the ninth grade up for teams. This means they look at a guy for ten years before hiring him. The potential plays for a game are computerized with possibilities like timed plays, different options for deception, moves, and complexity. In sixty minutes, the game gives the feeling that people can do more, be more, and this is exciting. There is a plan but when it all happens on the field, it is total chaos. You discover that the game really is all in the timing.[56]

The fifth initiative for succession planning focuses on the benefits of coaching and mentoring. Mentoring and coaching are excellent ways to scout for talent. Recent studies confirm the link between learning projects and coaching. Productivity with training alone increases positive performance; when training is combined with coaching, there are long-term, positive, and sustainable changes in behavior.[57] Credible and experienced executive coaches do not necessarily require personal experience in an industry-specific domain of expertise, but a professionally trained coach *must* have a good understanding of human systems, psychology, learning theory, and change management along with skills in facilitating understanding. The director of Coaching Psychology at the University of Sydney suggests that coaching needs to be grounded in psychology training to provide three distinct options:

There are essentially three kinds of coaching—skills, performance, and development. Skill coaching is a short-term approach following a training program. It enables an individual to transfer and embed learning from a development program into an organization. Otherwise, learning is too often lost and the investment in training is wasted. Performance coaching is a longer-term process that focuses on the gap between current and ideal performance, setting goals, and coaching to close the gap. Development coaching is like therapy for people who don't actually need therapy. Development coaching includes working on EQ skills, strategic vision, and how to work more effectively with people. For example, globalization means managers are dealing with people internationally they have never met face to face. They have to learn how to build and sustain long-distance relationships, and coaching can help.[58]

Grant suggested that organizations should invest coaching dollars preparing people for transitions between operational and general leadership when they are in their thirties. For succession planning purposes, preparation has to

happen in the *lead-up* to the transition, not afterwards. Many managers make the transition into direct leadership roles in their late forties or early fifties. Coaching in most industries is initiated when managers are making the transition, and for many, this is too late.[59] Many leaders realize too late that leadership styles rewarded in a competitive operational environment do not serve them in CEO roles. Unless people are open to ongoing learning and willing to adapt, remedial coaching is of little use.

Mentoring is often described as another form of coaching, but there is a difference. According to Grant, mentoring passes personalized, professional, and knowledgeable expertise down the line to less experienced people in an organization.[60] Mentoring shares what it is like *being* a great domain expert rather than *doing* it. One of the reasons this book was written was to capture and share leadership stories as a form of mentoring on paper. Mentoring offers many potential benefits to the museum sector. An international mentor network is a cost-effective way to retain the knowledge of experienced directors when they retire from organizational life. A mentor network provides new roles for experienced scouts to develop an international pool of potential leadership talent.

The sixth and final initiative focuses on the benefits of leadership forums as a succession planning option. Leadership forums break down the isolation many directors feel in leadership roles. My experience with executive coaching in other industry sectors reveals common experiences between museum directors and the corporate sector—feelings of isolation, the weight of responsibility, and a sense of competition that creates further isolation. Remember what the director of the Tate Gallery said: "There are so few people one can actually share ideas with."[61]

Regular leadership forums with existing and potential leaders provide an opportunity to sense, shape, and integrate potential leaders into a professional network. For example, the forums used in the *Leading with Passion* course are based on what Jaworski called deep dialogue.[62] Deep dialogue uses a specific technique to create a space where participants experience heightened and meaningful interpersonal connections, interconnections, and synchronicity. Senge described deep dialogue as *learningful conversations*, balancing inquiry with advocacy, exploring thinking while remaining open to other influences.[63] Senge described two essential skills for deep dialogue forums. The first is reflection, slowing down thinking processes to increase awareness. The second is holding conversations in which views are shared in

a collaborative, consensual way. One museum professional described this as "a joint sense of social justice, humanism, and humor; a way of looking at the unspoken, an iconoclastic approach, an investigation of the obvious, looking deeper, questioning more, and laughing more often."[64] In the *Leading with Passion* program, deep dialogue forums provide opportunities for leaders in other industry sectors to share their passion and tell stories through the four-fold leadership role model. We facilitate a circle of respect where the leadership forum follows a certain protocol. One of the most surprising insights is realizing we all have the potential to be leaders; we are all equal, although it may not always appear that way.

## INTEGRATING PRINCIPLES AND PRACTICE FOR ACTION

In conclusion, two change challenges lie ahead for museum directors—representing the story of the entrepreneurial quality of life (NF) museum and finding successors who can carry on as change agents. Although the art museum was case studied as an organization adapting to change, the fourfold leadership role described by directors is applicable to any organization. It has been a great pleasure working with museums to illustrate the fourfold leadership role; the importance of passion and EQ skills; and the link between that *vision thing*, visual arts, and human psychology. In the introduction, I described similarities between learning to see the outer world through art and learning to see the inner world through psychology. The lesson for leadership is learning how to see and create images in the mind's eye and bring that vision into reality.

The vision for the entrepreneurial museum in the 21st century lies not so much in the collection but in the museum's ability to create sociability around the collection. Kagle described the museum as a place where people have special training in *seeing*, which enables a community to open up, learn how to look up and down, and see ideas from a different frame of reference.[65] Another education specialist described how "Artistic learning incorporates a particular type of intelligence that involves the hands, heart and head in a unique mixture of thinking, feeling, and forming."[66] One particular American psychologist strongly urges cultural institutions, humanities programs in universities, and urban planners to reintroduce beauty in the visual arts, narrative in literature, and melody in music because the pleasure found in these sources meets a basic human need.[67] Stephen Weil, respected scholar with the

Smithsonian Institution, suggested that the art museum in particular is an underestimated place where these needs can be met.[68]

Learning how to *see* is one facet of the museum's story. Providing windows to see through is another facet. The director of the Philadelphia Museum of Art described this facet, reflecting on urban well-being:

> Museums actually have to do with the fate of a city. The degree of urban thrive determines how museums will thrive. Great museums depend on major urban centers. In these centers, museums play a role that spans internationalism and global connections. The museum is a global window on the world.[69]

The director for the MCA in Chicago agreed that the fate of museums depends on the fate of our cities around the globe. He described a distinct lack of common culture in the United States due to cultural fragmentation.[70] Cultural fragmentation is an international phenomenon that museums *cannot* correct but *can* counterbalance by actively celebrating cultural cohesion and creativity. The director for the Phillips Collection described this as a splendid opportunity to convey the value of culture, if culture can be conveyed as meaning-making for communities:

> I am disturbed by the thought of the museum as an entertainment alternative. I know the world and museums cannot stand still, but it disturbs me that art is not enough. We will see the end of this swing, oddly enough, through the internet and websites. Access to two-dimensional images will create a hunger in people for a glimpse of the real thing. The art itself with the real paint will become a draw. People will see the need for authenticity, and museums and art collections will provide a renaissance of *meaning* for people.[71]

Collections are only one way of satisfying a growing need for authenticity. Meaning-making through a collection needs to value process over content. The director of the Art Gallery of Western Australia underscored the importance of balancing other values, too, such as equity and quality, entertainment and education, cultural and social, inclusion and exclusion:

> We need to ask questions about cultural tourism. . . . Is the art museum a product? How can we distinguish the art museum from others to give it an edge in cultural tourism? More importantly, how can we get people to associate as ac-

tive members of a community? How can we get people in Australia to own the *social side* of the art museum? How can we get donors to work for us? How can we as directors tame huge egos that always want something special for themselves before they are prepared to give anything away?[72]

Challenging questions without immediate answers. The director of the MCA in Chicago concluded that museum leaders must create answers by viewing *the business* in a more philosophical way:

The nature of our business is one of sophisticated, refined intangibles and one has to get it right. Our business has to be stylish, attractive, innovative, and technically correct. My colleagues like to think we have a sacred charter to preserve material culture for future generations. But we are running a museum where the significance of this has to be questioned. In the end, it is all God's work.[73]

Looking further into the 21st century, Canada will most likely continue to enjoy what they call a 50/50 model, where the government remains committed to a substantial financial investment in cultural institutions. The United States, diverse and complex as it is, already leads the way with entrepreneurial museums in a nation that encourages and values entrepreneurial spirit.[74] Political changes in England may reverse savage cuts to cultural funding. Australia will continue to grapple with political influences on the way museums interpret the past and future.[75] The director for the Queensland Art Gallery in Brisbane suggested: "Every institution needs to be a shaper of change. I can predict that cultural heritage will require more access through new technology."[76] The director for the AGNSW in Sydney stressed:

Vision for an art museum is how the institution sits in the community. The role of the AGNSW is different than the Victoria and Albert Museum. Our role is a community role, not research. We are not a static icon for people to pass by. We have to work for our audiences and have to be closer to the ground.[77]

In conclusion, *Leading with Passion* evolved out of an international study on change, challenge, and complexity for museum leaders in the 21st century. Tracking change revealed organizations in transition, evolving new levels of complexity, and new skills to manage entrepreneurial enterprises. As change managers, directors undertake a demanding role. Many people said that

expectations for the director's role are impossible to meet. This research revealed a different story. Directors *are* managing change through relying first and foremost on energy or resilience. They live their passion, love their organizations, and use their EQ skills to create contexts where others can give their best with contagious enthusiasm. The transition from indirect leadership in a scholarly domain to direct leadership as ethical entrepreneurs has involved risks and costs. Not everyone has been willing to make the transition, take the risks, or pay the costs. Directors who contributed to *Leading with Passion* took the risks. Those of us who love museums reap the benefits. We hope our shared insights encourage that special 10 to 20 percent group of future directors to take the risks with these wonderful organizations called museums.

## NOTES

1. Gardner 1995a: 287.

2. Simons 2003: 4–5.

3. Gardner 1995a: 36–40.

4. Csikszentmihalyi 1990, 1993.

5. Boyatzis, Cowen, Kolb, & Associates 1995; Boddy, Patton, & MacDonald 1995: 179–92; Weller 1999: 136–46; Atkinson 1999: 502–11.

6. Australian Psychologists Press 1997: 4; McClure & Werther 1993: 39–47; Tan & Tiong 1999: 15–25.

7. Hirsh & Kummerow 1998.

8. Isachsen 1992; Freeman 1992; Myers & Myers 1993; Hirsh & Kummerow 1998; Kroger & Thuesen 1988.

9. Berry & Mayer 1989: 165–67; Suchy 1995: 142–48; Csikszentmihalyi & Hermanson 1995: 34–62.

10. Myers & McCaulley 1985: 244–92.

11. Hirsh & Kummerow 1998: 7–8, 18–21, 31.

12. Martin 1996; Hammer & Mitchell 1996: 2–15.

13. Khaleelee and Woolf 1996: 5.

14. Myers & McCaulley 1985: 293.

15. Anderson 2000: 46–67.

16. Dulewicz & Higgs 2000: 341–72; Higgs 2001: 509–33.

17. Gardner 1983; Goleman 1996, 1998; Cooper & Sawaf 1997; Cherniss & Goleman 2001; Palmer, Walls, Burgess & Stough 2001: 5–10; Farrelly 2003; Campbell Clark, Callister & Wallace 2003: 3.

18. Hirsh & Kummerow 1998.

19. La Motta 1992: 270.

20. Murdoch 1992: 18–19.

21. Myers 1993: 18.

22. Hirsh & Kummerow 1998: 13.

23. Myers 1993: 9.

24. Hirsh & Kummerow 1998: 14.

25. Myers 1993: 9.

26. Crisp 2003: 25.

27. Spence 1995 (I).

28. Rolla 1996 (I).

29. MacKay 1996 (C).

30. Cacioppe 1980: 1–43.

31. Douglas 2002: 26–27.

32. Csikszentmihalyi 1990: 235.

33. Freeman 1992: 37.

34. Sullivan & Suchy 1997.

35. Lyman 1997 (I).

36. Higgs 2001: 509–33.

37. Cacioppe 1980; Margerison & Lewis 1981; Isachsen 1992; Myers & Myers 1993.

38. Bradley & Frederic 1997: 337–53.

39. Stamp 1990: 10–13.

40. Jaques 1989: 20.

41. Jaques & Clement 1991: 53–58.

42. Stamp 1989: 21–23, 35–36.

43. Cuno 1996 (I).

44. Grant 2003 (I).

45. Bennis & O'Toole 2000: 170–76.

46. Boyatzis et al. 1995; Whetten & Cameron 1995; Whetten & Clark 1996: 152–81; Dunphy 1981: 94–126; Orioli 1996: 5; McCarthy & Garvan 1999: 437–45; Carlopio, Andrewartha, & Armstrong 2001: 69–74.

47. Connor 1995–2003 (I); Raby 1995 (I); Suchy 1998b.

48. Douglas 2003: 34–35.

49. Karpin 1995: 10–14.

50. Griffin 1996 (C); Griffin & Abraham 1999.

51. Weil 1996c.

52. Fulmer & Vicere 1995: 20–26.

53. Weil 1996c.

54. Fiori 1996 (C).

55. Gardner 1995a: 305.

56. Koshalek 1996 (I).

57. D'Costa 2002: 49.

58. Grant 2003 (I).

59. McCafferty 1996: 93–95.

60. Grant 2003 (I).

61. Serota 1996 (I).

62. Jaworski 1996: 116.

63. Senge 1990 (C).

64. Alswang 1996 (C).

65. Kagle 1996 (C).

66. Sullivan 1990.

67. Brockman 2002: 4–6.

68. Weil 1996c.

69. d'Harnoncourt 1996 (I).

70. Consey 1995 (I).

71. Moffett 1996 (I).

72. Latos-Valier 1996 (I).

73. Consey 1995 (I).

74. Brown 2003 (I).

75. Morgan 2002: 15; McDonald 2002: 47; McDonald 2003: 27; Martin 2003: 3.

76. Hall 1995 (I).

77. Capon 1995 (I).

# Appendix 1
# Research Methodology

*Leading with Passion* is based on an international research project tracking change, challenge, and complexity in the museum sector. The research was originally designed using stratified systems theory and the levels of complexity model.[1] The theory and model provide insights into the way work is structured in organizations, the capability individuals bring to organizations, and implications for flow or peak performance. My original research hypothesis focused on predicted shifts in organizational complexity associated with the director's role in museum leadership, with implications for succession planning. The art museum was chosen as a case study organization because professionals in the cultural industry sector and press described a range of change management difficulties for art museums and succession planning in the 1990s.

## BACKGROUND TO THE RESEARCH AND FIELDWORK

A keen interest in museum leadership was kindled during an internship at the Art Gallery of New South Wales in Sydney while completing a master of art administration at the College of Fine Arts, University of New South Wales, in Australia. When the degree was completed, work commenced with the Art Gallery of New South Wales on a short-term consulting project that became the catalyst for questions about strategic planning, leadership roles, and changes shaping museums internationally. These questions framed a series of conversations with museum professionals during a tour of cultural centers in 1993–1994 that included Singapore, Los Angeles, San Francisco, Seattle, Boulder, New York, Washington, Baltimore, and Chicago. Preliminary fieldwork interviews were conducted on the museum's approach to strategic planning,

change management, and succession planning at seven institutions: the Los Angeles County Art Museum, the Museum of Contemporary Art in Los Angeles, the Solomon R. Guggenheim Museum in New York, the Metropolitan Museum of Art in New York, the Museum of Modern Art in New York, the Phillips Collection in Washington, D.C., and the Portland Art Museum in Oregon.

Based on the initial fieldwork, a proposal for a PhD research project was developed; it was accepted by the Department of Art History at the University of Western Sydney in 1994. My research commenced with an extensive literature search focusing on the evolution of the museum as a cultural institution, challenges facing directors in the 1990s, and changing criteria for the leadership role. Preliminary correspondence and discussions on succession planning were held with professionals in the museum sector in Australia and the United States. The discussions focused on change, challenges, the director's role, the selection process, career paths, and executive development for directors. Change management was identified as a major issue. The museum was evolving from what appeared to be a not-for-profit institution into a for-profit organization. The new hybrid model combined characteristics of both, which challenged directors and potential directors to adapt as change managers. The research was designed to map the challenges, the directors' approach to change management, and their perception of leadership for the 21st-century museum.

As cross-disciplinary research, the work bridges the cultural industry sector, organizational psychology, and management theory. My approach was grounded in experience with executive development programs and training in the discipline of organization development. Organization development relies on theories and techniques drawn from applied behavioral sciences.[2] The main theories used for the research include cognitive psychology, semantics or communication theory, social work, systems theory, action research, survey methodology, human resource management, personality theory, general management, and leadership theory.

Action research was chosen as the most valid technique for observing and understanding changes in museum leadership. Action research involves direct engagement with respondents, in this case museum directors, exploring leadership and change from the respondents' point of view. As a form of positive rather than normative theory, action research is based on a philosophical acceptance of the respondents' experience as given, followed by research to explain

or interpret what was observed. Action research is a participative model of collaborative diagnosis that normally involves action ultimately being taken by the target group. In this case, the target group was current and potential museum directors as well as professionals involved with executive training and museum management.

Action research provides several strategies to choose from. The five most common strategies are observation, sensing interviews, survey feedback, analysis of organizational records, and future search workshops. My research used sensing interviews and survey feedback. Directors and other professionals were invited to collaborate in an investigation of current challenges, decision-making complexity, and factors for success in museum leadership through personal interviews and survey feedback. The research relied on establishing an extensive network of relationships with museum directors and other professionals in Australia, England, Canada, and the United States in order to conduct fieldwork from 1994 onward. Specific art museums were targeted based on the museum's location in a major tourism or cultural destination, within the English-speaking world and with a perceived community presence. The main tourism and cultural destinations included Sydney, Brisbane, Melbourne, Canberra, Los Angeles, San Francisco, Chicago, New York, Washington, Ottawa, Toronto, and London. Community presence was defined as the museum that other museum professionals recommended visiting because it offered something significant or special. For example, the site, collection, public programs, or stature in the museum field was perceived to be of some significance by professionals in the field.[3]

Research relationships with art museum directors commenced in early 1995 in Australia with phone calls, faxes, and extensive correspondence to arrange personal one-on-one interviews on site. The Australian fieldwork assisted the design of the survey questionnaire released in 1995 to alumni of the Museum Management Institute (United States), the Senior Museum Management Program (Australia), and targeted museums in England, Australia, and Singapore. Research relationships with art museum directors expanded in 1996 to include personal interviews with directors in the United States, England, and Canada. The interviews and the survey questionnaires were managed under guidelines approved by the Human Ethics Committee, University of Western Sydney in Australia. The research participants gave their written consent for information contributed to the research to be drawn on to enrich the study of museum leadership.

## QUALITATIVE RESEARCH

Forty-two ($N = 42$) art museum directors, deputy directors, or associate directors collaborated in either face-to-face or telephone interviews. Not all research participants directed museums that fit the original criteria. Some directors included were leading smaller regional museums rather than large capital city museums. As the research evolved, other professionals were recommended and included because their views and experience were critical to the debate on museum leadership. The list of museum directors and other professionals interviewed is in appendix 3.

Research with directors was conducted using a modified Career Path Appreciation (CPA) interview technique. Career Path Appreciation is a technique used by trained and licensed practitioners under strict policy guidelines provided by the Brunel Institute of Organization and Social Studies, University of West London, England. The theory underpinning CPA is a model of individual and organization complexity called stratified systems theory or the levels of complexity model. The model, a hierarchy of cognitive and task complexity, was originally conceived by Elliott Jaques and expanded by Dr. Gillian Stamp at the Brunel Institute of Organization and Social Studies.[4] Thirty-two ($N = 32$) respondents participated in the CPA interviews. The CPA normally spans three hours and includes four parts. The first part involves nine sets of phrase cards with six cards in each set. Respondents are given card sets and then asked to choose the card that best describes their approach to work. The second part uses a set of symbol cards as a form of problem-solving task. The third part tracks career history. The fourth part involves a feedback session to explore and confirm patterns detected in the data gathering. CPA data is analyzed and interpreted through the cognitive and task complexity model.

The CPA technique with museum directors was modified for sensing interviews only because of time constraints. Approximately ninety minutes of interview time was pre-booked for each research participant. Directors are extremely busy professionals. Five sets of phrase cards were used, along with the career history. The aim of the interview was not to assess the directors' level of capability but to gain an insight into role complexity. The phrase cards provided a consistent technique for directors to discuss their approach to work and the decision-making process. The phrase cards included the following five sets:

1. General principles
2. General processes

3. Approach to each problem
4. First action on the problem
5. Reactions to gaps in knowledge

Interviews were recorded by hand and transcribed into interview notes for content analysis against the levels of complexity model. Telephone interviews ($N = 10$) were conducted when access was impossible because of geographical distance. These were also recorded by hand and transcribed into interview notes for content analysis against the levels of complexity model. The directors were asked the following questions:

1. What are the current challenges a museum director faces?
2. Have there been significant changes to the museum director's role?
3. How would you describe your career path including key influences?
4. What recommendations would you give to an aspiring director?

Sensing interviews, either through the CPA interview or by telephone, provided critical qualitative data. The validity of qualitative data relies on accurate content analysis against the levels of complexity model. Validity of qualitative data also relies on establishing a clear context to present and interpret the information. In this case, the research was continually grounded against change management issues reported in the industry sector by professionals working in the field.

To better understand entrepreneurism in a museum context, focus groups were held with staff at the Museum of Contemporary Art (MCA) in Sydney and interviews were conducted with specialists in the field of entrepreneurism. Two sessions on the entrepreneurial museum were conducted at the MCA, a nongovernment-funded organization, and the results were described in a paper presented at the 1995 Museums Australia National Conference held in Brisbane, Australia.[5]

Because of time constraints and access issues, interviews were not conducted with trustees on museum boards. To balance the directors' perception of the board interface, several interviews were held with specialists in board development. Opinions were sought from government officials involved with trustee appointments, consultants involved with board development, and national organizations specializing in nonprofit board development, such as the National Center for Nonprofit Boards in Washington, D.C. Interviews were

conducted with consultants and staff specializing in museum management, selection and recruitment, training, and board development. The interviews explored two key questions: the director's role in museum management and current changes in the museum sector.

Insights and issues for museums in regional locations were canvassed via participation in conferences held by the Australian Regional Galleries Association, Museums Australia, the American Association of Museums, the International Council of Museums, and the first international conference on museum leadership held in Ottawa in 2000, hosted by ICOM and the Canadian Museum Association.

Extended quotes drawn from the qualitative research are used in *Leading with Passion*. Extended quotes may be regarded as an unusual approach, but they were used for two reasons. First, lived experience is the best form of authority. Extended quotes give the directors an opportunity to describe and illustrate their experience of leading change for the 21st-century museum. Second, extended quotes provide evidence for my interpretations about shifts in organizational complexity, as well as patterns associated with personality type preferences. The interpretations put on the quotes need to be grounded in the context of the interviews. Self-reflection must be respected as a valid technique to assess the directors' perception of change and leadership challenges. In this sense, qualitative research is about plausibility rather than probability. Conclusions are based on what may be plausible, based on data analysis using particular theories and interpretations as a practitioner trained and experienced in CPA as well as the Myers-Briggs Type Indicator. My analysis and conclusions are based on faith in the directors' perspectives.

## QUANTITATIVE RESEARCH

Quantitative data was generated through a survey questionnaire. The survey questionnaire was designed to explore change issues in the museum sector, integrating aspects of the levels of complexity model and leadership theory. One hundred and forty-four (144) questionnaires were distributed to alumni of the Getty Museum Management Institute (United States), alumni of the Senior Museum Management Program (Australia), art museum directors located in distant parts of Australia, the Singapore Art Museum, and directors of five art museums in London. The survey contained forty-three multiple choice, open-ended, and rank-ordered questions covering nine areas:

1. Museum respondent profile: type, role, staff numbers, budget, and attendance figures
2. Organization culture: levels of complexity, leadership style, and phase of organization development
3. Position: salary, use of performance contracts, and training
4. Change management: current challenges and predicted changes
5. Relationships: board of trustees, authority, and areas of responsibility
6. Organization development: projects, marketing, and communication
7. Legal responsibilities: stewardship and governance
8. Collection management: factors in decision making
9. Financial management: public and private funding

The response rate for the survey questionnaire was 21 percent. The survey is a sample of a population group referred to as museum directors and is used for descriptive purposes only.[6] The thirty anonymous respondents were primarily directors or deputy directors. The respondents represented art, combined art/history, history, park/zoo, and children's museums. Countries represented included Australia/Singapore, the United States/International, and the United Kingdom. Data was prepared using Excel and analyzed by tracking mean averages and highest frequency of response. No statistical testing was done on the data. Survey data is in appendix 2.

## ADDITIONAL RESEARCH

After my PhD was successfully completed in 1998, I continued to track change in the museum sector to ensure a thorough understanding of the context, issues, and contemporary opinion on museum leadership. Outcomes were exchanged with other professionals in the field through the International Committee for Training of Personnel under the International Council of Museums, Museums Australia, and the Sydney Arts Management Group. Projects in the cultural industry sector also provided ample opportunity to observe change issues:

- Contributing to museum guide training programs at the Art Gallery of New South Wales in Sydney, Australia
- Facilitating workshops and conference panels for the Australian and World Federation of Friends of Museums

- Acting as an honorary fellow for the Museum Studies Program at Deakin University in Melbourne, Australia
- Facilitating a management skills development program with cultural enterprise groups

Although the art museum was the case study organization, issues were tracked across a broad spectrum of organizations involved in the cultural industry sector. Field visits were made to a variety of enterprises to sense their approach to marketing, public programs, access, and customer service. Field visits included national heritage sites in England, world heritage sites like the Daintree Rainforest and Great Barrier Reef in Australia and Volcano National Park in Hawaii, an international music camp in northern Michigan, a national photographic studies center in Maine, and the Monterey Bay Aquarium in California. Some of these cultural enterprises were developing extremely creative entrepreneurial strategies, balancing ways to ensure the future viability of the organization while guaranteeing customer satisfaction at the same time. These field visits created a much deeper appreciation of our shared global cultural heritage, both natural and human made.

## NOTES

1. Stamp 1989; Jaques & Cason 1994.

2. Kolb, Rubin, & McIntyre 1979; Dunphy 1981; Harvey & Brown 1982; Milton, Entrekin, & Stening 1984; Hersey & Blanchard 1988.

3. Waterlow 1993 (I); Gibson 1995–2002 (I); Capon 1995 (I); Kent & Gray 1995–1998 (I).

4. Jaques 1956, 1989; Jaques & Cason 1994; Stamp 1986, 1988, 1993.

5. Suchy 1995.

6. Speigel 1972: 1.

# Appendix 2
# Survey Questionnaire

The sample survey was conducted in 1995 as a benchmark for change. It was part of a much broader body of research on the director's role in museum leadership. Most of the respondents were directors or deputy directors. The majority of respondents were from the United States/International group and employed by art museums, history museums, or institutions that combined art/history. The results create a representative sample of change and leadership challenges in the museum sector. The survey was conducted with the following:

1. Alumni of the Museum Management Institute in the United States
2. Alumni of the Senior Museum Managers Course in Australia
3. Targeted art museums in Australia, the United Kingdom, and Singapore

There were thirty respondents, or $N = 30$. A number appears on each table indicating how many respondents out of the sample size of thirty answered the question. Open-ended questions generated a variety of themes, which were recorded as categories most often mentioned (table 25). Statisticians may detect that some tables do not add up to exactly 100 percent. This is due to a minor rounding error in the Excel program. As a sample survey, statistical analysis included mean averages and highest frequency of response for descriptive purposes only. Chi-square and other forms of statistical testing were not used.

## MUSEUM RESPONDENT PROFILE

| Country | N = 30 |
|---|---|
| Australia/Singapore | 33% |
| United States/International | 60% |
| United Kingdom | 7% |

## What type of institution do you work for?

| Table A.   Museum | N = 30 |
|---|---|
| Art | 57% |
| Natural history | 0% |
| Children's | 3% |
| Science | 0% |
| History | 17% |
| Park/Zoo/Garden | 3% |
| Other/Combined art and history | 20% |

## What is your role in the institution?

| Table B.   Role in the Museum | N = 30 |
|---|---|
| Director/CEO | 70% |
| Deputy director | 13% |
| Senior curator | 10% |
| Chairman of the board | 0% |
| Business development manager | 0% |
| Head of exhibition planning | 0% |
| Head of public programs | 0% |
| Marketing manager | 0% |
| Communications/PR | 0% |
| Other | 7% |

## How many staff does your institution employ?

| Table C.   Staff | N = 30 |
|---|---|
| 25 | 44% |
| 50 | 7% |
| 75 | 15% |
| 100 | 15% |
| 125 | 4% |
| 150 | 4% |
| 200 | 4% |
| 300 | 7% |

What is your institution's annual budget?

| Table D.  Budget | US$ *N* = 19 | A$ *N* = 9 |
|---|---|---|
| $ 2M | 26% | 56% |
| $ 4M | 32% | 0% |
| $ 6M | 21% | 22% |
| $ 8M | 11% | 0% |
| $ 10M | 5% | 11% |
| $ 12M | 0% | 0% |
| $ 14M | 0% | 11% |
| $ 25M | 5% | 0% |

How many visitors does your institution attract annually?

| Table E.  Audience-1,000s | *N* = 29 |
|---|---|
| 50 | 17% |
| 100 | 17% |
| 200 | 21% |
| 300 | 14% |
| 400 | 10% |
| 500 | 7% |
| 600 | 3% |
| 700 | 3% |
| 800 | 3% |
| I million | 3% |

## ORGANIZATION CULTURE

1. What is the amount of time required to complete the most complex task related to your work and to see the effectiveness of the decisions taken?

| Table 1.  Task | Time to Complete | *N* = 28 |
|---|---|---|
| Level 1 | Up to three months | 0% |
| Level 2 | Up to one year | 4% |
| Level 3 | Up to two years | 32% |
| Level 4 | Up to five years | 57% |
| Level 5 | Up to ten years | 4% |
| Level 6 | Up to fifteen years | 4% |

2. Which one of the following describes your current experience of work and responsibilities?

**Table 2.  Levels of Work Complexity**  *N* = 30

| | |
|---|---|
| **Quality focus:** Making or doing something concrete for the museum. Managing self and resources to optimum effect. Using practical judgment. Shares help, expertise and ideas for improvements.<br>Level 1 time horizon = up to three months. | 13% |
| **Service focus:** Demonstrating the purpose and mission of the museum. Assessing and serving audience/stakeholder needs. Responding to and resolving particular situations, cases, audience needs. Explaining why and how work is to be done. Share experience/knowledge, inform, and respond.<br>Level 2 time horizon = up to one year. | 7% |
| **Good practice focus:** Maintaining the various ways the museum's purpose is being realized in provision of services or production of goods. Imagining all the possible practices and systems for good practice, selecting the best solutions, and making the most of the people/finance/technology to realize what was chosen. Share practice/systems refinements; inform/manage improvements as a mini-organization.<br>Level 3 time horizon = up to two years. | 10% |
| **Development focus:** Managing the relationship between the corporate plan's mission for the museum and how it can be achieved. Setting the framework and developing new ways to achieve the mission, resourcing established services/practices, terminating services/practices that are not effective. Develop and share innovations, manage change and continuity.<br>Level 4 time horizon = up to five years. | 20% |
| **Mission/Strategic intent:** Ensuring the long-term external and internal viability of the museum/gallery as a whole in financial and social terms. Guiding the museum through conflicts and modifying re: external changes. Maintaining a national position/presence. Representing the museum to the external world and to itself. Set and be the source of current and new business directions/targets. Share strategic information, create a working atmosphere. Control of capital/revenue expenditures as a whole.<br>Level 5 time horizon = up to ten years. | 37% |
| **Other** Two options chosen | 13% |

3. Given your response to Question 2, is this a change from your previous experience of work? If so, when did the change occur?

**Table 3.  Changes**  *N* = 19

| | |
|---|---|
| Within the last year | 21% |
| 1–2 years ago | 26% |
| 2–4 years ago | 26% |
| 4–6 years ago | 5% |
| 6+ years ago | 21% |

## 4. How would you describe your leadership style?

| Table 4. Leadership Style | N = 30 |
|---|---|
| **Participative:** Visionary strategic thinker. Financial planner. Balance priorities for stability with growth. Team building. Organization skills. Crisis management skills. Moderate risk taker. People management skills. Development orientation. High energy level.<br>**Growth phase/New acquisition** | 70% |
| **Charismatic:** Visionary strategic thinker. Hands on, takes charge. In-depth technical know-how. Analytical skills. Organization skills. Human resource knowledge. Negotiation skills. Breadth of knowledge about all functions of the organization. Charismatic communicator. Risk taker.<br>**Start-up/Turnaround phase** | 20% |
| **Directive:** Knows the business and institution. Administrative skills. Systematic. Problem finder and solver. Efficiency, not growth orientation. Sets high standards. Tells and sells. Minimizes risk. Rationalization phase/ Existing business | |
| **Coercive:** Good political skills. Instructs and persuades. Risk taker. Tough-minded and determined. High analytical skills re: cost/benefit orientation. Need respect, not affection. Organization skills. Paternalistic people manager.<br>**Downsizing/Divestment phase** | 3% |

## 5. What phase of development is your organization currently experiencing?

| Table 5. Phase of Organization Development | N = 30 |
|---|---|
| **Start-up:** Creating a vision of the museum/gallery. Establishing core technical and marketing expertise. Building the museum team. | 7% |
| **Turnaround:** Rapid and accurate problem diagnosis. Fixing short-term and ultimately long-term problems. | 10% |
| **Existing business:** Efficiency. Stability. Succession. Sensing signs of change. Making the most of what's profitable for the museum. | 13% |
| **Growth:** Increasing audience reach. Managing rapid change. Building long-term health for future vision. | 53% |
| **Liquidation/Divesting:** Cutting losses, making tough decisions, making the best arrangements possible for a poorly performing organization. | 0% |
| **New acquisition:** Adding a new outlet/activity to the organization. Integrating the new with the old. Establishing sources of information and control. | 17% |

## POSITION

6. What training and development activities have you attended in the last five years?

| Table 6.   Courses | N = 17 |
|---|---|
| Marketing | 14% |
| Strategic planning | 17% |
| Organization development | 13% |
| Team building | 19% |
| Executive negotiation | 12% |
| Financial management | 9% |
| Board/Trustee development | 7% |
| Legal frameworks | 6% |
| Other | 3% |

| Courses in North America | N = 17 |
|---|---|
| Museum Management Institute | 65% |
| American Federation of Arts | 6% |
| American Association of Museums | 6% |
| University | 6% |
| Canadian Museum Association | 18% |

| Courses in Australia | N = 7 |
|---|---|
| Museum Management Program | 43% |
| University program | 14% |
| Tasmania (source not indicated) | 14% |
| Western Australia (source not indicated) | 14% |
| Other | 15% |

7. Is the director's remuneration package linked to a performance contract?

| Table 7 Link | N = 29 |
|---|---|
| Yes | 28% |
| No | 72% |

## 8. How often is the remuneration package reviewed?

| Table 8.   Salary Package Reviews | N = 25 |
|---|---|
| Annually | 68% |
| At the end of the contract period, which was<br>    was 3 years for 20% and 5 years for 60% | 24% |
| On appointment of a new director | 8% |
| Beginning of the corporate plan period | 0% |
| At the end of the corporate plan period | 0% |

## 9. Has your remuneration package been adjusted in the last two years?

| Table 9.   Changes | N = 24 |
|---|---|
| Yes | 54% |
| No | 46% |

## 10. What factors contributed to the adjustment?

| Table 10.   Salary Package Changes | N = 17 |
|---|---|
| Increased size of budget to be managed | 3% |
| Increased number of staff to be managed | 13% |
| Changes to the corporate plan | 17% |
| Increased responsibility for fund-raising | 23% |
| Increased responsibility for marketing | 7% |
| Other: all of the above & changes in govt. policy | 37% |

## 11. Do you feel you are paid your worth? If not, how much is the job worth?

| Table 11.   Worth | N = 30 |
|---|---|
| Yes | 57% |
| No | 43% |

| Suggested Salary-1,000s | US$ N = 6 | A$ N = 3 |
|---|---|---|
| 25 | 0% | 0% |
| 35 | 0% | 33% |
| 50 | 17% | 0% |
| 75 | 17% | 0% |
| 100 | 67% | 67% |
| 125 | 0% | 0% |

## CHANGE MANAGEMENT

12. What were the major challenges for directors over the last two years?

| Table 12.   Challenges up to 1995 | N = 29 |
|---|---|
| Reduced public funding | 11% |
| Increased fund-raiding responsibilities | 11% |
| Increased visitor-centered programming | 13% |
| Increased focus on strategic planning | 11% |
| Master planning for building or moving sites | 14% |
| Board or government restructures | 8% |
| Human resource management issues | 3% |
| Changes in accounting systems | 3% |
| Appointment of a new director | 2% |
| Internal reorganizations and restructures | 14% |
| New collection policy development | 6% |
| Development of Friends of the Museum | 2% |
| Increased political or advocacy activity | 3% |

13. What are predicted challenges for 1995–2000?

| Table 13.   Predicted Challenges up to 2000 | N = 28 |
|---|---|
| Decreased public funding | 20% |
| Increased visitor-centered focus | 7% |
| Maintaining financial stability | 10% |
| Implementing master plans for buildings | 18% |
| Increased visitor growth | 7% |
| Maximizing asset management | 3% |
| Conservation issues | 2% |
| Increased capital campaigns | 5% |
| Competition from and alliances with other museums | 5% |
| Community demands and involvement | 2% |
| Introduction of IT systems | 2% |
| Increased focus on strategic planning | 3% |
| Acquisitions and repatriation of objects | 5% |
| Restructuring of the organizations | 2% |
| Increasing staffing and maintaining staff morale | 10% |

14. Which of the following describes the corporate planning process for the museum?

**Table 14.  Corporate Planning Process**                 *N* = 30

| | |
|---|---|
| Initiated and managed by the director alone | 7% |
| Involves the director and key people who were: | 53% |
|   • Team of senior management staff | |
|   • Board of trustees | |
|   • Key targeted staff | |
|   • Key stakeholders | |
|   • Friends of the Museum/Volunteers | |
| Involves the director, chair of the board, and other trustees | 17% |
| Involves the director and an external consultant | 0% |
| Other | 23% |

**Span of the Corporate Plan**

| Span | *N* = 25 |
|---|---|
| 1 year | 8% |
| 2 years | 12% |
| 3 years | 36% |
| 4 years | 8% |
| 5 years | 36% |

**Frequency of Corporate Plan Review**

| Reviewed | *N* = 25 |
|---|---|
| Once a year | 72% |
| Two years | 12% |
| Three years | 4% |
| Other | 12% |

15. What is the ideal organization structure to back up directors so the museum's mission is achieved as stated in the corporate plan?

**Table 15.  Organization Structure**                 *N* = 17

| | |
|---|---|
| Executive management teams only | 12% |
| Hierarchy of decision makers | 12% |
| Director = senior management team | 59% |
| External advisors and central admin. | 6% |
| Departments with teams | 12% |

## 16. How is the museum's role changing over the next five years?

| Table 16.   Changes for the Museum's Role | N = 29 |
|---|---|
| Decreased academic focus | 6% |
| Increased social and community presence | 38% |
| Increased use of the museum as a recreational site | 4% |
| Increased educational or knowledge focus | 13% |
| Conservation | 4% |
| Greater access through technology | 4% |
| Increased audience service or customer orientation | 13% |
| Increased focus on contemporary art | 2% |
| Redefinition of the role of the museum | 6% |
| Increased role in tourism | 2% |
| Consolidation of financial position | 2% |
| Changing emphasis on exhibitions either more/less | 6% |

## 17. What appears to be shaping the changes?

| Table 17.   Change Shapers | N = 30 |
|---|---|
| Government policy | 16% |
| Social expectations | 16% |
| Audience demands | 24% |
| Museum itself | 18% |
| Legal/Ethical issues | 2% |
| Leisure pursuits | 9% |
| Demands from community | 7% |
| Tertiary institutions | 1% |
| Other | 6% |

## 18. Who are the museum's key stakeholders?

| Table 18.   Key Stakeholders | N = 26 |
|---|---|
| Government funding agencies | 13% |
| Boards of trustees and staff | 14% |
| Public | 22% |
| Members/Friends/Volunteers | 10% |
| Artists and special groups | 8% |
| Schools/Universities/Academics | 10% |
| Corporate sponsors | 5% |
| Tourists | 5% |
| Tax payers | 3% |
| City/Town/Community | 6% |
| Collection owners | 3% |

19. What key ethical issues are predicted for the next five years?

| Table 19.   Ethical Issues | N = 30 |
|---|---|
| Conflict of interests | 17% |
| Moral rights legislation | 17% |
| Import of cultural products | 6% |
| Cultural diversity | 43% |
| Cultural product treaties | 11% |
| Other | 6% |

## RELATIONSHIPS

20. In terms of key decision making, what role does the board of trustees play compared to the director?

| Table 20.   Board Role | N = 29 |
|---|---|
| Ultimate authority | 16% |
| Strategy/Long-term planning | 13% |
| Policy/Governance | 41% |
| Financial control | 16% |
| Guidance/Advisory role only | 16% |

21. What are the director's decision-making rights versus board/trustee control?

| Table 21.   Director's Role and Decisions | N = 25 |
|---|---|
| Director's operational freedom greater than line of report to the board | 92% |
| Board control greater than director rights | 4% |
| Director's rights greater than board via a CEO | 4% |

22. What policy area is the board/trustees responsible for?

| Table 22.   Boards and Policy | N = 27 |
|---|---|
| Fund-raising and financial development | 29% |
| All areas of policy | 51% |
| Acquisitions | 3% |
| Strategy/Mission development | 11% |
| Advisory role only | 6% |

## 23. Which key staff groups contribute to policy development?

| Table 23.  Staff Input to Policy | N = 29 |
|---|---|
| Director + board | 7% |
| Director + staff representatives | 28% |
| Director + department heads/committee | 31% |
| Director + executive management team | 34% |

## 24. Which external groups contribute to policy development?

| Table 24.  External Input to Policy | N = 24 |
|---|---|
| Government authority | 34% |
| Volunteers/Friends of the Museum | 9% |
| Board/Foundation | 6% |
| Users/Customers | 14% |
| Professional organizations or corporations | 17% |
| Arts councils/Advisory groups | 34% |

## ORGANIZATION DEVELOPMENT
## 25. What changes are predicted for key staff roles in the museum?

| Table 25.  Predicted Changes | N = 24 |
|---|---|
| Curators | Combining curatorial and administration |
| | Develop exhibitions/acquisitions for diversity |
| | Diminished authority and scholarship |
| | Increased customer focus |
| Business development | Increased emphasis on business alliances |
| | Increased need for business acumen |
| | Need to broaden support for the museum |
| Financial management | Consolidation of financial position and system |
| | Greater emphasis on information systems |
| | Increased efficiency and finance information |
| Marketing/PR | Increased visibility |
| | Sponsorship focus |
| | Continued growth in function/effectiveness |
| | Developments in tune with user groups |
| Public programs | Attract more audiences/increase access |
| | Generate revenue to "pay for themselves" |
| | Increased need to reflect audience diversity |
| | Inclusion in long-term planning |
| Exhibition planning | Plan in accordance with popular demands |
| | Focus on attracting larger audiences |
| | Inclusion in long-term planning |
| | Continued growth in function/role |
| Human resources | Increased training/education |
| | Increased workplace diversity |
| | Increased use of volunteers |
| | Specific initiatives (e.g., performance reviews) |

26. Who does the director draw on first for major decisions regarding the museum?

**Table 26.   Staff Input to Decisions**                           *N* = 27

| | |
|---|---|
| Curators | 23% |
| Exhibition planner | 9% |
| Business development manager | 4% |
| Marketing manager | 6% |
| Financial systems manager | 13% |
| Public programs manager | 7% |
| Human resource manager | 1% |
| Commercial services manager | 1% |
| Board/Trustees | 20% |
| Other | 14% |

27. In succession planning, which staff are likely candidates for the director's job?

**Table 27.   Succession Planning**                                *N* = 25

| | |
|---|---|
| Curator | 36% |
| Exhibition planner | 5% |
| Business development/sponsorship | 5% |
| Financial systems manager | 0% |
| Human resources manager | 0% |
| Commercial services manager | 0% |
| Public administrator | 9% |
| University professor (e.g., art history) | 4% |
| Trustee | 2% |
| Director of another museum/gallery | 38% |

28. What organizational change projects did the museum initiate in the last two years?

**Table 28.   Past OD Projects**                                   *N* = 26

| | |
|---|---|
| New development or marketing departments | 7% |
| Restructuring the board of trustees | 5% |
| Restructuring the organization as a whole | 35% |
| Implementing a master building plan | 12% |
| Conducting management reviews | 12% |
| Enterprise agreements with staff | 5% |
| Team building activities | 5% |
| Implementing information systems | 2% |
| Financial/Fund-raising activities | 2% |
| Audience research projects | 5% |
| Strategic/Corporate/Human resource plans | 12% |

## 29. What organizational change projects are planned?

| Table 29.   Planned Projects | N = 25 |
|---|---|
| Organization restructures | 26% |
| Capital campaign | 5% |
| Strategic/Corporate planning | 13% |
| New building facilities | 13% |
| Program policies and processes | 11% |
| Audience development & PR | 8% |
| Cost/Service delivery reviews | 5% |
| Fine-tuning structure/alliances | 13% |
| Increase staffing levels | 5% |

## 30. What other organization has the museum used as a role model for change?

| Table 30.   Planned Projects | N = 30 |
|---|---|
| Private sector/Corporations | 22% |
| Small businesses | 4% |
| University/Schools | 17% |
| Nonprofit organizations | 9% |
| Other cultural organizations | 48% |

## 31. If we define marketing as the way that museums respond to needs and changes in its constituencies, what marketing trends have you detected over the last two years?

| Table 31.   Market Trends | N = 25 |
|---|---|
| Increased target or direct marketing | 14% |
| Increased customer service focus | 19% |
| Increased educated visitor groups | 11% |
| Increased tourism from overseas and interstate | 19% |
| Increased young visitors | 11% |
| Change in communication with stakeholders | 8% |
| Increased audience/visitor surveys | 8% |
| Increased use of the mass media | 6% |
| Increased competition | 3% |

## LEGAL RESPONSIBILITIES

32. What changes do you predict regarding legal obligations?

| Table 32.  Legal Obligations | N = 30 |
|---|---|
| Copyright issues re: new technology | 15% |
| Censorship and moral rights issues | 5% |
| Access and equity issues | 15% |
| Research | 3% |
| Financial accountability/tax status | 13% |
| Labor changes & multiskilling | 5% |
| Cultural treaty/indigenous peoples | 13% |
| Board liability issues | 8% |

33. If stewardship is part of the legal obligation, how do you define and ensure stewardship?

| Table 33.  Stewardship Obligations | N = 15 |
|---|---|
| Conservation of objects within the collection | 20% |
| Exhibition programs to display the collection | 15% |
| Access rights by the public to the collection | 20% |
| Publications on the collection | 10% |
| Heritage legislation/government acts | 35% |

34. Which of the following operations is the director legally responsible for?

| Table 34.  Legal Responsibility | N = 25 |
|---|---|
| Board advisory role | 18% |
| Employment practices | 18% |
| Acquisition policy | 10% |
| Copyright | 4% |
| Health and safety | 10% |
| Multiculturalism | 1% |
| Disability access | 0% |
| Collection management (security/maintenance) | 13% |
| Legal structure of the organization | 21% |
| Other | 4% |

## COLLECTION MANAGEMENT
35. What value base is used to make acquisition decisions?

| Table 35.  Acquisition Decisions | N = 28 |
|---|---|
| Best or connoisseurs value | 43% |
| Typical or educative value | 23% |
| Availability of the work | 13% |
| Conservation | 3% |
| Collection policy | 7% |
| Mission for the museum | 10% |

36. What tool is used to value acquisitions and the collection?

| Table 36.  Valuation Tools | N = 21 |
|---|---|
| Auction market | 39% |
| Professional art dealers | 17% |
| Director/Curator acumen | 9% |
| Professional valuer or appraiser | 35% |

37. How often is the collection valued?

| Table 37.  Review Period | N = 16 |
|---|---|
| Yearly | 50% |
| Two years | 13% |
| Three years | 6% |
| Four years | 0% |
| Five years | 31% |

38. Who conducts the valuation?

| Table 38.  Valuations | N = 20 |
|---|---|
| Curators on staff | 39% |
| The director | 5% |
| Commercial gallery valuer | 15% |
| Art auction house | 35% |
| Insurance company valuer | 5% |

## 39. What is the director's decision-making role regarding acquisitions?

| Table 39.  Director's Decisions | *N* = 26 |
| --- | --- |
| Director approves/trustees confirm | 35% |
| Curator/Director approves/trustees confirm | 38% |
| Curators/Director defers/board consultation | 8% |
| Director/Board approve based on policy | 19% |

## 40. What safeguards are in place to limit individual decision making?

| Table 40.  Director's Decisions | *N* = 26 |
| --- | --- |
| Full board of trustee approval | 12% |
| Management committee approval | 27% |
| Guidelines/Policy to ensure action | 27% |
| Hierarchy of decision makers for stops/limits | 23% |
| No safeguards | 12% |

## FINANCIAL MANAGEMENT
## 41. How much do the following funding sources contribute to the museum's revenue?

| Table 41.  Tied Source of Funding | *N* = 18 |
| --- | --- |
| State government | 22% |
| Federal government | 12% |
| Benefactor programs | 4% |
| Bequests | 10% |
| Endowments | 9% |
| Patron programs | 4% |
| Sponsorships | 10% |
| User charges | 13% |
| Investments | 2% |
| License fees | 0% |

## 42. Is government funding tied to a particular area of museum management?

| Table 42.  Tied Funding | *N* = 23 |
| --- | --- |
| No tied grants | 9% |
| Building or services construction | 10% |
| Building maintenance | 20% |
| Special projects | 14% |
| Staffing | 19% |
| Equipment update (e.g., computers) | 5% |
| Exhibitions | 12% |
| Public programs | 2% |
| Other | 7% |

## 43. What does government funding depend on?

| Table 43.  Government Requirements | N = 23 |
|---|---|
| Evidence of a corporate plan | 17% |
| Composition of the board of trustees | 5% |
| Business development manager or fund-raiser | 13% |
| Evidence museum is seeking other funding | 33% |
| Implementation of particular policies* | 18% |
| None of the above | 13% |

*Specific audience focus or government priority

# Appendix 3
# Research Interviews

*Leading with Passion* is based on action research, interviewing and observing respondents in the field on the topic of the director's role in museum leadership. Primary respondents included museum directors, deputy directors, or associate directors who voluntarily participated in personal interviews using either a modified Career Path Appreciation interview approach or structured telephone interview. Secondary respondents included human resource development managers, educators, research academics, psychologists, coordinators of professional development associations or programs, museum specialists, and executive recruitment consultants. The original research was conducted under strict guidelines developed and monitored by the Human Ethics Committee at the University of Western Sydney in Australia. Museum directors who gave written consent for their interview information to be used by the researcher for professional development reasons are noted with an asterisk (*) in their citation. Interview data and consent forms are held in confidence by the author in Sydney, Australia.

Abraham, M. 1998–2002. Interviews with Morrie Abraham, curriculum designer for *Organization, Change and Adaptation* in the School of Management at the University of Technology Sydney in Sydney, NSW, Australia.

Anderson, M. 1996. Interview with Max Anderson, director of the Art Gallery of Ontario in Toronto, Ontario, Canada, on June 25.*

Ayers, M. 2002. Interviews with the previous director of human resources for the Sydney Opera House, who is currently in private practice in Sydney, NSW, Australia.

Barbeito, C. 1995. Interview with Carol Barbeito, director of Barbeito and Associates, a consulting firm based in Colorado specializing in board development for nonprofit organizations, in Sydney, NSW, Australia, on April 4.

Barnes, T. 2002. Telephone interview with Trevor Barnes for a follow-up study on the course *Leading with Passion: 2001 EQ Leadership Program*, conducted for the New South Wales State Premier's Department in Sydney, NSW, Australia, on November 28.

Beech, M. 1995. Interviews with Martin Beech, director of the New South Wales State branch of ProNed, a consulting firm specializing in board development in Sydney, NSW, Australia.

Beech, M. 1996. Interview with Milo Beech, director of the Arthur M. Sackler Gallery and the Freer Gallery of Art in Washington, D.C., on April 18.*

Bergman, R. 1996. Interview with Robert Bergman, director of the Cleveland Museum of Art in Cleveland, Ohio, U.S., on June 23.*

Binder, M. 1998. Interview with Myron Binder, representative for Q'Metrics (a division of Orioli Essi Systems Inc) in San Francisco, California, U.S., on April 15.

Birtley, M. & Boylan, P. 1998–2002. Collaboration on training of museum personnel with Margaret Birtley, coordinator of the Museum Studies program at Deakin University in Melbourne, VIC, Australia and Patrick Boylan, Chairperson of the International Committee for Training of Personnel (ICTOP).

Borg, A. 1996. Interview with Alan Borg, director of the Victoria and Albert Museum in London, England, on May 2.

Boyatzis, R. 1998–2000. Correspondence with Dr. Richard Boyatzis and the Dept. of Organizational Behavior at Case Western Reserve University in Cleveland, Ohio, U.S., while coordinating research with my students in the MBA program at the University of Technology Sydney who were participating in a norming exercise for the Emotional Competence Inventory.

Brown, K. 2003. Interview with Kathleen Brown, past principal director for the west coast division of LORD Cultural Resources Planning and Management and current director of Atelier in San Francisco, California, U.S., on January 8.

Buhrman, J. 2002–2003. Information exchange with Jahn Buhrman, past president of the museum volunteers committee at the National Museum of Bangkok, Thailand.

Burke, J. 1996. Interview with James Burke, director of the Saint Louis Art Museum in St. Louis, Missouri, U.S., on June 7.*

Capon, E. 1993. Discussions with Edmund Capon, director of the Art Gallery of New South Wales in Sydney, NSW, Australia while completing an internship for a masters degree.

Capon, E. 1995. Interview with Edmund Capon, director of the Art Gallery of New South Wales in Sydney, NSW, Australia, on April 13.*

Capps, M. 1995. Interview with Mary Jo Capps, arts sponsorship development consultant in Sydney, NSW, Australia, on April 4.

Churcher, B. 1994. Discussions with Betty Churcher, director of the National Gallery of Australia in Canberra, ACT, Australia.

Churcher, B. 1995. Interview with Betty Churcher, director of the National Gallery of Australia in Canberra, ACT, Australia, on April 3.*

Coaldrake, M. 1995. Interview with Margaret Coaldrake, president of the Council of Museum Directors in Canberra, ACT, Australia, on April 3.*

Connor, B. 1995–2003. Discussions with Bob Connor, curriculum designer for *Effective People Management* in the Graduate School of Business at the University of Technology Sydney in Sydney, NSW, Australia.

Consey, K. 1995. Interview with Kevin Consey, director of the Museum of Contemporary Art in Chicago, Illinois, U.S., on June 12.*

Csikszentmihalyi, M. 1996. Interview with Mihaly Csikszentmihalyi, head of the Department of Psychology, University of Chicago in Chicago, Illinois, U.S., on April 3.

Cuno, J. 1996. Telephone interview with James Cuno, director of the Harvard University Art Museums in Cambridge, Massachusetts, U.S., on June 21.*

d'Harnoncourt, A. 1996. Telephone interview with Anne d'Harnoncourt, director of the Philadelphia Museum of Art in Philadelphia, Pennsylvania, U.S., on June 28.*

Danilov, V. 1997. Interview with Victor Danilov, director of Museum Management Program at the University of Colorado in Boulder, Colorado, U.S., on August 20.

Davis, J. 2000. Discussions on adult learning patterns and strategies with Joy Davis, program director for the Cultural Resource Management Program in the Division of Continuing Education at the University of Victoria in British Columbia, Canada.

de Falla, J. 1996. Interview with Josie de Falla, director of the Maryhill Museum in Goldendale, Washington, U.S., on March 28.*

de Montebello, P. 1996. Interview with Philippe de Montebello, director of the Metropolitan Museum of Art in New York, New York, U.S., on April 11.*

Demetrian, J. 1996. Interview with James Demetrian, director of the Hirshhorn Museum and Sculpture Garden in Washington, D.C., U.S., on April 16.*

Doyle, K. 1994. Telephone interview with Kate Doyle, a representative for Arts Training Australia in Canberra, ACT, Australia, on November 11.

Fiske, P. 1996. Interview with Pat Fiske, director of the National Museum of African Art in Washington, D.C., U.S., on April 19.*

Gaudieri, M. 1996. Telephone interview with Mimi Gaudieri, coordinator for the Association of Art Museum Directors in New York, New York, U.S., on June 13.

Gibson, E. 1995–2002. Interviews with Elizabeth Gibson, senior public programs officer at the Art Gallery of New South Wales in Sydney, NSW, Australia.

Goh, S. 1996. Interview with Sok Goh, an executive consultant for Collins Consulting Group, specialists in finance industry recruitment in Sydney, NSW, Australia, on September 4.

Grant, A. 2003. Interview with Dr. Anthony Grant, director of the Coaching Psychology Unit in the School of Psychology, University of Sydney, NSW, Australia, on March 28.

Griffin, D. 1995. Interview with Dr. Des Griffin, director of the Australian Museum in Sydney, NSW, Australia, on November 29.*

Hall, D. 1995. Interview with Doug Hall, director of the Queensland Art Gallery in Brisbane, QLD, Australia, on February 20.*

Hawley, A. 1996. Telephone interview with Anne Hawley, director of the Isabella Stewart Gardner Museum in Boston, Massachusetts, U.S., on April 4.*

Howard, J. 1995. Interview with John Howard, senior consultant with the Office of Public Management, State Premier's Department in Sydney, NSW, Australia on March 30.

Jenneman, E. 1996. Interview with Eugene Jenneman, director of the Dennos Museum Center in Traverse City, Michigan, U.S., on May 13.*

Kent, P., & Gray, C. 1995–1998. Research supervision sessions with Dr. Phillip Kent and Dr. Campbell Gray in the School of Humanities, University of Western Sydney in Sydney, NSW, Australia.

Kolb, N. 1996. Telephone interview with Nancy Kolb, director of the Please Touch Museum in Philadelphia, Pennsylvania, U.S., on June 21.*

Koshalek, R. 1996. Interview with Richard Koshalek, director of the Museum of Contemporary Art in Los Angeles, California, U.S., on April 2.*

Latos-Valier, P. 1996. Telephone interview with Paula Latos-Valier, director of the Art Gallery of Western Australia in Perth, WA, Australia, on September 2nd.*

Leigh, T. 1995. Telephone interview with Terry Leigh, coordinator of the Senior Museum Management Program, Monash University, Mt. Eliza Center, in Melbourne, VIC, Australia, on September 22.

Levenson, J. 1996. Interview with Jay Levenson, deputy director of the Solomon R. Guggenheim Museum in New York, New York, U.S., on April 12.*

Lowry, G. 1996. Interview with Glen Lowry, director of the Museum of Modern Art in New York, New York, U.S., on April 12.*

Lydecker, K. 1996. Interview with Kent Lydecker, associate director of education at the Metropolitan Museum of Art in New York, New York, U.S., on April 11.*

Lyman, D. 1997. Interview with David Lyman, founder and director of the Maine Photographic Workshops in Rockport, Maine, U.S., on August 28.

Maisel, E. 1995. Interview with Eric Maisel, a psychotherapist working exclusively with creative and performing artists in Berkeley, California, U.S., on June 16.

Marzio, P. 1996. Telephone interview with Peter Marzio, director of the Museum of Fine Arts in Houston, Texas, U.S., on June 27.*

Maurer, E. 1996. Interview with Evan Maurer, director of the Minneapolis Institute of Arts in Minneapolis, Minnesota, U.S., on May 9.*

McAuley, I. 1995. Interview with Ian McAuley, lecturer in public administration at the University of Canberra in Canberra, ACT, Australia, on December 24.

McCaughy, P. 1996. Interview with Patrick McCaughy, director of the Yale Center for British Art in New Haven, Connecticut, U.S., on April 15.*

Moffett, C. 1996. Interview with Charles Moffett, director of the Phillips Collection in Washington, D.C., U.S., on April 17.*

Molen, L. 1996. Interview with Larry Molen, executive vice president for development and public affairs at the Art Institute of Chicago in Chicago, Illinois, U.S., on June 26.

Nichols, N. 1996. Telephone interview with Nancy Nichols, executive recruitment consultant with the search firm Heidrick & Struggles in New York, New York, U.S., on June 13.*

Orioli, E. 2003. Interview with Esther Orioli, director of Orioli Ezzi Systems in San Franciscio, California, U.S., on January 8.

Ottley, D. 1995. Telephone interview with Dr. Dennis Ottley, senior lecturer in marketing and entrepreneurship in the Faculty of Management at the University of Western Sydney in Sydney, NSW, Australia, on August 15.

Parker, H. 1995. Interview with Harry Parker, director of the Fine Arts Museums of San Francisco in San Francisco, California, U.S., on June 14.*

Paroissein, L. 1995. Interview with Leon Paroissein, director of the Museum of Contemporary Art in Sydney, NSW, Australia, on August 10.*

Perkins, R. 1996. Interview with Richard Perkins, manager for the Tate Gallery, St. Ives, in St. Ives, Cornwall, England, on April 28.

Phillips, R. 1997. Interview with Rebecca Phillips, deputy director of human resources and project manager for the EQ and Leadership Development program at the Los Alamos National Laboratory in Los Alamos, New Mexico, U.S., on August 25.

Pines, D. 1996. Interview with Doralynn Pines, associate director of administration for the Metropolitan Museum of Art in New York, New York, U.S., on April 11.*

Potts, T. 1995. Interview with Tim Potts, director of the National Gallery of Victoria in Melbourne, VIC, Australia, on August 11.*

Powell, E. 1996. Interview with Earl Powell, director of the National Gallery of Art in Washington, D.C., U.S., on April 17.*

Raby, D. 1995. Telephone interview with David Raby, director of Corporate Programs at Monash University, Mt. Eliza Center, in Melbourne, VIC, Australia, on March 6.

Rolla, M. 1996. Interview with Maureen Rolla, program coordinator for the Museum Management Institute under the American Federation of Arts in New York, New York, U.S., on April 12.

Ross, D. 1996. Interview with David Ross, director of the Whitney Museum of American Art in New York, New York, U.S., on April 11.*

Sano, E. 1995. Interview with Emily Sano, director of the Asian Art Museum of San Francisco, California, U.S., on June 15.*

Serota, N. 1996. Interview with Nick Serota, director of the Tate Gallery in London, England, on April 30.*

Shaw, M. 1996. Interview with Melinda Shaw, director of the Illinois Children's Museum in Decatur, Illinois, U.S., on June 21.

Simpson, S. 1994. Interview with Shane Simpson, founder of the Arts Law Center of Australia in Sydney, NSW, Australia, on November 22.

Slazenger, L. 1996. Interview with Larry Slazenger, president of the Center for Nonprofit Boards, an educational foundation in Washington, D.C., U.S., on April 17.

Slutzkin, L. 1997. Interview with Linda Slutzkin, art consultant and past senior educator at the Art Gallery of New South Wales in Sydney, NSW, Australia, on May 16.

Smith, S. 1996. Interview with Susan Smith, executive director of the Decatur Area Arts Council in Decatur, Illinois, U.S., on June 21.

Speed, R. 2003. Telephone interview with Richard Speed, program director for Australia's Museum Leadership Program in Melbourne, VIC, Australia, on March 11.

Spence, S. 1995. Telephone interview with Sean Spence, executive recruitment consultant for Russell Reynolds International, regarding the selection process for the director of the National Gallery of Victoria in Melbourne, VIC, Australia, on March 6.

Stamp, G. 1996. Interview with Dr. Gillian Stamp, past director of the Brunel Institute of Organization and Social Studies at Brunel University of West London, Uxbridge, Middlesex, England, on April 23. The author was trained by Dr. Gillian Stamp as a practitioner in Career Path Appreciation and practiced from 1989 to 1998.

Thomson, S. 1996. Interview with Shirley Thomson, director of the National Gallery of Canada in Ottawa, Ontario, Canada, on June 25.*

Walsh, J. 1995. Interview with John Walsh, director of the J. Paul Getty Museum in Santa Monica, California, U.S., on June 7.*

Waterlow, N. 1993. Interview with Nick Waterlow, director of the Ivan Dougherty Gallery at the College of Fine Arts in Sydney, NSW, Australia, on November 1.

Weil, S. 1996. Interview with Stephen Weil, past deputy director of the Hirshhorn Museum and senior scholar at the Center for Museum Studies at the Smithsonian Institution in Washington, D.C., U.S., on April 16.

Whitmore, D. 1996. Interview with Damien Whitmore, head of communications for the Tate Gallery in London, England, on April 10.

Wood, J. 1996. Interview with James Wood, director of the Art Institute of Chicago in Chicago, Illinois, U.S., on June 26.*

# References

Abruzzo, J. 1991. Forecast for the nineties. *International Arts Manager* January: 41–43.

Aburdene, P., & Naisbitt, J. 1994. *Megatrends for women.* London: Arrow.

AIT (Advanced Intelligence Technologies) & Orioli Essi Systems. 1996/1997. *EQ Map.* Orioli Essi Systems: San Francisco.

Alexander, E. 1996. *Museums in motion: An introduction to the history and functions of museums.* Walnut Creek, Calif.: AltaMira Press.

Alswang, H. 1996. *Museums as communities and institutions of values.* Paper presented at the national American Association of Museums conference.

American Association of Art Museum Directors. 1992. *Professional practices in art museums.* New York: Association of Art Museum Directors.

American Association of Art Museum Directors. 1996. *The 1996 salary survey.* New York: Association of Art Museum Directors.

Anderson, J. 2000. Intuition in managers. *Journal of Managerial Psychology* 15 (1): 46–67.

Art Gallery of New South Wales. 1996. *Summary report from the AGNSW corporate affairs department* to the NSW government, unpublished.

Art Gallery of Ontario. 1995. *The annual report 1994–1995.* Toronto: Art Gallery of Ontario.

Arts Research Center of the Alliance for the Arts. 1993. *The economic impact of major exhibitions at the Metropolitan Museum of Art, the Museum of Modern Art, and the Solomon R. Guggenheim Museum.* New York: Arts Research Center.

Atkinson, S. 1999. Personal development for managers: Getting the process right. *Journal of Managerial Psychology* 14 (6): 502–11.

Australian Association of Social Workers. 2002. *Code of ethics.* Canberra: Australian Association of Social Workers.

Australian Broadcasting Corporation. 1996. Everybody's business. *Open Learning Series.* November 28.

Australian Broadcasting Corporation. 2002. A new art museum. *The Seven Thirty Report.* November 13.

Australian Bureau of Statistics. 1995. *Attendance at selected cultural venues.* Catalogue No. 4114.0. Commonwealth of Australia.

Australian Psychologists Press. 1997. *MBTI testing material, resource material, and training programs.* Carlton South, Victoria: Australian Psychologists Press.

Barker, G. 1986. A snub to the British art world? *Art News* 85: 50.

Bello, M. 1993. *The Smithsonian Institution, a world of discovery: An exploration of behind-the-scenes research in the arts, sciences, and humanities.* Washington, D.C.: Smithsonian Institution.

Bennie, A. 1997. Irishman to head national gallery. *Sydney Morning Herald,* May 29, 3.

Bennis, W. 1984. *Leaders.* New York: Harper Perennial.

Bennis, W., & O'Toole, J. 2000. Don't hire the wrong CEO. *Harvard Business Review* 78, 3 (May/June): 170–76.

Berry, N., & Mayer, S., eds. 1989. *Museum education, history, theory and practice.* Virginia: National Art Education Association.

Birkett, D. 2002. The face speaks with international eloquence. *Sydney Morning Herald,* September 11, 9.

Bloch, N. 2001. The accidental empire. *Earthwatch Journal* April: 15.

Boddy, D., Patton, R., & MacDonald, S. 1995. Competence-based management awards in higher education. *Management Learning* 26: 179–92.

Boyatzis, R., Cowen, S., Kolb, D., & Associates. 1995. *Innovation in professional education.* San Francisco: Jossey-Bass.

Boyd, W. 1995. Wanted: An effective director. *Curator* 38: 171–84.

Boylan, P. 1993. Cross-community curatorial competencies. *Museums Journal* 93: 26–29.

Bradley, J., & Frederic, J. 1997. The effect of personality type on team performance. *Journal of Management Development* 16 (5): 337–53.

Bricklin, D. 2001. Natural-born entrepreneur. *Harvard Business Review* September: 53–59.

Bridge, J. 2002. *Corporate governance.* Presentation by Jane Bridge from Boardroom Partners for the Institute of Management Consultants, New South Wales, Australia. November.

Brockman, J. 2002. Great minds think unalike. *Sydney Morning Herald,* Spectrum, October 12, 4–6.

Burdett, J. 1990. Identifying leaders: The challenge of the 90s. *Drake Business Review* 4: 4–5.

Burke, J. 1994. *Bi-annual report 1993 and 1994 for the Saint Louis Art Museum.* St. Louis, Missouri.

Business and Professional Women. 2002. *What is social capital?* Sydney: Newsletter for the Business and Professional Women Network. New South Wales. December.

Butler, S. 1996. *Credentials for the new century: Museum leadership and management.* Paper presented at the national American Association of Museums conference.

Cacioppo, R. 1980. *Working with different types: The theory, research, and application of psychological types at work (an Australian study).* Paper presented at the Management Educators Conference, Monash University. W.A.I.T. Monograph. Contact: Senior Management Center, Australian Institute of Management, West Australia.

Caldwell, B., & Carter, E. 1993. *The return of the mentor.* London: Fulmer Press.

Campbell Clark, S., Callister, R., & Wallace, R. 2003. Undergraduate management skills courses and student EQ. *Journal of Management Education* 27 (1): 3.

Capon, E. 1996a. *Fund-raising*. Presentation given to volunteer museum guides at the Art Gallery of New South Wales in Sydney.

Capon, E. 1996b. The art of giving. *LOOK* November: 13.

Capon, E. 2002. Fantastic acquisitions. *LOOK* December: 8.

Carlopio, J., Andrewartha, G., & Armstrong, H. 2001. *Developing management skills: A comprehensive guide for leaders*. 2nd ed. Frenchs Forest: Pearson Education Australia.

Case, M. 1996. Tales of change. *Museum News* 75: 22–23, 73.

Cembalest, R. 1991. Reviving the Corcoran. *Art News* 90: 50.

Cembalest, R. 1992. Powell's progress. *Art News* 91: 36, 38.

Cherniss, C., & Goleman, D., eds. 2001. *The emotionally intelligent workplace*. San Francisco: Jossey-Bass.

Chung, K. 1987. Do insiders make better CEOs than outsiders? *Academy of Management Executives* 1: 3.

Cochrane, P. 1997. Arts miss out on funding. *Sydney Morning Herald*, March 20, 15.

Colbert, F. 2002. Keynote Speaker. The New Wave: Entrepreneurship and the Arts. Symposium hosted by the Bowater School of Management and Marketing, Faculty of Business and Law. Melbourne: Deakin University.

Colonghi, J. 1996. *New faces of philanthropy: Developing ethnic-specific fundraising campaigns*. Paper presented at the national American Association of Museums conference.

Colonghi, J. 2000. Paper presented at the International Committee of Museum Management conference hosted by the International Council of Museums and the Canadian Museums Association.

Connor, B. 2003. *Effective people management: Study guide*. School of Management. University of Technology Sydney.

Cooper, R., & Sawaf, A. 1997. *Executive EQ: Emotional intelligence in leadership and organizations*. New York: Putnam.

Courtenay, B. 1997. *A recipe for dreaming*. Melbourne: Penguin.

Crisp, L. 2003. The friends and enemies of Brian Kennedy. *Australian Financial Review*, April 5, 25.

Csikszentmihalyi, M. 1990. *Flow: The psychology of optimal experience.* New York: Harper Row.

Csikszentmihalyi, M. 1993. *The evolving self: A psychology for the third millennium.* New York: Harper Perennial.

Csikszentmihalyi, M., & Hermanson, K. 1995. Intrinsic motivation in museums: What makes visitors want to learn? *Museum News* 74: 34–62.

Csikszentmihalyi, M. 1996. *Creativity: Flow and the psychology of discovery and invention.* New York: Harper Perennial.

D'Arcy, D. 1996. Mergers and closures are the new proposals for US museums. *Art Newspaper,* July/August, 27.

D'Costa, D. 2002. The extra value of a life coach. *Sunday Telegraph,* November 14, 49.

David, J. 1993. Report claims 40,000 workers in museums. *Museums Journal* 93: 12–13.

Day, J. 1993. California dreaming. *Museums Journal* 93: ii.

Dayton, K. 1987. *Governance is governance.* Washington, D.C.: Independent Sector Publications.

Deal, T., & Kennedy, A. 1982. *Corporate cultures: The rites and rituals of corporate life.* Reading, Mass.: Addison-Wesley.

Delbridge, A., ed. 1982. *The concise Macquarie dictionary.* Lane Cove, New South Wales: Doubleday Australia.

Devine, M. 1990. *The photofit manager: Building a picture of management in the 1990s.* London: Unwin Hyman.

Dobbs, S., & Eisner, E. 1990. Silent pedagogy in art museums. *Curator* 33: 217–35.

Douglas, L. 2002. Museum adventure in Dallas. *Museum National* 11 (1): 26–27.

Douglas, M. 2003. Why soft skills are an essential part of hard world business. *British Journal of Administrative Management* 1 (34): 34–35.

Downing, S. 1997. Learning the plot: Emotional momentum in search of dramatic logic. *Management Learning* 28: 27–44.

Drucker, P. 1985. *Innovation and entrepreneurship: Practice and principles.* London: Heinemann.

Duitz, M. 1995. Reflections of a museum director. *Museum News* 74: 29–46.

Dulewicz, V., & Higgs, M. 2000. EQ: A review and evaluation study. *Journal of Managerial Psychology* 15 (4): 341–72.

Duncan, C. 1995. *Civilizing rituals: Inside public art museums.* London: Routledge.

Dunphy, D. 1981. *Organisational change by choice.* Sydney: McGraw-Hill.

Dunphy, D., & Stace, D. 1990. Unpublished research on leadership competency development conducted by the Australian Graduate School of Management, University of New South Wales, for Westpac Banking Corporation in Sydney, Australia.

Durden-Smith, J., & de Simone, D. 1983. *Sex and the brain.* London: Pan Books.

Editor. 1992. The populist patrician departs. *Art News* 91: 29.

Editor. 1997. Arts council role deserves enriching. *The Australian,* March 31, 10.

Editor. 2001. When merchants enter the temple. *The Economist,* New York and London, April 19. Website story id = 578920.

Elder, J. 2002. The virgin knight. *The Sun Herald,* Sunday Life, November 24, 23–25.

Excellerated Research Inc. 1997. *Business school for entrepreneurs.* Sydney: Excellerated Australia.

Falk, J., & Dierking, L. 2000. *Learning from museums: Visitor experiences and the making of meaning.* Walnut Creek, Calif.: AltaMira Press.

Farrelly, K. 2003. Follow the leader. *Sydney Morning Herald,* My Career, March 29, 1.

Fewster, K. 1996. *Museum management: Developing programs in difficult times.* Paper presented at the national Museums Australia conference.

Fineman, S. 1997. Emotion and management learning. *Management Learning* 28: 13–25.

Fiori, D. 1996. *Credentials for the new century: Museum leadership and management.* Paper presented at the national American Association of Museums conference.

Fox, C. 2002. True believer: The man who invented EQ says there is no turning back. *Australian Financial Review, BOSS,* November 3, 64–67.

Fox, C. 2003. Gauging employees' emotional wellbeing. *Australian Financial Review,* April 8, 67.

Fraser, R. 1990. Leadership in turbulent times. *Training and Development Journal* December: 35–37.

Freeman, D. 1993. *Talking type in organizations*. Melbourne: Australian Psychologists Press.

Fukuyama, F. 1995. *Trust: The social virtues and the creation of prosperity*. London: Penguin.

Fulmer, R., & Vicere, A. 1995. *Executive education and leadership development: The state of the practice*. University Park, Penn.: Pennsylvania State Institute for the Study of Organizational Effectiveness.

Galagan, P. 1990. *Executive development in a changing world*. Virginia: American Society of Training and Development.

Galbraith, J. 1982. Designing the innovating organization. *Organizational Dynamics* 10: 5–25.

Galla, A. 2003. Intangible heritage. *International Council of Museums News* 56 (1): 10.

Galligan, D. 1996. *Credentials for the new century: Museum leadership and management*. Paper presented at the national American Association of Museums conference.

Gardner, H. 1983. *Frames of mind: The theory of multiple intelligences*. New York: Basic Books.

Gardner, H., in collaboration with Emma Laskin. 1995a. *Leading minds: An anatomy of leadership*. New York: Basic Books.

Gardner, H. 1995b. Self-raising power. *The Australian*, August 16, 27.

Garfield, D. 1995. Inspiring change: Post-heroic management. *Museum News* 74: 32–56.

Gerstein, N., & Reisman, H. 1987. Strategic selection: Matching executives to business conditions. In *The art of managing human resources*, ed. E. Schein. New York: Oxford University Press.

Gilmore, A., & Rentschler, R. 2002. Changes in museum management: A custodial or marketing emphasis? *Journal of Management Development* 21 (10): 745–60.

Gittons, R. 2002. We're more money-hungry, less ethical. *Sydney Morning Herald*, October 14, 35.

Glynn, M. 1996. Innovative genius: A framework for relating individual and organizational intelligences to innovation. *Academy of Management Review* 21: 1081–1111.

Goleman, D. 1996. *Emotional intelligence: Why it can matter more than IQ.* London: Bloomsbury.

Goleman, D. 1998. *Working with emotional intelligence.* London: Bloomsbury.

Goleman, D., ed. 2003. *Destructive emotions and how we can overcome them.* London: Bloomsbury.

Gragg, R. 1996. Triumphant tombs ends Sunday. *The Oregonian,* September 15, 2.

Gray, J. 1993. *Men are from Mars, women are from Venus.* New York: Harper Collins.

Griffin, D. 1996. *Effective management of museums in the 1990s.* Presentation at the Museums Australia Conference.

Griffin, D., & Abraham, M. 1999. Management of museums in the 1990s. In *Management in museums,* ed. K. Moore. London: Athlone Press.

Gurian, E. 1996. *A savings bank for the soul.* Paper presented at the national Museums Australia conference.

Hammer, A., & Mitchell, W. 1996. The distribution of MBTI types in the U.S. by gender and ethnic group. *Journal of Psychological Type* 37: 2–15.

Harvey, D., & Brown, D. 1982. *An experiential approach to organization development.* 2nd ed. New Jersey: Prentice Hall.

Hersey, P., & Blanchard, K. 1988. *Management of organizational behavior: Utilizing human resources.* 5th ed. London: Prentice Hall.

Hewett, J. 2003. Finally, a board wakes up. *Sydney Morning Herald,* Business & Money, March 1, 49.

Higgs, M. 2001. Is there a relationship between the Myers-Briggs Type Indicator and emotional intelligence? *Journal of Managerial Psychology* 16 (7): 509–33.

Hirsch, W. 1990. *Succession planning.* Institute of Manpower Planning. England: University of Sussex.

Hirsh, S., & Kummerow, J. 1998. *Introduction to type in organizations: Individual interpretive guide.* Palo Alto, Calif.: Consulting Psychologists Press.

Hochfield, S. 1989. A sacrificial lamb? *Art News* 88: 62.

Horin, A. 2002. Grey rights shaping museum's vision of future. *Sydney Morning Herald,* November 23, 2.

Hudson, K. 1987. *Museums of influence.* Cambridge: Cambridge University Press.

Hughes, R. 1990. Nothing if not critical: Selected essays on art and artists. New York: Penguin.

International Committee for the Training of Personnel. 2003. *E-news.* ICOM (UNESCO). http://icom.museum/imd.html and www.museumsfriends.org.

International Council of Museums. 2001. *New definitions for the museum and museum professionals.* Paris: UNESCO.

Isachsen, O. 1992. *Working together: A personality centered approach to management.* 2nd ed. Coronado, Calif.: New World Management.

Jaques, E. 1956. *Measurement of responsibility.* Falls Church, Va.: Cason Hall.

Jaques, E. 1989. *Requisite organization: The CEO's guide to creative structure and leadership.* Falls Church, Va.: Cason Hall.

Jaques, E., & Cason, K. 1994. *Human capability: A study of individual potential and its application.* Falls Church, Va.: Cason Hall.

Jaques, E., & Clement, S. 1991. *Executive leadership: A practical guide to managing complexity.* Oxford: Blackwell.

Jaworski, J. 1996. *Synchronicity: The inner path of leadership.* San Francisco: Berrett-Koehler.

Johnston, R. 1996. Paper presented at the national Museums Australia conference.

Jones, D. 1994. Masters at work. *The Australian,* November 11, 10.

Kagle, J. 1996. *Communities and museums: Rebuilding the relationship.* Paper presented at the national American Association of Museums conference.

Karp, I., Creamer, C., & Lavine, S., eds. 1992. *Museums and communities: The politics of public culture.* Washington, D.C.: Smithsonian Institution Press.

Karpin, D. 1995. In search of leaders. *HR Monthly* June: 10–14.

Keating, P. 2001. Professional passion. *Management Today* May, 2.

Kellogg, F. 1996. Fixing it: Repair and revival of the national endowment for the arts. *Museum News* 75: 34–41.

Kets de Vries, M. 1988. The dark side of CEO succession. *Harvard Business Review* 88, 1 (January/February): 56–60.

Khaleelee, O., & Woolf, R. 1996. Personality, life experience and leadership capability. *Leadership and Organization Development Journal* 17: 5–11.

Kolb, D., Rubin, I., & McIntyre, J. 1979. *Organization psychology: An experiential approach.* New Jersey: Prentice Hall.

Kraut, A., & Pedigo, P. 1989. The role of the manager: What's really important in different management jobs. *Academy of Management Executive* 3: 286–93.

Kroger, O., & Thuesen, J. 1988. *Type talk: How to determine your personality type and change your life.* New York: Delacorte.

La Motta, T. 1992. *Using personality typology to build understanding.* Annual Developing Human Resources. Pfeiffer and Company.

Leeuwen van, H. 1996. Professors bring business managers and critics to book. *Australian Financial Review,* October 11, 18.

Levenson, H. 1988. You won't recognize me: Predictions about changes in top-management characteristics. *Academy of Management Executive* 2: 119–25.

Leys, N. 2000. Climbing to the top. *Sydney Morning Herald,* My Career, June 14, 6.

Lorsch, J., & Khurana, R. 1999. Changing leaders: The board's role in CEO succession. *Harvard Business Review* 3, 77 (May/June): 96–105.

Low, A. 2002. *What glass ceiling: Women and entrepreneurship.* Presentation at the Institute of Management Consultants, New South Wales, Australia. September.

MacKay, M. 1996. *Credentials for the new century: Museum leadership and management.* Presentation at the national American Association of Museums conference.

Mair, D. 2000. Apres moi? *BOSS: Australian Financial Review,* June 4, 26–31.

Maisel, E. 1992. *A life in the arts: Practical guidance and inspiration for creative and performing artists.* New York: Tarcher/Putnam.

Makris. R. 2003. *Participant attendance 1999 and 2001: Museum leadership program.* Executive Development Unit, Melbourne Business School. University of Melbourne, Australia.

Margerison, C., & Lewis, R. 1981. Mapping managerial styles. *International Journal of Manpower* 2: 1.

Margo, J. 2001. Are you high or low on EQ? *Australian Financial Review,* Men's Health, August 10, 14.

Maroevic, I. 1997. Museums and the development of local communities after the war in the former Yugoslavia. *Museum News* 5: 12–14.

Martin, C. 1996. *Estimated frequencies of the types in the United States population.* Gainesville, Fla.: Center for Application of Psychological Type.

Martin, L. 2003. History in her making. *Sydney Morning Herald,* Spectrum, February 8, 3.

Maslen, G. 1996. Big picture man. *Sydney Morning Herald,* Good Weekend, October 19, 21–27.

McCafferty, J. 1996. Your own Vince Lombardi. *CFO: The Magazine for Chief Financial Officers* 12: 93–95.

McCarthy, A., & Garvan, T. 1999. Developing self-awareness in the managerial career development process: The value of 360-degree feedback and the MBTI. *Journal of European Industrial Training* 23 (9): 437–45.

McClure, L., & Werther, W. 1993. Personality variables in management development interventions. *Journal of Management Development* 12 (3): 39–47.

McDonald, J. 1997a. The best game in town. *Sydney Morning Herald,* April 12, 14.

McDonald, J. 1997b. Artful dodging. *Sydney Morning Herald,* May 17, 35.

McDonald, J. 1997c. Luck of the Irish. *Sydney Morning Herald,* May 29, 15.

McDonald, J. 2002. The quiet removal of the NMA's director. *Australian Financial Review,* December 12, 47.

McDonald, J. 2003. Ideology and the threat to the arts. *Weekend Australian Financial Review,* January 4–5, 27.

McShane, I. 2002. Professional development report on training in Western Australia. *Museum National* 10 (3): 3.

Mezias, S., & Glynn, M. 1993. The three faces of corporate renewal: Institution, revolution and evolution. *Strategic Management Journal* 31: 235–56.

Miller, J. 1999. A bright outlook for cultural businesses. *SMARTS* 17: 24.

Milton, C., Entrekin, L., & Stening, B. 1984. *Organizational behavior in Australia.* Sydney: Prentice-Hall of Australia.

Moore, G. 1992. *Heart talk.* Bangkok: White Lotus.

Moore, K., ed. 1994. *Museum management.* London: Routledge.

Morgan, G. 1988. *Riding the waves of change: Developing managerial competencies for a turbulent world.* San Francisco: Jossey-Bass.

Morgan, J. 1997a. Tall orders. *The Australian,* February 15, 10.

Morgan, J. 1997b. The young master. *The Australian,* May 19, 11.

Morgan, J. 2002. Review of the national museum is politically motivated. *Sydney Morning Herald,* December 16, 15.

Morgan, J. 2003. Healing art and the medicine in music. *Sydney Morning Herald,* February 2, 28.

Mulcahy, K. 2002. *Entrepreneurship or cultural Darwinism: Perspectives on the American system of cultural patronage.* Paper presented at the New Wave: Entrepreneurship and the Arts. Symposium hosted by the Bowater School of Management and Marketing, Faculty of Business and Law. Melbourne: Deakin University.

Murdoch, J. 1992. Defining curation. *Museums Journal* 92: 18–19.

Museum of New Zealand Te Papa Tongarewa. 1999. *National training network for museums.* A report prepared for Te Papa National Services by Skill Development Associates Ltd. Wellington, New Zealand.

Myers, I. 1993. *Introduction to type.* Palo Alto, Calif.: Consulting Psychologists Press.

Myers, I., & McCaulley, M. 1985. *Manual: A guide to the development and use of the Myers-Briggs type indicator.* Palo Alto, Calif.: Consulting Psychologists Press.

Myers, I., & Myers, P. B. 1993. *Gifts differing.* Paulo Alto, Calif.: Consulting Psychologists Press. CPP Books.

National Center for Culture and Recreation Statistics 1999. *Australia's culture No. 11: Selected cultural industries 1999–2000.* Cultural Ministers Council: Statistics Working Group. Prepared by the National Center for Culture and Recreation Statistics and the Australian Bureau of Statistics.

National Gallery of Australia. 1995. Advertisement for director. *Art Newspaper,* 48, 8.

National Gallery of Australia. 2002. *Museums: Sites of communication.* Symposium hosted in partnership with the National Portraits Gallery in Canberra, Australia.

National Gallery of Victoria. 1994. *Position description for the director.* National Gallery of Victoria in Melbourne.

Orioli, E. 1996. *EQ Map Interpretation Guide.* San Francisco: Orioli Essi Systems.

Palmer, B., Walls, M., Burgess, Z., & Stough, C. 2001. EQ and effective leadership. *Leadership and Organization Development Journal* 22 (1): 5–10.

Patching, K., & Chatham, R. 1998. Getting a life at work: Developing people beyond role boundaries. *Journal of Management Development* 17 (5): 316–37.

Pearce, J. C. 1992. *Claiming the potential of our intelligence.* New York: Harper Collins.

Pennar, K. 1996. How many smarts do you have? *Business Week,* September 16, 52–55.

Peters, T. 1987. *Thriving on chaos: Handbook for management revolution.* London: Macmillan.

Potter, C. 1989. What is culture: And can it be useful for organisational change agents? *Leadership and Organization Development Journal* 10: 17–24.

Potts, D. 1997. Go-it-alone women shun boardrooms. *The Sun-Herald,* June 8, 67.

Rentschler, R. 2002. *The entrepreneurial arts leader: Cultural policy, change and reinvention.* Nathan, Queensland: University of Queensland Press.

Reynolds, P. 1992. Better teach yourself. *Museums Journal* 92: 16–18.

Reynolds, P., Bygrave, W., Autio, E., Cox, L., & Hay, M. 2002. *The 2002 executive report.* Global Entrepreneurship Monitor. Ewing Marion Kauffman Foundation at Babson College (USA) and the London Business School.

Riley, G., & Urice, S. 1996. Art museum directors: A shrinking pool? *Museum News* May/June: 48–64.

Roodhouse, S. 1994. Training matters. *Museums Journal* 92: 28–31.

Russ, K. 2000. Building capability. *HR Monthly* March: 37.

Sadler, P. 1991. *Designing organizations: The foundation for excellence.* London: Mercury.

Sargent, A. 1981. *The androgynous manager.* New York: American Management Association.

Schein, E. 1985. *Organizational culture and leadership.* San Francisco: Jossey-Bass.

Schriesheim, D., & Neider, L. 1989. Leadership theory and development: The coming new phase. *Leadership and Organization Development Journal* 10: 17–26.

Senge, P. 1990. *The fifth discipline.* New York: Doubleday.

Siege, A. 1996. *New faces of philanthropy: Developing ethnic-specific fundraising campaigns.* Paper presented at the national American Association of Museums conference.

Silcock, A. 2000. Rekindling spark. *HR Monthly* April: 32–33.

Simons, M. 2003. Unaccustomed as I am. *Sydney Morning Herald,* Spectrum, March 15, 4–5.

Simpson, S. 1989. *Museums and galleries: A practical legal guide.* Sydney: Redfern Legal Center.

Singer, P. 2002. *Writings on an ethical life.* Sydney: Harper Collins.

Sola, T. 1994. Museum generalists: New professionals in the age of synthesis. *Museum Management and Curatorship* 13: 61–65.

Soren, B. 2002. *Qualitative and quantitative audience research.* In *The manual of museum exhibitions,* ed. B. Lord & G. Lord. Walnut Creek, Calif.: AltaMira Press.

Spate, V., ed. 1980. *French painting: The revolutionary decades 1760–1830.* Sydney: Australian Gallery Directors Council.

Speiss, P. 1996. Toward a new professionalism: American museums in the 1920s and 1930s. *Museum News* 75: 38–47.

Spiegel, M. 1972. *Theory and problems of statistics.* New York: McGraw-Hill.

Spock, M. 1996. *Charting a course for the future.* Paper presented at the national American Association of Museums conference.

Stamp, G. 1986. Career paths in tomorrow's organizations. *Industrial and Commercial Training* 18: 17–21.

Stamp, G. 1988. *Longitudinal research into methods of assessing managerial potential. Technical Report 819.* United States Army Research Institute for Behavioral and Social Sciences, Alexandria, Va.

Stamp, G. 1989. *Career path appreciation: Practitioners guide and associated material.* Brunel University of West London: Brunel Institute of Individual and Organization Studies.

Stamp, G. 1990. *A matrix of working relationships.* Brunel University of West London: Brunel Institute of Individual and Organization Studies.

Stamp, G. 1993. Well-being at work: Aligning purposes, people, strategies, and structures. *International Journal of Career Management* 5: 1–36.

Steckel, R. 2002. *Business models for financing and managing the arts: A global view.* Paper presented for the biennial Australian Institute of Arts conference.

Strickland, C. 1992. *The annotated Mona Lisa.* Kansas City, Mo.: Andrews McMeel.

Suchy, S. 1993. *From the outside in: Views of sponsorship management in a public art gallery.* Internship project report completed for the master of art administration. College of Fine Arts, University of New South Wales, Australia.

Suchy, S. 1995. The organization culture of a museum: Implications for communication and museum management. *Communicating Cultures.* Collected proceedings from the national Museums Australia conference. Pp. 142–47. Re-edited as Suchy, S. 1998. *Leadership: Personality theory and that vision thing.* Gainesville, Fla: Center for Application of Psychological Type.

Suchy, S. 1998a. *An international study on the director's role in art museum leadership.* Doctoral thesis. University of Western Sydney, Australia.

Suchy, S. 1998b. *Leading with Passion.* A three month in-company EQ leadership development and change management program. DUO PLUS Pty Ltd, Sydney.

Suchy, S. 1999a. Emotional intelligence: Passion and museum leadership. *Museum Management and Curatorship* 18 (1): 57–71.

Suchy, S. 1999b. *Cultural and business outlook: Foundation management skills.* Professional development program for the cultural industry sector coordinated by Su Hodge Enterprises and sponsored by the Australian Council for the Arts and the Department of State and Regional Development. Sydney, NSW.

Suchy, S. 2000a. Grooming new millennium museum directors. *Museum International* 206, 52 (2): 59–64.

Suchy, S. 2000b. *Developing leaders for the 21st century: Engaging the hearts of others.* Paper presented at the first international conference on museum leadership hosted by the Canadian Museum Association and the International Committee on Museum Management (UNESCO).

Suchy, S. 2000c. *Succession planning workshop.* Ottawa: Canadian Museums Association.

Suchy, S. 2001a. Questions of leadership: Planning ahead. *Museum National* 9 (3): 4.

Suchy, 2001b. Professionalising the muse. *Museum National* 9 (3): 25.

Suchy, S. 2001c. *Coaching change management: Change agent skills.* An in-company trainer training program for change transition teams. DUO PLUS Pty Ltd, Sydney.

Suchy, S. 2001d. *EQ leadership program report.* Prepared by DUO PLUS Pty Ltd for the New South Wales Premier's Department. Sydney, Australia.

Suchy, S. 2002a. *Selling integrity: The entrepreneurial museum.* Paper presented at the New Wave: Entrepreneurism and the Arts. Symposium hosted by the Bowater School of Management and Marketing, Faculty of Business and Law. Melbourne: Deakin University.

Suchy, S. 2002b. Personal change and leadership development: A process of learning how to learn. *Study Series 10: ICOM International Committee for the Training of Personnel.* Paris: UNESCO.

Suffield, L. 1996. Entrance charges scrapped at leading Australian museum. *Art Newspaper* 61 (July/August): 14.

Sullivan, G. 1990. *Artistic intelligence: Putting your hands, heart and head in the picture.* Unpublished paper presented at a seminar on art education at the College of Fine Arts, University of New South Wales, Australia.

Sullivan, G., & Suchy, S. 1997. *Comparative analysis of participating artists personality types.* College of Fine Arts, University of New South Wales, Australia.

Sung, A. 1996. *New faces of philanthropy: Developing ethnic-specific fundraising campaigns.* Paper presented at the national American Association of Museums conference.

Sutton, D. 1986. The national gallery imbroglio. *Apollo,* September: 230.

Sutton, R. 2002. The weird rules of creativity. *Harvard Business Review* September: 96–103.

Sykes, J. 2002. Power and glory. *LOOK* September: 12.

Tan, V., & Tiong, T. 1999. Personality type and the Singapore manager: Research findings based on the MBTI. *Singapore Management Review* 21 (1): 15–25.

Tannen, D. 1990. *You just don't understand.* Sydney: Random House.

Tate Gallery, St. Ives. 1996. *1994/5 Visitor Survey.* Exeter: West Country Tourist Board.

Tolles, B. 1996. *Credentials for the new century: Museum leadership and management.* Paper presented at the national American Association of Museums conference.

Tramposch, W. 1994. Some thoughts on organization and training. *Museum Management and Curatorship* 13: 61–65.

Tunny, D. 1997. World's friends meet amidst Mexico's past. *LOOK* March: 12–13.

Varela, F. 2003. The scientific study of consciousness. In *Destructive emotions and how we can overcome them*, ed. D. Goleman. London: Bloomsbury.

Vecchio, R., Hearn, G., and Southey, G. 1995. *Organizational behavior: Life at work in Australia.* Sydney: Harcourt Brace.

Vines, H. 2000. Putting values to work. *HR Monthly* April: 12–18.

Washburn, W. 1996. Education and the new elite: American museums in the 1980s and 1990s. *Museum News* 75: 60–63.

Weil, S. 1995. *A cabinet of curiosities: Inquiries into museums and their prospects.* Washington, D.C.: Smithsonian Institution Press.

Weil, S. 1996a. *Charting a course for the future.* Paper presented at the American Association of Museums conference.

Weil, S. 1996b. The distinctive numerator. *Museum News* 75: 64–65.

Weil, S. 1996c. *Credentials for the new century: Museum leadership and management.* Paper presented at the American Association of Museums conference.

Weller, L. 1999. Application of multiple intelligence theory in quality organizations. *Team Performance Management* 5: 136–46.

Whetten, D., & Cameron, K. 1995. *Developing management skills.* 3rd ed. New York: Harper and Collins.

Whetten, D., & Clark, S. 1996. An integrated model for teaching management skills. *Journal of Management Education* 20: 152–81.

Wilcoxon, S. 1996. *Charting a course for the future.* Paper presented at the national American Association of Museums conference.

Winkworth, K. 1994. Taking it to the streets: Museums and communities. *Museum National* 3: 4–6.

World Commission on Culture and Development. 1996. *Our creative diversity.* Paris: UNESCO.

Zeller, T. 1996. From national service to social protest: American museums in the 1940s, 1950s, 1960s, and 1970s. *Museum News* 75: 48–59.

# About the Author

Dr. Sherene Suchy is a specialist in individual and organization development, managing a private practice in Sydney, Australia. As an organization development professional, Sherene's work spans over twenty years of industry experience. Her primary area of interest is EQ leadership development and successful change management. Professional experience includes roles as a team member, manager, and consultant in public and private organizations across a range of industries in Australia, Malaysia, and Singapore. This experience provides a rich depth of anecdotal insight for her role since 1994 as an adjunct lecturer with the School of Management in the Graduate School of Business at the University of Technology Sydney, in Australia. As a change manager, Sherene facilitates sessions for corporations preparing international executives and their families for successful cross-cultural adaptation. She encourages expatriates to use museums as sites for cultural orientation in their new home countries.

Dr. Suchy's qualifications include a bachelor of social work (psychology) from the Royal Melbourne Institute of Technology; a graduate diploma in communication management (organization communication) from the University of Technology Sydney; a master of art administration from the College of Fine Arts at the University of New South Wales; and a PhD (philosophy) from the University of Western Sydney in Australia. Memberships include the Australian Association of Social Workers, Institute of Management Consultants, and the International Council of Museums.